W9-CAZ-430

The EVERYTHING Cartooning Book

Dear Reader:

Cartooning gives me incredible satisfaction. I've been publishing a daily comic strip on the Web since 2000. You can read today's comic at *www.greystoneinn.net*. It appears in newspapers, too—the largest of which is the *Philadelphia Daily News*. I have three comic strip collections published in book form. Even my "day job" was the result of advice from an editorial cartoonist who suggested I'd have better luck submitting cartoons to a newspaper as an employee. That led to a career in journalism, which has lasted more than a decade.

I've had this obsession with cartooning since I was about eight years old. I've been drawing as far back as I can remember. I doodled more than I took notes in college. I own more graphic novels and comic strip collections than any other type of book.

That's why I wanted to write this book. It's the only subject I really feel qualified to teach. If you're a beginner, I can help you get started. If you've been cartooning for a while, I can help you take the next step to professional work. And if you're an experienced cartoonist, I have some tips and tricks that will help you become even better at what you do.

Brad J. Guigar

The EVERYTHING® Series

Editorial

Publishing Director	Gary M. Krebs
Managing Editor	Kate McBride
Copy Chief	Laura MacLaughlin
Acquisitions Editor	Eric M. Hall
Development Editor	Julie Gutin
Production Editor	Jamie Wielgus

Production

Production Director	Susan Beale
Production Manager	Michelle Roy Kelly
Series Designers	Daria Perreault
	Colleen Cunningham
	John Paulhus
Cover Design	Paul Beatrice
	Matt LeBlanc
Layout and Graphics	Colleen Cunningham
	Rachael Eiben
	Michelle Roy Kelly
	John Paulhus
	Daria Perreault
	Erin Ring
Series Cover Artist	Barry Littmann
Interior Illustrator	Brad J. Guigar

Visit the entire Everything® Series at www.everything.com

THE
EVERYTHING
CARTOONING
BOOK

Create unique and inspired
cartoons for fun and profit

Brad J. Guigar

Adams Media
Avon, Massachusetts

*This book is dedicated to every smart-aleck kid that
gets caught by the teacher doodling in the margins.
Life is lived in the margins.*

————————————

Copyright ©2005, F+W Publications, Inc. All rights reserved.
This book, or parts thereof, may not be reproduced
in any form without permission from the publisher; exceptions
are made for brief excerpts used in published reviews.

An Everything® Series Book.
Everything® and everything.com® are registered trademarks of F+W Publications, Inc.

Published by Adams Media, an F+W Publications Company
57 Littlefield Street, Avon, MA 02322 U.S.A.
www.adamsmedia.com

ISBN: 1-59337-145-4
Printed in the United States of America.

J I H G F E D C B A

Library of Congress Cataloging-in-Publication Data
Guigar, Brad J.
The everything cartooning book : create unique and inspired
cartoons for fun and profit / Brad J. Guigar.
p. cm.
An everything series book
ISBN 1-59337-145-4
1. Cartooning—Technique. 2. Comic books, strips, etc.—
Technique. I. Title. II. Series: Everything series.
NC1764.G85 2004
741.5—dc22
2004018993

This publication is designed to provide accurate and authoritative information with regard
to the subject matter covered. It is sold with the understanding that the publisher is not
engaged in rendering legal, accounting, or other professional advice. If legal advice or
other expert assistance is required, the services of a competent professional person should
be sought.

—From a *Declaration of Principles* jointly adopted by a Committee of the
American Bar Association and a Committee of Publishers and Associations

Many of the designations used by manufacturers and sellers to distinguish their products
are claimed as trademarks. Where those designations appear in this book and Adams
Media was aware of a trademark claim, the designations have been printed with initial
capital letters.

*This book is available at quantity discounts for bulk purchases.
For information, call 1-800-872-5627.*

Contents

Acknowledgments

I'd like to thank a few people whose expertise in their fields made them invaluable assets in assembling information for this book. Meaghan Quinn, a Webcartoonist (✍www.eattheroses.com), helped explain the world of manga. Rich Bailey, of the *Philadelphia Daily News* color lab, clarified page pairing and other prepress issues. My process for scanning line art is based on advice given to me by Harry Stone, also of the *Daily News* color lab. Finally, thanks to Stu Rees for sharing information on copyright and trademark law.

Most importantly, thanks to my wife, Caroline, and my son, Alex, without whose unwavering support this book would have been impossible. Thanks, as well, to my parents, John and Rita Guigar, and my in-laws, Tim and Joyce Miller, for their love, understanding, and support.

Top Ten Newspaper Cartoonists

1. Charles Schulz, *Peanuts*. In a bittersweet story befitting his comic, Schulz announces a retirement forced upon him by the ravages of colon cancer, then dies quietly in his sleep the night before his final Sunday comic strip appears in newspapers.

2. Gary Larson, *The Far Side*. A decade after he ended his daily feature, new single panel comics are still accused of being "*Far Side* ripoffs."

3. Thomas Nast, political cartoonist. Corrupt politician William Marcy "Boss" Tweed—a constant target of Nast's political cartoons—offered the artist more than $100,000 to "study art abroad." The offer rose to half a million and then turned into a death threat. Later, Spanish authorities used a Nast cartoon to identify and apprehend the fleeing Tweed.

4. Will Eisner, *The Spirit*. Although Eisner is widely known as a pioneer in the comic-book industry, he got his start when *The Spirit* started appearing in newspaper comic-book supplements.

5. Walt Kelly, *Pogo*. Devastating political satirist and a master of language rivaling Dr. Seuss, Kelly paved the way for future satirists like Aaron McGruder and Garry Trudeau (see #6).

6. Garry Trudeau, *Doonesbury*. Besides being one of the foremost examples of political satire, his comic strip is one of the few that achieved longevity without becoming stale.

7. Bill Watterson, *Calvin and Hobbes*. One of the rare cartoonists who boasted consistently funny writing with breathtaking illustration, Watterson made us remember our childhood the way no one had done before.

8. Berkeley Breathed, *Bloom County*. Mixing thoughtful political and social satire with heavy doses of plain old lunacy, Breathed defined the 1980s for many comics fans.

9. Bud Fisher, *Mutt and Jeff*. The first successful daily newspaper comic strip, appearing in the San Francisco Examiner for the first time in 1907.

10. Scott Adams, *Dilbert,* and Jim Davis, *Garfield* (tie). Both cartoonists have proven to be both excellent humorists as well as savvy businessmen, parlaying their creations into formidable wealth.

Introduction

▶ TO BE A CARTOONIST is to master one of the last true forms of magic here on earth. The ability of a cartoon to tug at a heartstring or tickle a rib is truly amazing. From wartime propaganda to modern-day Japanese manga, cartoon art has proven to have extraordinary communication properties. It can convey an idea that would otherwise take paragraphs to explain. It can make us feel. That's magic.

Cartoon art separates itself from other art forms in two main ways. First, cartoon art exploits the human eye's ability to discern familiar objects from abstract shapes. Second, time is depicted by the sequential progression of images.

Cartoons take advantage of the eye's eagerness to find logic in shapes. Objects can be simplified into their most general shapes. A face can be represented with a circle, two dots, and a line for the mouth. Not all cartoons feature this kind of oversimplification, but all take advantage of the intrinsic need for humans to organize shapes into familiar mental images.

This can be a powerful tool, when used wisely. For example, a rectangle with a triangle on top (and a little embellishing) reads as a house. Any house, in any city. It can read as *your* house. Since there aren't any identifying characteristics to classify it otherwise, your eyes will fill in the necessary details—or the details it is cued to fill in.

Show the cartoon to a farmer in Bad Axe, Michigan, and he'll correctly identify it as a house—as he envisions an aluminum-sided ranch-style house. Show the same drawing to a Philadelphia urbanite and she

will make the same identification—as she pictures a brick-built row house. One image, many interpretations. Pretty powerful stuff for communicating complex ideas to large groups of people.

If you think about it, this also makes cartoon art one of the first truly interactive art forms! Every person who views a cartoon translates the images based on his or her background. It's this interactive play between reader and image that gives cartoon art such punch. The reader identifies strongly with the image because—knowingly or not—she has invested something of herself into the image.

The other defining concept in cartooning plays off the willingness of the mind to read sequential images as a continuous narrative. In other words, as images are gathered into a unit, the brain puts them into an order—much like it did when presented with the primitive "house." Faced with sequential images, the brain assumes a "first this happened, then that happened" correlation between the images. Instead of being seen as a grouping of separate ideas, sequential images are seen to have a chronological relationship with one another. Without that relationship, there are only static, unrelated images. The presence of that relationship makes storytelling possible. Time passes; plots unfold; and characters act, react, and change. Furthermore, time can be shown to pass in small increments or in large leaps. Time can go forward or backward. Several actions can be depicted as happening at the same time. Or time can be made to stand still.

So, whereas the interactive play between viewer and image gives a cartoon power, it is this depiction of time through sequential images that gives a cartoon its magic. And as this happens, those images become more than concepts; they become real. Interactive imagery makes us recognize a cartoon. Sequential storytelling makes us care. Pure magic.

Chapter 1

Getting 'Tooned Up

Cartooning doesn't require a heavy initial investment. If you want to use a ballpoint pen on notebook paper, feel free to do so. However, if you'd like to draw cartoons professionally, consider buying some high-quality supplies and learning to use professional drawing tools. Investing in better equipment will have a noticeable impact on your work. If you don't take this step, it's possible to fall into bad habits that will hinder your success as you get more serious about your work. It's okay to start small, but it's less forgivable to start small-minded.

The Drawing Table

A drawing table is an excellent investment. After all, you're going to be spending quite a bit of time drawing. With a good drawing table, you should be able to adjust the height and the angle of the drawing surface to suit your drawing posture comfortably. If you draw hunched over the dining-room table, you're going to risk back pain, eyestrain, and the occasional pizza stain on finished art. A less expensive option is a tabletop that sits on top of a regular table.

Drawing Table Accessories

You'll need to buy a T-square or install a horizontal rule onto your drawing desk. Either option is useful for drawing straight lines. A plastic triangle—guided against your T-square or horizontal rule—will enable you to draw straight vertical lines.

Also consider splurging on a comfortable chair to work in. You should be able to adjust the height and back support. If you plan on moving from the drawing table to a computer workstation, consider a chair with wheels.

A swing-arm lamp is perfect for directing light directly onto your drawing surface. Even if your work area has good overhead and/or natural light, you should have one of these lamps. If you're right-handed, install it on the left-hand corner of the table so it shines on your paper and throws the shadow cast by your hand away from the area you're concentrating on. Lefties, install your lamps on the right-hand side.

Handy Equipment

Once you have the basic furnishings of a cartoonist's studio, you may want to consider a few other items. Some of these can be expensive purchases. Beginners may find substitutions at garage sales or online auctions.

Light Box

Some cartoonists use a light box to trace images so they maintain a consistent look from panel to panel and from day to day. The light box is also useful for tracing reference photos to create a background. As long as you're

not tracing over someone else's illustrations and passing them off as your own, tracing is considered fair use.

A light box is an excellent tool, but it's not cheap. If you're good at basic woodworking, you may want to build your own. Fashion a wooden box with an inset piece of ¼" Plexiglas on top. Install a fluorescent light inside—an incandescent light will heat up the glass and make drawing uncomfortable.

▲ A homemade light box

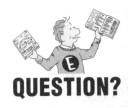

QUESTION?

Can't I get the same results using my window?
Even if you live in an area where it's always sunny, it would be hard on your back. If you can't build a box, start with a milk crate. Or ask a doctor for an old X-ray reader. Or convert your outdated scanner using instructions found here: *http://mediapickle.com/new/viewpage.php? pageID=lightbox.*

Flat Storage

As a practicing cartoonist, you will accumulate several hundred pieces of finished art each year. Find a safe, dry place to store them—a place where they are safe from water, pests, mildew, pets, and so on.

Protect your art by storing it inside plastic containers with lids that shut tight. Buy the containers at a large enough size that you can store your finished work without folding or bending it. When you're shopping for these containers, consider buying ones that are stackable. You'll be surprised how quickly they fill up.

Taboret or Cabinet

Think about how you want to store your supplies. Something with a flat surface on top and three or four drawers would work best. You could buy a taboret at your local art supply store, but any number of common furniture items could also work: an old nightstand, a small chest of drawers, a filing cabinet, etc. The "home organization" section of your favorite department store will probably have something to fit the bill. It should be small enough to fit next to your drawing table and tall enough to allow you to reach your tools from a seated position.

Drawing Tools

Of course, you're free to use any method of creating an image, but as a professional artist, you should limit yourself to those tools that produce crisp, easily reproduced lines quickly and predictably. The standard method is to sketch in pencil and finish the art in ink using a pen, brush, or marker.

Sketching Pencils

Pencils are for sketching only—not for final art. Pencil work is too likely to be smudged or damaged as it is processed for publication. Avoid working final art in pencil unless there are special circumstances that dictate otherwise.

Since the lines you make in pencil are not intended to be seen in the final art, use "nonphoto blue" pencils. The color of the lead—light blue—

does not photocopy well, nor is it particularly readable by a scanner. That means pencil marks will disappear as the work is processed for publication. Lines drawn with these pencils will not have to be erased unless they are very dark. You can ink over them, safe in the knowledge that the stray pencil marks that remain will disappear in the production process.

If you prefer mechanical pencils, take heart. You can buy blue leads at any office supply or art supply store. They work just as well as the nonphoto blue pencils.

FACT

When you go to the art supply store, take your notebook as well as your checkbook. Write down the price of the item you need as well as its product number. When you get home, plug the product number into an Internet search engine (you may need to add the manufacturer's name). You'll find countless merchants vying for your business. Keep the art store's price to compare.

Black and White Ink

Always use an opaque waterproof black, like India ink. Once it sets, it stands up to time and wears wonderfully. Don't experiment with cheaper products that claim to be "just as good." It's a terrible feeling to look back on old work you're proud of and see the line work faded because you used cheap supplies.

Accidents happen—even to experienced inkers—so don't panic. Use opaque white ink for corrections. Daler-Rowney Pro White is a popular brand among cartoonists.

Brushes

Red sable brushes such as the Winsor & Newton Series 7 are considered to be the best by many cartoonists. They stand up to wear wonderfully and they work well with India ink. Some brushes flop and wobble when loaded up with ink. Red sable brushes flex and spring back into shape. Buy a few different sizes and shapes and experiment to find the ones you're

comfortable with. In general, you'll want a couple of pointed brushes for line work and a rounded brush for filling in blacks.

To prepare a brush, dip it into the ink and then pull it across a sheet of scrap paper, twirling it in your fingers as you draw the brush back. This forms the brush into a point and distributes the ink evenly inside the bristles. You can produce very thin or very thick lines depending on how hard you push the brush into the paper.

Pens and Nibs

There are several types of pens to choose from. The trick is to find the one you like the best and practice with the ones that produce the lines you want. You'll want to try a crow quill pen for fine lines. For lettering, select a couple of pens with rounded ends: A Hunt Globe 513 and a Speedball D5 or B6 are excellent choices.

Although you can get by with one pen holder and several nibs (a nib is the pen's tip), it's recommended you buy a few holders. That way, you can switch from one nib to another as you complete your work, without making a mess.

Wash pen nibs and brushes with mild soap and warm water after every use. Avoid using hot water—it damages brushes by loosening the glue that holds the bristles. Dry everything on an old towel or paper towel. With even the best upkeep, your drawing instruments will need to be replaced when they become worn. Using brushes and pens past their prime will result in poor-quality images.

Select a nib, place it in the holder, and dip the pen into your bottle of ink. Start the ink flow on a scrap of paper. Once the ink is flowing freely, you may begin to draw. Your lines will be thicker or thinner depending on the pressure you put on the pen—but at a lower range than that gained by using a brush.

The trick to using pen-and-ink sets is to anticipate when the ink will run out of the nib and redip it before you run out. As your nib runs out of ink,

you will probably push down harder in an attempt to make the ink flow more rapidly. Pushing down too hard causes the prongs of the nib to spread out farther and leave feathery marks where lines were intended.

For ultracrisp lines of a consistent width, learn to use Rapidograph pens. A set usually contains an ink cartridge, one holder, and several pen nibs in assorted sizes. The pen must be held at a 90° angle to the paper, and you must resist the urge to bear down on the paper to produce heavier lines. Rapidographs are somewhat hard to learn, but they produce beautiful lines for those who've mastered them.

Cartooning Markers

Markers are probably the easiest and most recognizable method of creating line art. Resist the urge to use those comfortably familiar El Markos and Sharpies. They're great markers, but they're just not advisable for this kind of work.

Rather, you should try pens from the Pigma Micron line. Again, several sizes can be bought at your art supply store. They stand up to constant use better and the ink is archival. Pigma Micron also boasts a set of markers with brushlike nibs. Feel free to experiment with these, but not at the expense of learning to master a good brush-and-ink technique.

The problem with using markers is that people tend not to change their markers frequently enough. Many will use a marker until it runs dry or until they've mashed the nib into a useless nub. Of course, once they look back over the work they've produced with this one pen, they can see a long, steady degradation of line quality that wasn't as evident when they were concentrating on keeping their deadlines. When you select your markers, buy two or three. It's easier to retire an older marker if you have another ready to take its place.

Paper Options

Bristol board is the paper most commonly used by cartoonists. It handles India ink well and stands up to wear and tear. It's also acid-free, so it will not yellow over time. It comes in several sizes and can be bought by the sheet or by the pad. Opt for the stiffer, heavier bristol—300- to 400-pound, two-ply.

Bristol comes in vellum and plate finish. Plate is ultrasmooth and by far the more favorable for ink work. The vellum finish is more textured, which can be detrimental to good line work.

Some cartoonists use tracing paper for their illustrations. This makes tracing over previously drawn characters much easier. The obvious drawback is that working on such fragile paper isn't easy.

Other Useful Items

You now have the basic tools needed to start producing professional-quality cartoons. As you start drawing you will notice that you need to make a few other purchases. These aren't crucial items, but they're worth a trip to the art supply store:

- **Ruler:** For measuring panel dimensions (in points as well as inches)
- **Ink compass:** Useful for drawing circles
- **Circle/oval templates:** For drawing circles and ovals
- **Kneaded eraser:** For cleaning up final art
- **Masking tape:** To hold the illustration board to the drawing table
- **Wooden body model:** For envisioning posture/stances
- **Mirror:** For self-modeling expressions
- **Tracing paper:** Useful both on the light box for reworking images and under your drawing hand for preventing smudges
- **Graphic tablet:** Used for drawing images directly into your computer

Tape or glue pennies to the underside of your triangle to raise it off the surface so it won't smear your ink. You can buy a special triangle with a raised edge, but this homemade technique results in a much better gap between triangle and paper.

These are all items of secondary importance. But they will each come in handy as your skills (and therefore, expectations of yourself) improve.

Chapter 2

The Computer Workstation

A cartoonist in today's market is expected to scan and process his own work and submit it for publication in digital form. It's important that your computer is user-friendly and reliable. You need enough storage space for all your files (and you're going to accumulate plenty) and enough memory to run all of your software and peripherals. A computer that crashes often, causing you to have to reload software and lose works in progress, is unacceptable.

Choosing a Computer

This is another juncture at which opting for the less expensive choice may end up costing you more money down the road. Don't be misled by the fact that PC-based computers have dominance in the home-user market. In the commercial art and publication worlds, Apple computers lay claim to being the dominant platform.

Keep expandability and connectivity in mind when purchasing a new computer. You should be able to easily update the computer's memory to keep the computer up to date as long as possible. You also need to be able to connect several peripherals such as a scanner, a printer, secondary drives, and so forth.

Purchasing a computer is one of the largest expenditures a working cartoonist will make, so it's important to think it through. After the drawing is complete, you will be spending plenty of time at your computer workstation—scanning and processing your work, communicating with clients through e-mail, keeping track of records and billing, and researching reference images. Make room in your studio for the hard drive, a monitor, a scanner, and a printer. This will become your personal production facility.

Scanning In Your Work

The key peripheral for a cartoonist is the scanner. True, some cartoonists use graphic tablets to draw digital images that reside primarily on their hard drives, but assuming you're producing art by hand, you're going to need a little help getting digital.

Here's the good news: Technology has progressed to the point that you can buy a very good scanner at a very reasonable price. Here's the bad news: Most cartoonists draw their original images about twice as big as they will appear in publication. Therefore, a newspaper comic strip artist who sees his work reduced to a 6" × 2" space creates original art that is 12" × 4".

Be sure you keep your original art in mind when purchasing a scanner. If you're planning on working larger than 8½" × 11", you'll want a scanner with a larger scanning bed. Scanners with 8½" × 14" scanning beds are available, but they are slightly more expensive and a little harder to find.

You need not worry about scanner resolution—measured in pixels per inch (ppi)—if you're buying a new scanner. If you're purchasing a used unit or using an existing scanner, you should make sure the scanner is capable of scanning at 600 ppi and higher.

Printing It Out

If you prefer to see your completed work on paper rather than on the screen, you should invest in a good printer. The best option is a laser printer. This will give you a very good indication of how your image will look in print. Of course, it's only good for black-and-white art.

When you print images with color or gray tones, you'll notice that a laser printer prints these values with a dot pattern. Actually, virtually all printing is done with dots, measured in dots per square inch (dpi). The higher the dpi, the harder it is to discern the dots. Look closely at a newspaper (about 200 dpi) to see dots in action.

Ink-jet printers have become extremely good—and have the added capability of printing in color. If buying a laser printer is not an option, consider a good ink-jet printer to be a very close approximation of what you will see in publication. Be careful, though—printing a PostScript file (such as an EPS file) on an ink-jet printer can be tricky.

An added benefit of a good ink-jet printer is that it allows you to produce high-quality color prints. Selling glossy prints of your cartoons is a great way to make your work pay double. Your color printer can also use specialty paper to print out magnets, temporary tattoos, decals, key chains, and other items. These will come in handy in promoting your work.

Digital Storage

In the same way that you have to take special care in storing your physical artwork once it is completed, you must also take pains to archive your digital images once they have been printed. You will be amassing several hundreds of megabytes of data in a very short time, so taking them off the hard drive and storing them on reliable media is very important. The best method of archiving old data is on CDs. Most new computers come equipped with a CD burner. If your unit is older, you can buy one separately.

Blank CDs are very inexpensive (about a dollar each, if you buy in large quantities), and each CD holds upward of 700 megabytes. That's a lot of storage for a dollar. That's also a lot of data lost if something goes wrong. Follow these important safety tips and your CD will outlive you.

- Never write on a CD with a pencil or a ballpoint pen—or a marker with a solvent-based ink. Instead, use a CD labeling pen (found at most office supply stores) with water-soluble ink to write on the CD surface—and then only on the area of the CD where the manufacturer indicates it is safe to write.
- Avoid sticking labels or other adhesives on the surface of a CD.
- Handle a CD with your fingertips and only around the outer edge.
- Never place a CD on any surface. It should go from the case to the CD-ROM and back to the case.
- Store CDs in a cool, dark place. Direct sunlight and high temperatures can damage and warp a CD.
- Use a clean, soft lint-free cloth and only approved CD-cleaning solvent to clean a dirty CD. Wipe in a straight line from the inner hole to the outer edge.

Even the most careful handling will never be able to prevent disasters such as fires or storms, so burn two CDs at a time. One CD is for normal use and the other is a master CD to replace the first in an emergency. If possible, store the master CD in a different location—even a different house. In the event of a fire, it may not make a difference that one set of CDs were on the first floor and the other set was in the basement—they would both be ruined.

ALERT!

Some cartoonists burn samples onto CDs and send them to prospective editors, but this isn't a good idea. Print editors want to know what your work looks like in print. The low-resolution image they would see on the screen is a poor substitute. And if you forget to make the CDs readable on both Mac and PC, an editor may not be able to view your work at all.

Pixel-Editing Software

You need software to help you prepare your scanned-in work for submission. First and foremost, consider your options for image-editing software. Once an image is scanned, it is comprised of pixels. Think of pixels as little dots that are the smallest divisible element of your illustration. Pixel-editing software should be able to do the following:

- Work in high resolutions (such as 600 ppi) without slowing down the hard drive
- Create bitmaps
- Convert color to grayscale, RGB, CMYK, and indexed color modes
- Save in TIFF, JPEG, PNG, and GIF formats
- Adjust the sharpness and contrast of an image
- Work in layers
- Add and edit type
- Apply bicubic resampling to allow you to enlarge an image while maintaining smooth edges

There are several software packages that do some of these very well, but you need to be able to do all in order to get the most out of both your print- and Internet-based opportunities. The free software that shipped with your scanner may not be up to the challenge.

Adobe Photoshop and Photoshop Elements

Adobe Photoshop is the standard in the professional printing industry and comes with an industry-standard price tag. However, it's one of

the few software packages powerful enough to be worth the expense. It does all of the required actions well and does them quickly. You will never be faced with an image-correction problem that cannot be solved in Photoshop.

If the cost of buying Adobe Photoshop is daunting, consider the scaled-down Photoshop Elements. It doesn't have all the features of Photoshop, but it covers all of the necessities mentioned earlier. It's a fine tool for the working cartoonist, at a fraction of the cost of Photoshop.

All of the tips for processing art for publication will be described in terms of Photoshop commands. Both Photoshop and Photoshop Elements are available on Windows and Mac platforms.

CorelDraw Essentials

PhotoPaint, which also meets all of the criteria, ships as part of CorelDraw. It offers a wide array of image-correction functions and is fairly intuitive. Many of the Photoshop commands discussed in this book have a parallel function available in PhotoPaint. If you already have PhotoPaint, or are unwilling to buy Photoshop, it's the next best thing. CorelDraw Essentials is quite affordable and available for both Windows and Mac.

Vector-Based Software

Some cartoonists are skipping the drawing board completely and designing their work in vector-based software. Vector software is based on math rather than pixels. You can draw lines, create shapes, apply colors to the lines and the areas inside those lines, and complete a host of other visual effects presented to you as part of a toolbox. An advantage of vector-based software is that it is infinitely scalable—you can enlarge or reduce the art indefinitely without harming the image. There are two dominant software packages to consider: Adobe Illustrator and Macromedia FreeHand.

Macromedia FreeHand and Adobe Illustrator

These two are identical in terms of ability and ease of use. Files from either can be imported into Photoshop. FreeHand is also very compatible with Macromedia Flash, which is used in animation. Illustrator, on the other hand, has a virtually seamless interface with other Adobe products, such as Photoshop and Acrobat.

FACT

Some artists who use a pressure-sensitive graphics tablet to draw on their computer choose to draw in a vector-based software rather than a pixel-based one. In addition to producing sharp lines, vector software renders images that are easily resized and can be pasted into different backgrounds, allowing the artist to reuse the same drawing in several panels.

CorelDraw

CorelDraw is another vector-based image software package to consider. Files created in this software have enormous cross-compatibility with software such as FreeHand, Illustrator, and Photoshop, and excellent compatibility with Corel Painter. It's not one of the "name" software packages, but that doesn't mean that it's not worth your time to explore.

Design Software

Some cartoonists use design software—such as QuarkXPress or Adobe InDesign—to lay out comic book pages or to compose comic strips. Both feature remarkable font manipulation and are great choices for adding text to cartoons digitally.

If your cartooning plans include self-publishing—either comic books or collections of comic strips/panels—then you're going to be investing in one of these software packages. Quark is the industry standard in printing, but Adobe's InDesign is a fast-rising challenger with some impressive font-handling features.

Access to the Internet

The cartoonist's computer workstation should have a connection to the Internet. This is an indispensable resource for finding photo references when drawing unfamiliar objects. It's also helpful in facilitating the brainstorming process. Finally, many artists find that the Internet is a wonderful place to try out new material and get feedback.

Some search engines, such as Google, have a special search function for images. For example, if you're looking for a photo of a tractor to use as reference for a drawing, do a search for "tractor." When the results appear, click on the "Images" tab. You will be presented with thousands of photos you can choose from.

Furthermore, there is an incredible community of cartoonists who communicate online. They range from polished pros to green neophytes, but they all have something in common: They love cartooning. And, in almost every case, they're more than happy to discuss their obsession with like-minded individuals. It's a wonderful place to get technical advice, a tough critique of your work, or some much-needed emotional support.

Your computer is going to have a much bigger role in cartooning than you may have guessed. It's important to take this into consideration when purchasing a new hard drive or a replacement. Good software and peripherals, although expensive, can often pay for themselves in terms of comfortably meeting deadlines with professional, hassle-free art.

Chapter 3

The ABCs of Lettering

While most novice cartoonists put hours of time into perfecting their drawing skills, they hardly put any time into practicing writing the words that accompany their illustrations. Lettering, as it's called, is more important than you might think. It can work seamlessly to facilitate the cartoon-reading process, or it can be a deadly obstruction.

Understanding Typography

Before you can understand lettering, it's best to become acquainted with typography—the art of how letters are formed and arranged in text. Typography is based largely on the interaction between the shapes of letters. When typography is done correctly, it's transparent—the letters form words so coherently that the play between letters themselves is hard to spot.

Serif and Sans Serif

Fonts (also referred to as type) are classified into two categories: serif and sans serif. Serifs are the little "handles" added to the ends of letters; these handles make reading easier by improving the eye's ability to connect letters into words. Sans serif fonts feature letters drawn with simple strokes and no affectation (*sans* is French for "without"). On your computer, the Times font is serif: Helvetica is sans serif.

ABCDEFG

ABCDEFG

◄ The font on top is serif; the one below is sans serif.

One would assume that serif fonts would be the ideal choice for comic lettering, but just the opposite is true. Serif lettering, although easily readable at small sizes, conveys a sense of formality and seriousness. Most serif fonts are completely inappropriate for cartoon usage—except in the special cases, such as captions under some single-panel comics.

ALERT!

The exception to the sans serif rule in cartooning is the capital letter *I*. It is preferred to have serifs on the *I*, but only when *I* is used as a proper noun (*I*). When it's used as part of another word ("It," "Idea"), the *I* should be typeset sans serif.

Rules of Alignment

You have three options for aligning your text. You can center it, or you can justify it to the left or right margin ("flush left" and "flush right," respectively). Most typography in comic strips and books is centered (this works especially well in word balloons), which means that the line of type is centered between the left and right borders. Beginners should lightly pencil the letters in blue first, adjust to center the line of text, and then pencil in the lettering more firmly.

A Font's Voice

Type has the ability to make us "hear" the words in a certain "voice" as we read the words. If the words are conveyed in hard-to-read lettering or lettering that speaks in the wrong voice, the cartoon will suffer. Even once you rule out all serif lettering, the lion's share of sans serif types tend to strike the wrong chord.

> THIS TYPE
> IS CENTERED

> THIS TYPE
> IS ALIGNED
> FLUSH-LEFT

> THIS TYPE
> IS ALIGNED
> FLUSH-RIGHT

▲ Centered, flush-left, and flush-right text

To better understand this complex psychological interaction, think about the ways type conveys feeling. Letters that are tall and thin convey a feeling of propriety and elegance. Type in which each letter is drawn with a line of varying thickness might be a bit too energetic for a cartoonist's use—and hard to read in more than one line at a time. Italics convey motion and energy, but they, too, are hard to read in paragraph form. Wide, round lettering conveys an affability and friendliness that might be more appropriate for a cartoonist.

It Takes Preparation

Much of hand lettering comes down to planning and setup. The actual construction of the letters should come quite naturally once the proper guide

lines have been spaced out on the paper. Since type requires precise measuring, use the side of your ruler that measures points.

FACT

There are 72 points in an inch. The increments are much smaller and, therefore, more appropriate in measuring small text. It's much easier to say that the type in your newspaper is about 8.5 points than to say it's not quite 4/32 of an inch (0.11806 inches).

Lettering in All Caps

You will rarely see lowercase lettering in a comic. Lowercase lettering involves measuring many more guide lines than uppercase lettering does, and few working cartoonists have the time to devote to such detail. You will notice that most comic strips and comic books feature typography involving capital letters only. This is called working in "all caps."

Capital letters also allow for a wider range of humor. For example, a proper noun (the name of a particular person, place, or thing) would normally stand out because it gets capitalized. In all caps, it can be disguised.

▲ In this cartoon, "Irony" is a disguised proper noun.

Measuring Lettering Guides

To measure guides for lettering, you need to indicate the height of the letters and the space between lines of text (called "leading"). First, draw a horizontal line a comfortable distance—about 6 to 8 points—from the upper boundary of your image. Type that runs too closely to the borders of your comic will be difficult to read. For the same reason, leave the same

6- to 8-point margin from the left and right borders. If you're lettering 12-point type, the second horizontal line will come 12 points below the first. Between these two lines, your first line of type will be lettered.

A common typographical rule of thumb is to calculate leading as 20 percent of the type size. For 12-point lettering, that's about 2.5 points. The third line is drawn 2.5 points below the second. This third line, besides indicating the leading, is also the top line for the next row of text. A fourth line is drawn 12 points down, and a fifth is drawn 2.5 below that. The result is a grid onto which you can letter the text of your comic.

ALERT!

Remember that most cartoonists work about twice the size that the final art will appear in. So, 12-point text will actually translate to 6-point. It's not advisable to letter smaller than that.

You may wish to build a lettering grid on your computer and print out a master copy. When you're ready to letter your comic, you can place the guide under your illustration board on your light box. The light box will enable you to see the grid through the board, allowing you to letter the comic without measuring lines over and over again.

Lettering by Hand

Once you've drawn your guides, rough the lettering into the comic in pencil. This is the time to check for grammar and spelling problems. Corrections will be much easier to accomplish before the mistakes are set in ink.

The two most common tool choices for lettering are markers and pen and ink. Some brave souls use a brush, but the practice demands masterful handling. Markers with nibs measuring 0.35mm to 0.55mm work well. Pen nibs with rounded tips such as Speedball's B5 and B6 are also good choices.

Just as important to your type's "voice" is the confidence and consistency of your lines. Keep your main strokes parallel and perpendicular to your guide lines, and try to keep them all the same thickness. Don't slant the letters unless you're trying to emphasize a word.

Common Hand Lettering Errors

Lettering errors harm a comic's legibility. The following is a list of letters that tend to be drawn incorrectly:

A: Don't draw the crossbar too high. It should be below the middle of the shape.

B: Two loops should not be identical. The top loop is slightly smaller and returns to the vertical stroke above its middle.

E: The three horizontal strokes should be the same width and equally spaced. Don't nudge the middle stroke toward the top or the bottom.

M, W: The peak in the middle should not stop short.

R: Draw a *P* and add a small tail under the loop. This tail does not intersect the vertical line.

S: The top curve is slightly smaller than the bottom one. Draw a snowman shape to help get the curves right.

As you practice lettering, these shapes will become more and more natural. Be sensitive to the particular needs of different letter shapes. For example, letters with curved strokes (*O, Q, C, U*) should fall slightly below the baseline to visually compensate for the white space trapped inside. Letters with intersecting strokes (*K, X, Y*) do not intersect right in the middle of the shape.

QUESTION?

How can I catch spelling errors?
Maybe you need to look at things differently. Try reading the comic upside down. This old proofreader's trick forces you to look at the words in a new way, enabling you to catch mistakes that you were glossing over before.

Pay Attention to Kerning

Adjusting the space between different letters—referred to as kerning— is one of the most delicate parts of hand lettering. Some letters need to be placed closer to their neighbors, and others need a little extra space. If you space your letters too closely, you'll end up with an illegible blotch. If your letters drift too far apart, they'll be read as individual letters rather than words.

As a general rule, words that trap space inside their shapes (*O, U, Q*) tend to need a little extra space on either side. Slim, vertical letters (*I, J, L*) need to be placed closer to their neighbors. The needs of a slim letter over-rule the needs of a fat one, so if *O* and *I* are adjacent, the letters should be placed slightly closer together. Letters with a slanted stroke on the left or right side (*K, X, W, V*) need to have their neighbors placed somewhat closer. It's not advisable for two letters to touch. Even letter pairs such as *TT* should have some white space between them.

THIS KERNING IS TOO TIGHT!

THIS IS TOO LOOSE!

THIS KERNING IS JUST RIGHT!

◀ Examples of good and bad kerning

Computer Lettering

Hand lettering has several advantages. It lends a unique look to the cartoon and helps single out the voice of your comic. In the same way a handwritten note is friendlier than a typed letter, hand lettering can give your comic a more personal feel.

However, hand lettering is a difficult craft to master and can be distracting—or downright disastrous—when done incorrectly. It is also time consuming, requires plenty of advance planning, and is difficult to edit. For all of these reasons, many artists opt for computer lettering. With computer lettering, you can keep everything consistent, and adjusting font size, kerning, and tracking to get more words into a small space is much easier.

Choosing a Computer Font

Even though you may have amassed an impressive array of computer fonts, you should be aware that very few of them will be appropriate for your comic. Some companies—such as Blambot (✐*www.blambot.com*) and Comicraft (✐*www.comicraft.com*)—focus entirely on designing fonts

for cartoons and comic books. Choose carefully. Not every cartoon font is appropriate for every comic.

QUESTION?

I found a font I liked, only to find out it's a PC-format font that isn't recognizable on my Mac. Is there anything I can do?
Download TTConverter from any number of places on the Internet (✍*www.macupdate.com*, for example). It's shareware that converts a PC font to a Mac font.

Due to the accessibility of various computer fonts, some people are tempted to give certain characters their own personal font—to add distinction to their voice. For example, they might choose a digitized font to depict a robot's voice. When you read cartoons that use this technique, you will see that the cartoonist has succeeded in one thing: He's made you pay particular attention to the font. But this is the last thing you should be doing! Fonts should be unobtrusive. Any font that calls attention to itself is being used incorrectly.

▲ Specialty fonts can be distracting.

A Font of Your Own

An alternative to buying a font is to create a computer font based on your own lettering. This can give your art a more personal look than using a

store-bought font will—and it's the next best thing to hand lettering. With a little preliminary work, the results can be very pleasing.

Macromedia offers software, Fontographer, that is an excellent tool for this procedure. It's available in both Windows and Macintosh platforms. To start, carefully hand letter the alphabet—including punctuation marks—on a piece of illustration board. The larger you make the characters, the less noticeable their flaws will be when the font is used. Scan the alphabet on your computer (for more on scanning line art, see Chapter 20). Fontographer will guide you though selecting each letter and importing it into a font grid. When you have imported all of your letters, the software will also help you kern the letters and establish special kerning for problematic letter pairs.

Judging Legibility

Most cartoon lettering is sized between 8 and 10 points; a good cartoon font should have excellent readability even at sizes as low as 7 points. Each artist must find the size that is large enough to maintain legibility, yet small enough so the words don't overpower the image. Increasing the size of your lettering decreases the number of characters that you can fit on each line of type.

Print some test copy at 7 points. Look at it carefully and consider the following:

- Is the text readable at a glance?
- Do the spaces inside characters such as *e* and *o* become clogged?
- Do letter combinations such as *ill* melt together into one unit?
- Are letters like *m* and *n* discernable from one another?
- Do letters like *L* and *I* blend together to form other letters, like *U*?

Also ask a few friends to read the samples and watch them as they do. Do they squint when they read the type? How long does it take them to read it?

It really doesn't matter whether you letter your comic by hand, choose a computer font, or develop a digital font on your own. The only thing that matters is the legibility of the print. If the lettering is difficult to read, it's impossible to build the rhythm and pacing that a great gag or a dramatic story demands. In the eyes of the reader, you're over before you start.

Chapter 4

Drawing 101

Drawing has a mystique about it. Whether it's attributed to divine intervention ("God-given talent") or genetics ("natural ability"), it's seen as something that a person is born with. The truth of the matter is that drawing relies on hand-eye coordination. It's a skill, not a talent. True, some people are born with better hand-eye coordination and do tend to be better artists. But drawing is a skill that anyone can master, as long as he or she is willing to practice.

The Importance of Sketching

Before you even begin sketching, do some good, old-fashioned people watching. Watch how they move, how they walk, and how they stand. Watch the interaction between a young couple and compare it to that of an older couple—and contrast both of these with the body language of strangers when they meet. Note how their clothes drape and fold over their bodies.

Draw every chance you get. The more you do it, the better you'll become. Get into the habit of carrying a sketchbook with you. Take some time to draw the world around you. Every image you study will be much easier for you to reproduce when you're working on your cartoon. Consider it time spent expanding your visual vocabulary.

You might feel a bit conspicuous carrying one of those big "artist's sketchpads" sold at the art supply store. If that makes you uncomfortable, you can buy a hardcover notebook. Generally used for journals or notes, they have blank pages and are excellent for sketching. It's perfect for when you want to sketch without drawing attention.

Remember, these are sketches, so don't obsess over finishing each drawing. It's more important that you capture gestures. For example, in sketching a cat, it isn't important to draw every whisker. Focus on reproducing the cat's posture and imitating its attitude on paper. If you'd like, you can go back later and develop some of your sketches into finished drawings.

Another excellent way to improve your drawing skill is to enroll in a life drawing class. Many community colleges offer these classes, in which a model poses for artists to sketch. The better you understand anatomy, the more lifelike your drawing will become.

Developing a Drawing Technique

Approach drawing as you would any physical activity—warm up and loosen your muscles. You're going to be spending a lot of time engaged in this activ-

ity. Establishing good working habits now can prevent drawing-related injuries such as carpal tunnel syndrome.

Learn the proper way to handle a drawing instrument. One of the most common mistakes beginners make is drawing from the wrist. When you draw, your entire arm should be in motion. Planting your elbow on the drawing table and using your wrist to move the pen will result in stilted curves and awkward lines. When you use your entire arm to draw, your drawing will be much more graceful and attractive.

Try to make a habit of loosening up with a few sketches before you start illustrating. These don't have to be your best attempts. You're just waking your muscles up and preparing them for some specialized activity. You might practice drawing a few gestures you'll be planning to implement in the illustration. Remember, though, these are just sketches—don't get caught up in making them pretty.

When you're working on an illustration, you can reference your earlier sketches for inspiration. You'll find all sorts of details you can incorporate into your drawing. You'll be surprised how vividly you remember the angles and the gestures of the object. It will lend an air of credibility and authority to your illustration.

Preparing an Illustration

When it comes time to work on an actual illustration, planning ahead is key. First, establish the correct size and dimensions of your finished art—you'll need to work at about twice that size. This has two purposes. First, it makes it much easier to include the small details that can make your illustration that much more effective. Second, everyone's hand shakes a little bit as they draw. These natural trembles disappear when the art is reduced, resulting

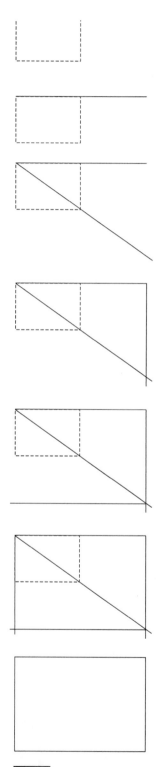

◀ The steps for enlarging an illustration grid

in sharp, distinct line work. You can easily figure out proportionate enlargement with this simple five-step process:

1. Lightly draw a rectangle using the final dimensions of your illustration on the upper left-hand corner of your paper.
2. Multiply the length by two. Extend the line for the doubled dimension to the new length.
3. Starting in the upper left-hand corner of the rectangle you drew in step 1, draw a diagonal line that passes through the bottom right corner of the rectangle.
4. Starting at the end of the line you drew in step 2, draw a vertical line that intersects the diagonal line.
5. Complete the larger rectangle and erase the unnecessary lines.

This process can also be used in reverse to figure out proportionate reduction.

Thumbnail Sketches

Now that you're ready to draw, go back to the sketchbook and spend a few minutes planning your strategy. It's a good idea to think in moviemaking terms. You're the director and you're deciding the best way to shoot the scene. Where will your actors stand? How will they gesture? What will the setting be? How will the scene play out?

Work on a few thumbnail sketches of your illustration (see the facing page). Thumbnails are small, quick sketches that include the major elements of the illustration. You can

▲ Doing thumbnail sketches will help you refine your drawing before you start working on the final illustration.

also plan shading and lettering placement at this point. There are several ways to illustrate a scene—and your reader is going to get bored of seeing the same compositions panel after panel, strip after strip. By drawing thumbnails, you can brainstorm creative strategies to present the scene.

It is much easier—and quicker—to address these design challenges at the thumbnail stage. When you're executing your final illustration, it's very awkward—and frustrating—to draw and redraw the same panel. The repeated erasure can also damage the surface of the illustration board, making your inking difficult.

Roughing the Image

Once you've established your plan of attack, it's time to start sketching the image onto your illustration board. This process is commonly referred to as roughing. It's an important step—and one that often gets rushed or ignored. If you're working for a client, they may request to see the rough version of your illustration.

Draw from Big to Little

Start by lightly sketching in the largest shapes. As you go, proceed to smaller and smaller shapes. Most people instinctually start from the top and work down. In other words, they will draw a person by starting with the head—stopping to draw the face in minute detail—and working down the shoulders to the torso, waist, legs, and, finally, feet. Unfortunately, it's very difficult to keep the body proportions accurate when using this method. The result is usually a drawing with a very large head, a small body, and tiny feet.

Some artists write notes to themselves during the roughing stage. They might note the day of the week a comic strip is going to run. Or they might remind themselves to concentrate on a particular effect during the inking process. If you find you have great ideas that get forgotten until after the ink is dry, then you may want to write notes to yourself, too.

Experienced artists rough in the entire body, checking to make sure the proportions are accurate. Details such as facial features will be the last step in the process. They will follow this process for every object they illustrate.

Breaking Down Objects into Geometric Shapes

Almost any object can be broken down into simple geometric shapes (circles, triangles, rectangles, etc.) and the extrusions of those shapes—a cylinder, for example, is an extruded circle, and a cube is an extruded square. Thinking of objects in terms of geometric shapes can make even the most complex illustrations easier to draw. It also gives your drawings a feeling of depth—a sense of three-dimensionality. For example, a book can be thought of as an extruded rectangle. A can of soda can be thought of as a cylinder.

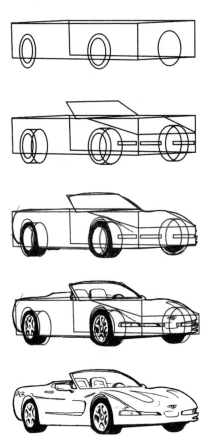

◀ A complex shape, in this case an automobile, can be built up from smaller, simpler geometric shapes.

If you want to draw a more complex shape—say, an automobile—you would start by indicating the car's body and hood (extruded rectangles) and wheels (cylinders). Remember to draw the large shapes first and work down to the smaller ones. Then you can start to rough in the image. You can visualize how the hood would fit inside the geometric area you've indicated. Some people find it easy to draw one side and extrude the shape across to the other side. Smaller and smaller details can be indicated—windows are rectangles, mirrors are ovals. In the end, you have a car that seems to have actual weight.

Don't make the mistake of judging these rules to be for beginners only. True, it's possible to get passable results by skipping these steps. You may be able to stumble onto good compositions on the fly. You may very well be able to draw a realistic car without drawing a single rectangle. But it's attention to the basics—thumbnails and roughs—that will give your final art the edge.

ALERT!

This is the best time to plan your lettering. If you're lettering by hand, measure your lettering grid and pencil in your text. If you're a computer letterer, scan in your sketch and type in the lettering. Print this out and place it under your illustration on your light box. Now you can refine your drawing, if needed.

The Inking Stage

Inking is the step that will produce the final image. Learning to ink well is crucial to producing a good cartoon. Whether you're using a pen, a brush, or a marker, there are some general rules that apply to good inking.

Unless you are working in a very mechanical style in which all of the lines will be uniform and consistent, you can vary the thickness of your lines to achieve several useful effects. One good inking effect is to try to indicate light and shadow by varying the thickness of the lines. Lines should get a little heavier when they are describing a part of a shape that lies away from the light source. Lines that are facing the light source should be thinner. This resulting look lends an illusion of depth to the illustration.

Another way to use line quality to give your drawing more depth is to ink background items in thinner lines than the foreground items. This is a great way to maintain some visual order in a very detailed illustration. If you choose to adopt this practice, be careful not to let the outline overpower the shape it describes.

FIRST OF ALL, YOU SHOULDN'T HAVE BEEN EAVESDROPPING.
SECONDLY, IF YOU MUST KNOW, I ASKED HER
IF SHE'D LIKE TO SEE MY "CRYPT TONIGHT."

▲ Notice how varying the thickness of the lines separates the foreground from the background.

If you make an inking mistake, resist the urge to use typographic correction fluid or similar products. Use opaque white ink. It will cover the error completely and leave a smooth surface suitable for reinking.

Most importantly, your inking should be clear and concise. You're aiming for an end result in which the reader will readily discern the action displayed. Breathe deeply, sit up straight, and relax. Your strokes should be long and firm. Short, choppy strokes don't translate well in print. A confident

attitude exuded by strong lines will make humor more funny and action more exciting.

ALERT!

Smudging is the most common obstacle to good inking. Right-handers should start at the upper left-hand corner of an illustration and ink down and to the right—letting the ink dry away from their hand as they go. If you're a lefty, reverse the process. A small sheet of clean paper under your drawing hand will also help keep your inking clean.

Additional Illustration Techniques

Beyond describing shapes with lines, there are several techniques available to a cartoonist to help create more believable images. Most of these techniques center around producing shades of gray—or the illusion of gray areas. Shading can create illustrations with considerable weight and depth.

Crosshatching

Through crosshatching, gray areas are created by fields of thin lines. Adding more thin lines over the first set—often running at a different angle—makes the gray darker. The eye reads these lines as a gray tone— even though they are really solid black lines. The final art that relies on crosshatching is still considered line art and has the flexibility and manage-ability that line art affords.

When crosshatching round objects, make the lines curve around the outside of the object. Drawing stiff, straight lines on a round object will rob them of their three-dimensionality and make them look flat. Curved cross-hatching reinforces the depth of your drawing. Crosshatch lines can also vary in width but should never be heavier than the lines used to form the shape of the object you are shading.

Once you've built up your grays using this method, you can achieve some remarkable effects by going back into the illustration with white ink. You can produce reflected light and other effects with minimal effort. The resulting work is very polished and professional looking.

FACT

It's important to familiarize yourself with some printers' terms. Line art is art composed solely of solid black lines. Art that uses continuous gray tones is referred to as grayscale art. Grayscale images can be converted to strict black-and-white images by making them halftones—converting the grays to black dots. Line art is more versatile; grayscale art results in large computer files and halftones require special handling (discussed in Chapter 20).

Grafix manufactures a bristol board with the crosshatching already done. The lines are invisible, but they're there. You brush a special developer onto the parts you'd like shaded, and the lines appear. The board is expensive, but the effects are very sharp. The Grafix Web site is found at *www.grafixarts.com.*

▲ The same illustration rendered in crosshatching, pointillism, ink wash, and Benday sheets

Pointillism

Another method for forming gray values without using actual gray tones is pointillism. The pointillism (or stippling) technique is similar to cross-hatching, except you make dots instead of lines. The smaller and more spread out the dots, the lighter the resulting gray value. The larger and more closely packed the dots, the darker the resulting gray.

As with crosshatching, the dots should never overpower the lines that form the object being shaded. This method is rarely used because of the time-consuming, mind-numbing nature of tapping one's pen or marker on the paper repeatedly to slowly build up grays. However, since the end result is considered line art, the result is a small computer file size and a greater ability to resize, if necessary.

Ink Wash

A third method is to dilute India ink with water—working in what is known as a wash technique. Adjusting the water-to-ink ratio yields different shades of gray. Egg cartons make great containers for mixing ink and water. Paint the gray into your illustration with a brush. Also, several applications of the same shade "washed" over the same area repeatedly will result in a deeper tone. The final art must be either scanned as a grayscale or converted to a halftone.

Benday Sheets

Benday sheets are sheets of clear plastic paper with adhesive on one side and dots printed on the other. It comes in several shades and textures. A small piece is cut off and stuck to the surface of the illustration. Then an X-Acto knife is used to carefully cut it into the shape desired.

Chapter 5

Skip the Model and Use Your Head

"First, draw a circle." You'll see that sentence in virtually every book on cartooning. You're shown a circle, a couple of dots are added for eyes, a dash for the mouth, and the author assures you that you're cartooning. It's an oversimplification. As with all art forms, you have to learn the rules before you can break them. Comic book artists will stay true to these guidelines. Caricaturists will distort them. Other cartoonists will distill them, creating unique faces that still resonate as human.

Front View

The anatomy of the human head tends to adhere to a few proportionate guidelines. Surprisingly, circles play a very small part. The predominant shapes are built on a system of ovals and egg shapes. Getting the proportions of these irregular shapes can be tricky, so many artists rely on a grid system to help correctly shape and place the elements of a head.

Front-View Grid

Start with a square. Divide it in half, vertically and horizontally. There's no need to measure, just roughly find the midpoint of the height and width. Add a horizontal line halfway between the center and the top. Do the same between the center and the bottom.

Now, draw a vertical line halfway between the center and the outer left edge. Do the same on the other side. Now you have divided the width into fourths. Put another vertical line midway between the outer left side and the nearest fourth. Do the same on the right side. Mentally block out the vertical eighth you have just measured on either side. It may help to shade them in so you don't use that space.

ALERT!

Dividing the grid into quarters and eighths is not as complicated as it seems. It's not necessary to use a ruler. Simply estimate the middle of a line. Once you've found the middle, you've divided the line in half. Divide each half to find quarters. Divide a quarter in half and you have eighths.

Drawing the Head

Draw a circle bounded by the left and right edges, the top line and the bottom quarter. From the outer edges of the circle, draw a curved line down to the bottom boundary. It should hit the bottom between the centerline and either of the nearest quarters. You now have a perfect skull shape to draw a head from the front view.

Once you've roughed in your head shape, the features tend to fall into place rather quickly. The eyes line up on the horizontal centerline. The ears

reach from just above the center to the bottom quarter. The nose is positioned along the vertical center and reaches from the horizontal center to the bottom quarter. The mouth is about a third of the rest of the way down from the nose.

Most generic facial features follow some proportional guidelines. Here are some major rules to follow:

- There is room for five eyes across the center of the head.
- The width of the mouth lines up with the outer edges of the eyes.
- The width of the nose lines up with the inner edges of the eyes.

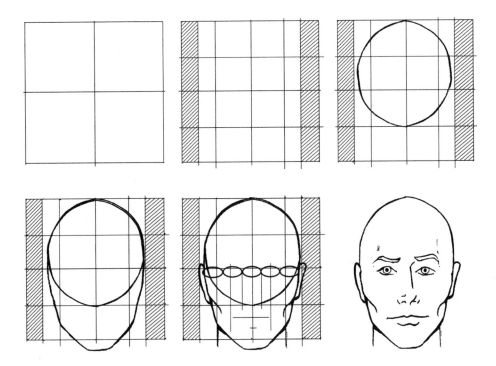

▲ Using a grid to draw a front view of the head

Most beginners tend to overemphasize facial features, creating a face that is much too big for the skull they've drawn. Remember, the main function of a human head is to protect the brain, so the largest mass is devoted to that cause. Eyes, ears, mouth, and nose are specialized organs and, therefore, are small, refined instruments. Draw them too large and the face will look awkward and amateurish.

Drawing a grid may seem complicated, but once you get into the habit of starting off this way, it becomes second nature remarkably fast. In time, you may want to skip the grid step altogether and simply draw ovals—dividing them according to your imaginary grid—but don't take that step until these proportions are ingrained in your memory.

Side View

The same proportionate guidelines that apply to the skull in a frontal view will help you draw a realistic head in side view. The only drawback to using a grid is that it can lead an artist to think of the head in terms of straight lines. This is particularly dangerous in the side view. To avoid drawing profile views of characters that look pushed up against a wall, remember that the face is positioned on a curved surface. The grid lines may be straight, but they're there to help you draw gently curved lines.

Start with the same grid you used for a front-view drawing. This time, though, don't omit the outer eighths. Draw an oval bounded by the left, right, and top edges and the "mouth line" (one-third of the way down from the bottom quarter). Indicate the jaw by drawing a curved line down from the outer edge of the circle to the bottom. The jaw line extends all the way back to the bottom of the circle in a gradually sloping line.

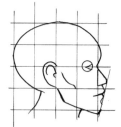

You'll notice that the features fall on the same grid lines. The eye is positioned on the centerline, about one-eighth from the edge of the circle. From the side, the eye's shape is best described as a sideways V. The ear is positioned on the vertical centerline, reaching from just above center to the bottom quarter line. Observe how the jaw line leads directly to the ear. The cheekbone extends from the top of the ear to the mouth. The nose extends outside the grid, reaching from the centerline to the bottom quarter. The mouth gets positioned about a third of the way down the bottom quarter.

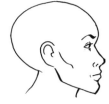

◀ Using a grid to draw a side view of the head

The most difficult aspects of drawing a head in profile are the nose and mouth. Many beginners tend to overemphasize the nose. The nose juts away from the skull and, really, is a rather small feature. It also "pulls" the mouth away from the skull. Draw a diagonal line from the tip of the nose to the jaw line to help judge how far the lips should come out. Finally, add details like nostrils and a chin.

Nostrils are a big part of why beginners have trouble drawing the nose. Remember, the openings point down—not out—from the nose. The rest of the nostril is built around this opening.

Three-Quarters View

Once you become familiar with the proportions used to design a head from the front and in profile, you're ready to tackle the many angles in between. When drawing a head that is turned slightly to one side, the grids that had previously been so useful tend to hinder more than help. Therefore, it's best to jump in with a skull shape and use the proportions you've memorized to help guide you through.

Remember, the skull is an oblong shape. Once you've drawn an oval, indicate the jaw. It should drop straight down from the front and connect in the middle of the skull on one side. Next, start indicating grid lines for the center, quarters, and the mouth line. (Note that these grid lines should be curved.) Draw the ears and the nose first, roughing in the eyes and the mouth last.

Drawing a three-quarters view isn't easy. First, the front of the head is not a smooth curve. The forehead juts out slightly, the eyes recede into the skull, and the cheekbones and chin project out. Second, since the head is turned on an angle, the features being drawn are subject to rules of foreshortening. Specifically, objects that are farther away are smaller. Keep the following tips in mind while drawing a head in three-quarters view:

- The eyes are not spaced evenly. Depending on the severity of the angle, one eye may be partially or totally obscured by the nose.

- Since it's seen at an angle, the line for the mouth is shortened.
- The ears do not lie flat against the skull; they stick out slightly.

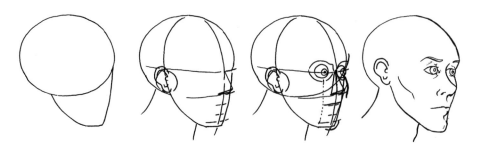

▲ Drawing a three-quarters view of the head

Drawing a head at three-quarters view takes a lot of practice. When you get frustrated, go back and re-establish the proper proportions in your mind by doing a few profiles and front views. Try drawing a triangle indicating the underside of the nose to get the nose to jut out correctly. Also, try to envision the entire eye inside the eye socket to help position the eyes and eyebrows.

Once you're able to draw a believable head, it becomes second nature to warp the grid and create unusual and unique characters. Time spent learning to draw realistically is time spent learning to be a great cartoonist.

A Look at Eyes

Eyes are said to be the windows to the soul. Curses are cast through the use of an "evil eye." "Look into my eyes" is a common phrase used by hypnotists. With all the importance placed on eyes, it's a good idea to put extra effort into drawing them well. You'll find that it's usually the first thing that people will point out in a faulty drawing.

When drawing eyes, keep the following in mind:

- The eye does not have a symmetrical shape.
- The eyebrow is hardly ever very close to the eye.
- Eyelashes are better drawn as a mass—especially lower lashes.

- The iris is partially covered by the upper eyelid.
- The pupil should be in the middle of the iris.
- The iris and pupil should be round—not oval.

Remember, the eye is set into the skull and the eyelids and eyebrows jut out. That's going to create some important shadows to be aware of. This becomes very important in drawing an eye from the side. Notice the iris and pupil from this angle are flattened into a very oblong oval. Finally, realize that the iris is not perpendicular from the ground—it tilts up slightly.

Drawing Hair

When drawing hair, beginners often focus on drawing individual strands, losing sight of the big picture. The result is usually a very bad hair day. It's more effective to consider the hair as one mass.

To start, sketch a hairline onto the head you've drawn. Unless you're drawing a short haircut, this line is for your visualization purposes only. Divide the hair into units. If the hair is parted, each side of the part is a unit. If the hair is pulled back into a ponytail, the ponytail is a unit. If the hair is layered, each layer is a unique unit.

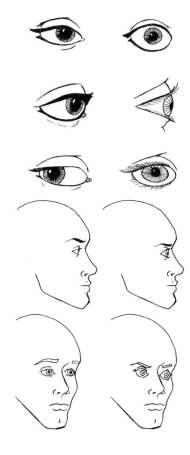

▲ On the left, well-drawn eyes; on the right, poorly drawn ones

Rough each unit of hair onto the scalp. Remember to follow the contour lines of the head. Wherever appropriate, attach the hair to the hairline. Use a loose, sketchy line. Starting with a firm line can result in hard-edged, plastic-looking hair.

ALERT!

Try to keep the hair wavy and full. The common error is to draw the hair too close to the scalp. This leaves the hair in the drawing looking flat. When drawing hair, err on the side of extra volume.

Now you're ready to start drawing individual strands of hair. You'll indicate the strands of hair in the shadows and leave the highlights white. Shadow areas are on the side of the skull that faces away from the light source and under hair that lifts away from the scalp. Pay special attention to the units that overlap. When two layers of hair overlap, the higher one will cast a shadow on the lower one. Don't forget the shadows caused by a part in the hair.

The strands should correspond to their units. If the unit goes back across the scalp, so should the strands. If the unit flips up and falls down into the face, the strands should reflect this. If the hair is pulled tightly back across the scalp, the lines should reflect this in being orderly and evenly spaced.

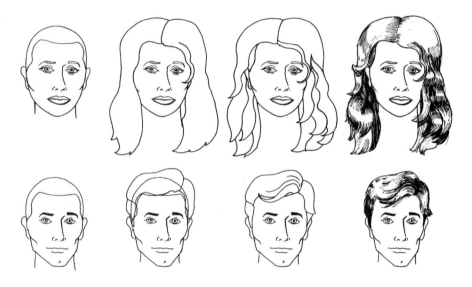

▲ Drawing hair in units

In drawing curly hair, the same principles apply. Consider the curly area one unit. Draw lines indicating curly strands where the shadows would fall across the unit. Resist the urge to fill the unit with curly strands, as this will actually leave the hair looking flat and dimensionless.

Now that you've indicated shadows and left highlights, you may choose to include some middle tones between the two. Use a lighter, looser stroke than you used to indicate shadow areas. Remember to make these strokes follow the contour of the overall area as well.

Comic book artists will want to consider the effect of outside forces on hair. Too often, the hair on these characters remains the same whether the person is standing, running, flying, or swimming. Attention to this detail—especially in a scene where a character is recoiling from a forceful blow—adds considerable drama.

Male and Female Characteristics

Men and women are drawn using the same grid. There's no difference in the methods for drawing their hair. But, obviously, men are drawn different from women. Paying attention to simple details will not only keep your drawings from looking androgynous, it will give your characters a deeper personality.

Male Facial Features

Masculine features are angular. There are very few soft curves to a man's face. The cheekbones, the nose, the mouth, and the eyes are drawn using sharp angles. It is also advisable to draw masculine features with a little additional weight in mind. For example, the end of the nose has a blunt or round edge—almost never pointed or upturned. The eyebrows can be heavier and more prominent. The same applies to the forehead, which can be drawn at a slightly flatter slope and can jut out over the eyes to a greater degree.

Other features are better drawn with fewer lines. For example, a man's eyes are drawn quite simply—with no embellishment around the eyelashes or brows. Also, a man's lips are hardly ever completely drawn in a cartoon. The result is awkward and distracting. Most cartoonists draw a simple line for the mouth and a smaller line underneath that indicates the bottom of the lower lip. The mouth line follows the contour of the bottom of the upper lip, and the lower lip line follows the two muscles under that lip.

Female Facial Features

Women's features are described by their curves. There are very few hard edges or angles on a female face. The cheekbones, eyebrows, and mouth are all drawn with graceful, curved strokes.

Feminine features are usually light and less dramatic. For example, the forehead has more of a curve than a slope—and it rarely is shown as protruding over the eyes. The eyes recede into the skull, but at a less noticeable degree than on men.

In comic books, female noses are almost always thin, pointed, and tilted slightly upward. The nostrils are small and don't flare at the edges. Eyes are more pronounced, due to exaggerated eyelashes and brows. Finally, both upper and lower lips can be drawn completely without an awkward result. Remember, though, the bottom lip is thicker than the upper lip for both sexes.

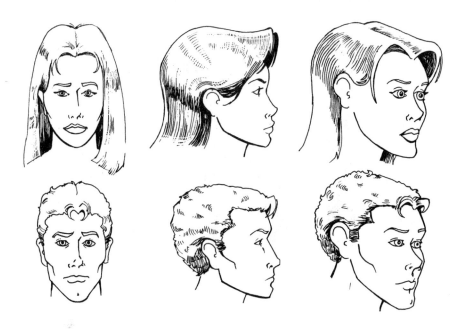

▲ Drawing male and female features

Bending the Rules

Now that you've mastered the classic features and proportions of male and female faces, you're ready to break some of the rules to represent a broader cast of characters. Surprisingly, it takes very little deviance from the standard grid to render a dramatic change in a character's appearance. Resist the urge to alter the grid itself unless your intended result is a caricature.

Racial Differences

Don't let ethnic bias get in the way when drawing characters from different racial backgrounds. Stereotypes and assumptions are misleading when drawing different races. In truth, there are many more similarities than differences. Focusing on the latter tends to produce a rather insulting illustration.

Asian people should not be drawn with slants where their eyes should be. The lips of a black person should not be exaggerated, nor should they be a completely different hue from the rest of the face. Slight alterations from the features you've already learned are often more than adequate when drawing people of different races.

Age Differences

It's so easy to make a face look older that many artists do it unintentionally. Every unnecessary line that an artist adds to a face will make that face look older. This is especially true for lines around the mouth and eyes.

Prove it to yourself by drawing a classic head. Add lines on either side of the mouth, extending down from the nose. The face just got older—right before your eyes. Now add a smaller pair of lines just outside the first pair. Draw the line under the eye where the bottom ridge of the skull's eye socket would be. Add some crow's feet around the eyes. You've made the once-young visage about forty years older by adding four sets of lines.

Of course, age can be seen on the human head in other ways. Gravity's effects will alter a face over time. If you drop the jaw line slightly while keeping the chin in the same position, you can give your characters jowls. The ears and nose continue to grow throughout life, so these features on an older adult can be rounder and larger. Remember, these are potent visual effects. A small change to the classic features will read as a decade of difference to your readers.

From Comic to Caricature

Learning to draw a standard face based on a grid is clearly most useful for creating realistic images or idealistic cartoons such as those in comic books.

But this method is not limited to drawing realistic images; a small, subtle nod to realistic drawing can make even the most abstract cartoon more lifelike.

FACT

Although Pablo Picasso is best known for his fantastic abstract images, he started as an accomplished realistic painter. His cubist paintings experimented with a new way of looking at an image—from several angles at once. They would not have been possible without a prior understanding of realistic drawing. Cartooning is no different.

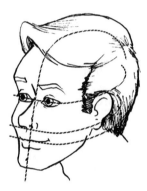 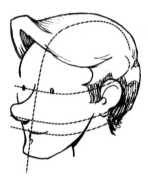

▲ The head on the left is a "realistic" cartoon; the one on the right is exaggerated. But even in the exaggerated drawing, the cartoonist has chosen to use a grid and the features are still somewhat realistic.

In the end, every minute you spend learning to draw convincing features will benefit your cartooning immensely. Don't be fooled by the finished work of the cartoonists you admire. Rest assured, they started at the same place. As always, it's where you go from there that defines your art.

Chapter 6

E Drawing Hands and Feet

The greatest challenge for a cartoonist is to convey several messages in a limited space and a short amount of time. Characters must express feelings beyond those written in the word balloons floating above their heads. In some cases, emotions may even contradict those words. Obviously, the head is the most powerful mode of expressing emotions. But to create characters that truly emote, you need to study gesture and posture, and that means drawing hands and feet. Learning to draw these features well will result in characters that project a full range of feeling.

Understanding the Hand

Many beginners fool themselves into believing that they need not bother with learning the anatomy of the hand. After all, a quick glance at your newspaper's comics section will reveal myriad abstracted appendages—from loose loops dangling from the ends of forearms to characters with only three fingers. How can anatomy possibly be important?

FACT

The "three-finger phenomenon" in cartooning stems from animation. Early animators found it much easier to animate hands with three fingers. It saved time and effort—and, therefore, money. The style was quickly adopted by other cartoonists, and it remains in use today—especially in the case of anthropomorphic (also known as "funny animal" or "furry") comics.

However, just as the case was in learning to draw a head, it's important to start from a realistic standing and work toward a more and more abstract image. Even the most abstract hands are drawn with an understanding of basic human anatomy.

Hand Anatomy

Drawing is a one-handed process, so you can use your nondrawing hand as a model while you sketch. Grab your sketchbook and make some notes. The time you spend studying one hand counts double because the front of one hand has exactly the same proportions as the back of the other hand.

The Front View

Hold your nondrawing hand, palm toward your face, with your fingers and thumb straight up. Notice the shape. It's a simple wedge, with a thumb that hangs on the outside. The index and ring finger are about the same length. The middle finger is longer and the pinky finger is shorter. Along the edges of the hand, the palm bows outward a little on the pinky side and a lot on the thumb side. Notice the round muscle at the base of the thumb.

Finally, notice the thumb itself, hinged to the outside edge of the palm, and turned almost 90° in comparison to the other fingers (allowing you to see the thumbnail).

If using your nondrawing hand as a model is unmanageable, you can buy a wooden hand model. It can be an excellent reference, mimicking several realistic hand positions.

The Side View

Now look at your nondrawing hand from the side. Again, the overall shape is that of a wedge—wide at the palm and narrow at the fingertips. Notice the muscle at the base of the thumb. It protrudes from the overall structure of the hand, giving it a natural "cup"—even when relaxed.

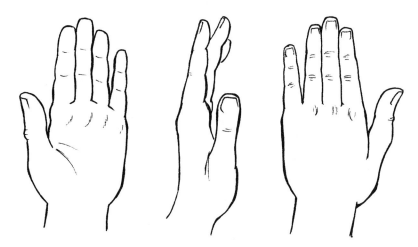

▲ Front, side, and back views of a hand

Basic Hand Structure

Hands are larger than beginning artists tend to draw them. In a realistic drawing, the hand is about the same length as the head—from forehead to chin. Also, pay close attention to the wrist. The hand flares out from the

wrist, becoming wider than the end of the forearm. Even at rest, the wrist flexes the palm at an angle to the forearm. The wrist connects the forearm to the base of the palm. A common error is to connect hand to arm via some point in the middle of the back of the hand.

Draw It Step-by-Step

In drawing the hand, the tendency is to concentrate on the fingers. After all, they're the most important part of the hand, right? Actually, in terms of illustration, the key to drawing a good hand is between the fingers and the wrist. From the front, it's called the palm, and from the back, it's called the dorsum. In either case, it's the best starting point when drawing a hand. Consider it another application of the "draw large to small" rule discussed in Chapter 4.

Start by drawing the palm/dorsum as a square. When sketching this shape in, consider any flex or angle of the wrist. Add about a quarter of the height to the top. This indicates the row of padding beneath the fingers. In a cupped position, this rectangle will disappear. Now, modify the sides so they flare out near the base slightly.

ALERT!

A sure way to draw awkward hands is to add accurate fingernails. If you want to avoid this, indicate the fingernails only as a curved line where the very front of the nail (the part you clip) would be. Extend a very short line back along the finger on the side (or sides, if the view is from the top). This also makes the finger itself more three-dimensional.

Next, sketch in the fingers as simple lines. There's no reason to be exact here, just indicate the general curvature of each finger. Remember the relative lengths of each finger. Add the thumb. Remember, the thumb has three segments, just like the fingers—the segment that connects it to the palm is hidden by the large muscle at the base of the thumb.

Firm up the lines, breaking them into three linear segments each. The segments of each finger are not of equal length. In each finger, the segments near the palm are long, the middle segments are shorter and the tip segments are

shorter yet. If it helps, you can envision these lines as the bones of the hand you're drawing.

Now it's time to "flesh out" the fingers. Each segment can be considered a separate cylinder. Of course, these cylinders get more and more narrow toward the tips of the fingers. The only segment that is different is the base segment for the thumb, which is indicated as a rounded muscle extending from the base of the wrist to the top of the original square you started with.

Now you can finish the drawing. Unless you're working on an extreme close-up view of the hand, don't obsess over every wrinkle and fold of the skin. Hands are best described by accurate shapes—not by details like knuckle folds and fingernails. Keep in mind that the muscle at the base of the thumb gets pulled over the palm area when the thumb crosses over into this region, leaving the palm only slightly bowed out on that side.

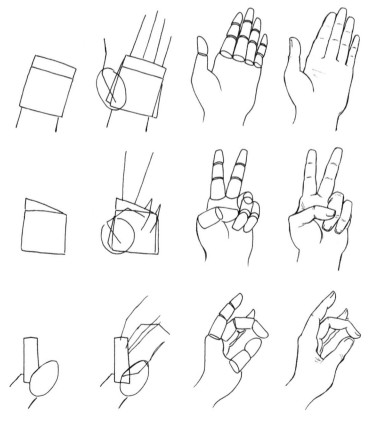

▲ Drawing a hand step-by-step

Masculine and Feminine Hands

Typically, men's hands are drawn somewhat squatter, with shorter fingers and blunt fingertips. Feminine hands are usually drawn with longer fingers that are very narrow at the tips. Avoid the mistake of drawing women with pointed fingertips. Even characters with long fingernails should not be drawn as if they have claws. When drawing a hand with long fingernails, resist the urge to draw the entire fingernail. The rules for drawing nails remain the same, even though the nail extends past the fingertip.

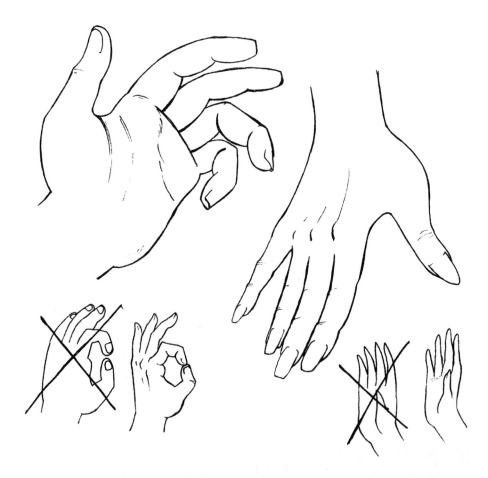

▲ Male hands (on the left) tend to be more compact and blunt, whereas female hands (on the right) are longer and more slender.

Hand Gestures

With a firm grip on the hand and its components, you are now ready to develop a wider range of emotion in your drawings. The position of a character's hands can reinforce, contradict, or provide a context for the words being spoken. Having practiced drawing hands, you're now ready to position them effectively.

Making a Fist

If you're planning on drawing an action comic or superhero comic book, you'll be drawing fists with predictable regularity. Remember, when the fingers come down into the palm area, the palm itself becomes a square shape. The padding under the fingers folds under, becoming the resting spot for the fingertips. Likewise, the thumb crosses over into the palm region, pulling its base muscle over and under the fingers.

Pay attention to a few details here: the way the skin bows out on the pinky side from the front, the space between the fingers and knuckles from the top, and the loose skin between thumb and forefinger from the side. Also, notice how the act of making a fist makes the veins in your wrist more pronounced. These details will make your action sequences seem much more dramatic.

Pointing

Pointing—index finger extended while the rest of the hand is making a fist—is one of the most popular and useful hand gestures. When the index finger points straight up, the speaker looks as if she is speaking authoritatively on a subject. This could also connote a discovery or an idea. In any case, the overall indication is one of intelligence.

Pointing the finger outward is an act of directing another's attention. Whether it's an accusation ("He did it") or an instruction ("Look over there"), the finger out draws the reader's eye to the intended target. It's a useful compositional tool and can be extremely powerful in helping to organize a complex scene.

Here are a few other pointing gestures to consider:

- Finger pointed down: "Come HERE"
- Finger pointed at head: "I'm thinking" or "You should think"
- Fingers pointed different directions: Confusion
- Finger pointed, thumb extended: the gesture of holding a gun
- Finger in front of lips: "Shhhh!"

Countless other gestures are created when the pointed index finger gesture converts to a curled index finger. Now a character scratches his head in thought, strokes her chin deviously, or motions to another to approach. It's a valuable gesture to learn to draw well. Adding the angle of the wrist, you now have the ability to produce countless gestures with the pointed finger position alone, as shown in the illustration below.

▲ Notice how small changes in the same hand gesture produce a wide range of expressions.

Thumbing

Another versatile gesture involves the hand in a fist position with the thumb extended. A thumb straight up indicates approval. A thumb to the side directs attention to the target in a less formal way than the pointed finger does. A thumbs-down, obviously, indicates displeasure. Of course, these are just a few options for using a thumbs-out gesture. Paired with

other body parts, this gesture takes on additional meanings. Here are some more possibilities:

- Thumb to mouth: Childish behavior
- Thumb to chest: Somewhat proud reference to self
- Thumb under chin: Thoughtfulness

Remember, when drawing a thumbs-out gesture, the palm/dorsum becomes a square shape. The entire hand will appear more compact. The natural response is to overcompensate by drawing a huge thumb. Refer back to your hand studies, if necessary, to keep the thumb as natural looking as possible.

FACT

As you may have noticed, the thumbs-out position is similar to the pointed finger in several connotations. The latter, however, is more direct and more threatening. It is for this reason that you see politicians making their points with their thumbs. You will seldom see a seasoned politico wagging a finger into a TV camera.

Loose-Finger Gestures

Of course, not all gestures are limited to ones that are based on a closed fist. Many gestures involve an open palm, with the fingers flexed to different degrees. One thing to remember when drawing a hand in such a pose is that the index finger is still the dominant finger. In a relaxed position, the fingers are more relaxed the farther they are from the dominant finger. In other words, the middle finger drops a little more than the index finger; the ring finger drops further, and the pinky further yet.

If you draw a loose-fingered hand that does not follow these rules—for example, the pinky is more rigid than the others—the resulting gesture is awkward and ungainly. Breaking the dominant-finger rule is a good way to portray a character experiencing severe discomfort.

In a loose-fingered gesture, the wrist becomes much more important in determining mood. A turn of the wrist can turn a gesture from helplessness

to prayer. Don't be afraid to experiment with different angles. The main danger in drawing a loose-fingered hand is that the hand hangs straight down and becomes meaningless.

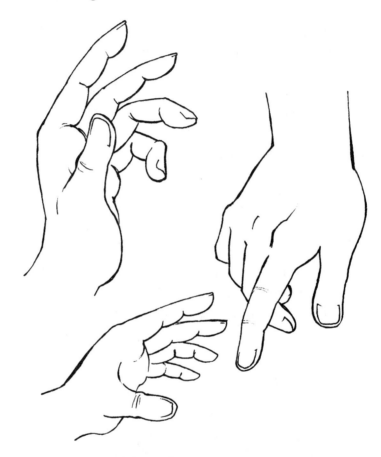

▲ Loose-finger gestures

OK Sign

Another example of the dominant-finger rule is in the OK sign gesture, made by touching the tips of the index finger and thumb. In this case, the index finger is flexed, the middle finger is less flexed, and so on. The pinky, although physically higher than the other fingers, is the most relaxed. A beginner's mistake to avoid is to draw the three nonactive fingers sticking straight out. It's not an impossible gesture, just an improbable one. The OK

sign gesture is rather limited in its direct use. However, it's a good starting point for hands that are making a pinching motion or manipulating something very small (pulling a slender thread, for example).

An extended pinky can add a much-needed flair to several bland gestures. In all cases, the pinky lends an air of superiority or regality to the emotion. Sipping a cup of tea becomes more formal when the pinky is out, and crossing one's arms in displeasure becomes that much more haughty, thanks to the pinkies.

Understanding the Foot

Feet generally present less of a problem to cartoonists because, in most cases, they are hidden inside shoes. However, inside those shoes are anatomical features with joints and proportions that need to be recognized. Feet, like hands, are commonly drawn too small. If a hand is about as tall as a face, a foot is over a hand and a half. This rule is easy to apply to men. Unfortunately, a woman drawn with correctly proportioned feet may look odd to many of your readers. Therefore, feminine feet can be drawn smaller—a little over a hand's length—without looking awkward.

A well-drawn character can be made to look awkward and off-balance due to poorly rendered feet. Worse yet, nervous artists quickly run out of ways to hide feet. Ironically, there's no reason to hide your character's feet. Following a few simple steps, feet are much more manageable than hands—even when the shoes come off.

Tips for Drawing Feet

The foot is basically a long wedge shape. It has two major points of articulation, the hingelike joint that connects the foot to the ankle and the joint that runs perpendicular to what are called the balls of one's feet. Most importantly, the heel extends back behind the leg. Avoid the mistake of making the leg and foot a simple angle, like a letter L.

From the top, the first toe is largest, and the others angle downward in size and placement. Notice how the tip of the little toe extends only as far as the base of the big toe. Also, pay attention to the instep—the area along the big toe side of the foot. It is not a straight line back to the heel—it curves inward and then back out.

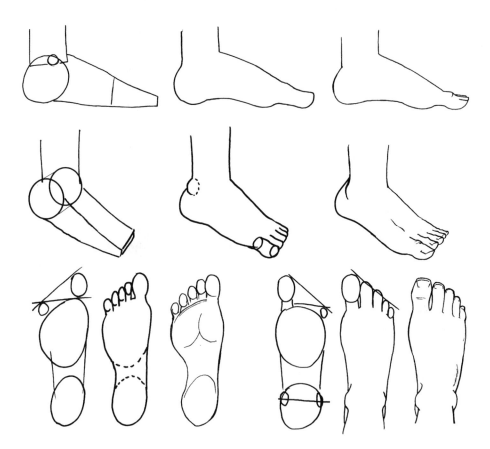

▲ The foot as seen from several angles

Imagining the Footprint

Most often, feet are drawn standing, walking, and running. This presents a much more complex challenge than drawing a foot in a side view or from below. One method for approaching a drawing with active feet is to imagine the footprints that will be left by the character. Once you're ready

to start roughing in a character's feet, sketch his footprints first. Consider the perspective and angle they would be seen at if he were not present. It's an easy shape to draw—a circle for the heel and an oblong oval for the rest. Then, rough in a three-dimensional wedge, based on your knowledge of the foot from the side view. You now have a well-proportioned sketch to firm up.

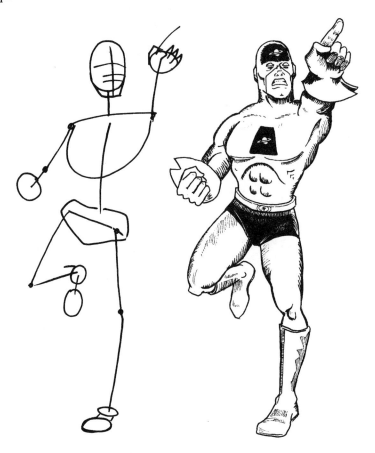

▲ Building feet from the footprint up

Action and Drama

Of course, feet are much more limited in displaying mood than are hands or the head. But that's no reason to discount their importance. Feet are the principal points of balance, and as such play a pivotal role for artists

depicting action scenes. There are a few key points to remember when deciding where and how to place the feet under your character.

At a normal, standing position, the feet will line up with the shoulders. The wider apart the feet, the more grandiose the mannerism becomes. Feet that are close together indicate meekness or politeness.

When a figure is in a typical standing pose, the head will always line up with the ball of one foot. If the figure is seen from head-on or directly behind, this relationship is impossible to see—the head will line up between the two feet. But from any other angle, this head-foot relationship can be seen. Disregarding this rule can make a standing character seem off-balance.

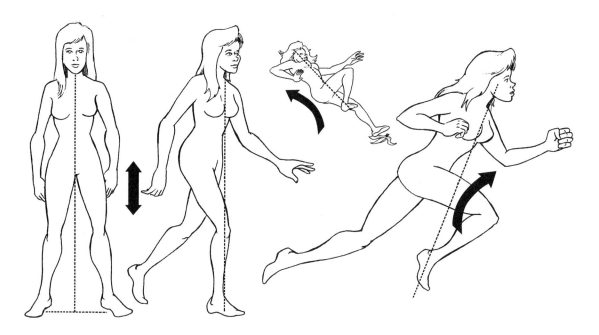

▲ On a standing figure, the head will always line up with the ball of one foot when seen from the side. Breaking this rule for nonstanding figures produces dramatic results.

Chapter 7

The Human Figure

Having studied drawing the head, hands, and feet, you're ready for larger challenges—and that means drawing the human body. This is a particularly crucial skill for the aspiring comic book artist to master. If you're planning to draw superheroes, you will go on to refine the lessons of this chapter. If you're planning on drawing cartoons or comic strips, you will simplify them into your drawing style.

Proper Proportions

In determining correct proportion, most of the measurements are guided by the size of the head. In reality, a person is about 7½ heads tall. In comic books, heroes tend to be drawn on an 8½-head scale.

QUESTION?

Who decided heroes should stand 8½ heads tall?
Michelangelo. He used these exaggerated proportions to create imposing heroic statues. For this reason, it is still commonly referred to as "heroic proportion."

Masculine Proportions

Whether your figure is 7½ or 8½ heads high, there are some proportional rules that will remain constant. Using the height of the head as a unit of measurement, you will be able to gauge where certain body parts will line up. For example:

- The fingertips, when relaxed, will reach about midway down the thigh.
- The armpits line up one head's height ("one head") down from the chin.
- The elbow will line up with the navel.
- The navel is one head down from the armpits.
- The crotch is one head down from the navel.
- The bottoms of the knees line up two heads below the crotch.

Pay particular attention to the proportions of the arms. No one seems to think their arms are as long as they are. Even cartoonists who get the overall length correct can misplace the elbow, placing it too high on the arm.

Also, the legs do not form a straight line down from the hips. Seen from the side, the lower part of the leg juts backward. If you drew a vertical line down through the center of the figure, the lower leg would mostly fall behind that line.

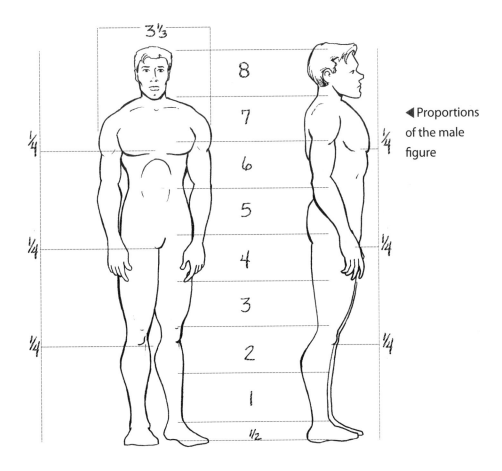

◀ Proportions of the male figure

Of course, measuring by the height of a head you haven't drawn yet can get confusing. Luckily there are some general proportion guidelines to follow that are based simply on the overall height of the figure. Keep these relationships in mind when starting your figure:

- The crotch will be in the very middle of the body's overall height.
- The nipples line up one quarter of the way down from the top.
- The bottoms of the knees line up one quarter of the way up from the bottom.

Once you rough in the figure, you can divide the height into "heads" and refine the proportions. The width of the male figure can be anywhere from 2⅓ heads to three heads wide. The widest dimension will be across the shoulders. The outside of the waist will line up roughly with the armpits.

Feminine Proportions

Women will still be 8½ heads tall, but their heads are drawn somewhat smaller, resulting in a shorter overall height. They follow the same proportional guidelines with very minor alterations:

- The fingertips, when relaxed, will reach about midway down the thigh.
- The armpits line up one head down from the chin.
- The elbows will line up with the waist.
- The waist is one head down from the armpits.
- The navel is slightly below the waistline.
- The crotch is one head down from the waist.
- The bottoms of the knees line up two heads below the crotch.

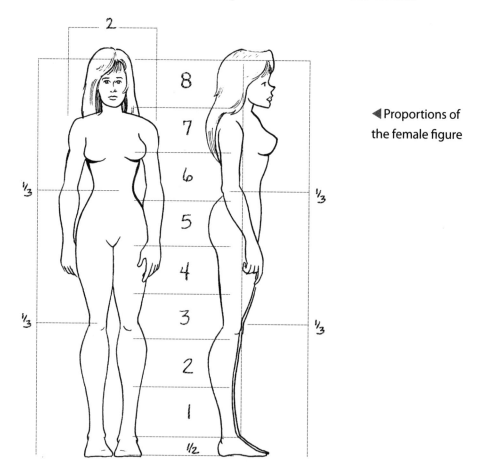

◀ Proportions of the female figure

Women also tend to be drawn narrower than men—two heads wide at the shoulders. Note that the woman's waistline is also much smaller than the man's—one head wide. However, her hips do not continue straight down as his do; they bow outward slightly. At their widest point, a woman's hips are wider than lines drawn down from the armpits.

Again, there are general guides you can use to get started drawing your female figure. As with the male, these are based on figure height, not head height. Use these to help rough in the figure as you begin your drawing:

- The crotch is in the middle.
- The waist is one-third down from the top.
- The bottoms of the knees are two-thirds down from the top.

Pay attention to the way the pelvis is tilted on the female figure. This tilt raises the buttocks and moves the lower abdomen back slightly. This is particularly evident from the side.

Drawing Children

Children present a unique drawing challenge. Their heads start large and grow slowly, while their bodies start small and grow rapidly. Also, a child's eyes at birth are almost the same size as adult eyes. They dominate the other facial characteristics, which seem relatively tiny on the large skull. This makes for a fluid set of proportions.

To makes things worse, children's proportions tend to be exaggerated in cartoons. Perhaps it's a way of ensuring the reader will definitely identify the character as a child and not a small adult. In any case, cartoon children develop at a much slower rate than their real-life counterparts. These distorted proportions even out in the early teens, when kids may be drawn shorter but have adult proportions.

Also, note the treatment of the face for young children. To indicate the relatively large size of the skull, the face is drawn a little smaller and a little lower down. The eye level of a young child, drawn as a cartoon, will fall lower than the usual halfway down.

▲ Proportion guidelines for children and cartoon kids; from the left, the pairs are adults, teenagers, ten-year-olds, five-year-olds, and one-year-olds.

Start from a Stick Figure

Some people say, "I can't draw; I can only do stick figures." In fact, a well-proportioned stick figure is a fantastic blueprint to figure drawing. It has the added extra advantage of being a fast, fluid process, which is great for roughing in a composition quickly and accurately.

Until the proper proportions become engrained into your memory, it may help to use the proportional guidelines. If you draw a straight vertical line indicating the figure's overall height, you can divide it into quarters (for men) or thirds (for women).

ALERT!

As with the grid used to draw a face, there's no need to measure when dividing the height line. To divide the line into thirds, use your best guess. To divide the line into quarters, divide the line in half and then each segment in half again.

Now that you've indicated your proportional reminders, draw a stick figure. Remember that a male is drawn wider than a female—this distinction is going to be most evident in the stick figure's rib cage. It's helpful to think of

these shapes as being adjustable, so indicate joints like shoulders, elbows, and knees as circles. This will make it easy to make small adjustments in gesture as you refine the stick figure.

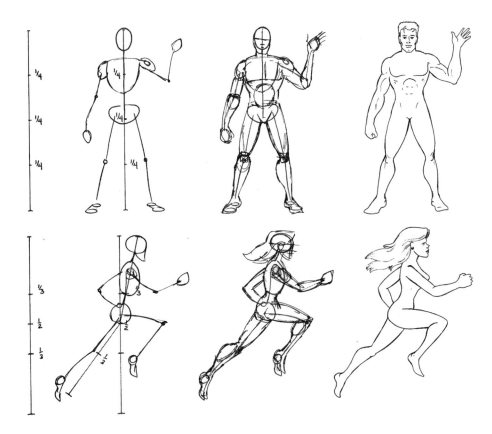

▲ Start your stick figure from a line divided into fourths (for men) or thirds (for women); in either case, the crotch falls in the center of the line.

Practice drawing stick figures for a few days. Populate a few dozen pages of your sketchbook with stick figures in every possible posture and from every conceivable angle. As you start to feel more comfortable, you'll start using the proportional reminder marks less often. Every once in a while, go back and check the proportions on one of your stick figures to make sure you aren't developing any bad habits.

Flesh Out the Form

Once you become comfortable with stick figures, you're ready to start converting them into three-dimensional images. Add cylinders for the upper arms and forearms, thighs and calves. To draw a man, the outer line of the torso falls in toward the waist. To draw a woman, the line curves in toward the waist and then out along the hips. Use the circle as a starting point for the head. Remember to work from large shapes to small, refining the details as you go.

Some computer software packages feature either preposed or poseable models that you can use for reference. Virtual Pose (✐*www.virtual pose.net*) and Poser (✐*www.curiouslabs.com*) both present good ways of getting more detailed visual information on the human body.

Pay Attention to Muscles

To draw a believable human figure, it's good to have a working knowledge of musculature. For comic book artists, exaggerated muscles will help define a character (for other cartoonists, a broader approach is better). In understanding how muscles wrap around the skeleton, enabling the body to move, an artist is able to draw the figure in motion much more convincingly.

This is especially important for cartoonists aspiring to illustrate superhero comics. Where other cartoonists will use general musculature to give their characters a more lifelike appearance, comic book artists will amplify and overstate specific muscles to give their characters a powerful look.

Arms

The upper arm has two major muscle groups to be aware of. The deltoids drape over the top of the shoulder. Under the deltoids is the bicep muscle. The forearm has several long muscles that extend down the length of the bone and attach at the wrist.

Notice how these muscles are all fairly oblong. Some comic book artists—eager to draw arms that wield tremendous power—tend to overemphasize these shapes until they become almost spherical. The result looks more like peas in a pod than a muscular arm.

Legs

There are two muscle groups on the legs to pay particular attention to. The quadriceps are made up of muscles that stretch down from the pelvis to the knee. Notice how they angle inward. They are attached along the outside of the leg near the pelvis and along the inside and top of the knee. Of course, the other muscle that bears mention on the leg is the calf, which protrudes on the back of the lower leg, below the knee. From the front, calves also bow out along the outside more than they do along the inside.

Torso

Of course, the major muscles on the chest are the pectorals. Pay particular attention to where they attach to the deltoids on the outside of the shape. When the arms are outreached, both the deltoids and pectorals are flexed, and therefore the lines from one will flow into the other.

The lower line of the rib cage will be evident in characters who are not carrying extra weight on their lower abdomen. Pronounced abdomen muscles will also make your character look buff. But resist the urge to go overboard here. It's colloquially called a six-pack for a reason: there are three pairs of muscles in this muscle group—no more.

Breasts

No body feature is more consistently overexaggerated than female breasts. In spite of the importance placed on this part of the anatomy by culture and commercials, you'll do well to remember that breasts are simple glands consisting of soft tissue. They are not generally spherical in shape.

Furthermore, breasts are connected to the pectoral muscles. Too often, beginners draw breasts that seem to connect to the collarbone. Draw the rib cage first. Next, add the breasts as extensions of the lower pectoral muscles.

The Body in Motion

Now that you can render a fairly realistic human figure in a standing position, you're ready to tackle more complex challenges. Drawing people in motion is still a matter of starting from a stick figure and fleshing out rough shapes, but now you'll have to take perspective and balance into account.

If you're finding it difficult to draw a stick figure in a realistic pose, consider using a wooden mannequin. Pose the mannequin and then use it as reference for your stick figure. This is a good way to check your proportions as well.

What's Your Perspective?

When drawn in perspective, an object that is close to the viewer will be drawn larger than the same object drawn farther away. The closer an object gets, the bigger it is drawn, relative to its actual size. So, in a drawing in which the character is pointing directly out at the reader, the hands—especially the index finger—will be much larger than the rest of the body.

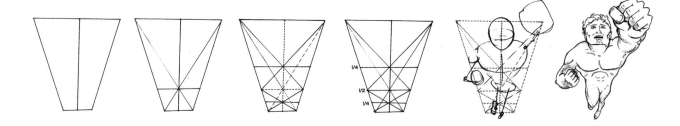

▲ When drawing a foreshortened figure, start with a box that recedes into the distance. Remember, you can find the center of any rectangle by drawing lines from the corners. The lines will always cross in the center. This actually divides the rectangle into two rectangles. Finding their centers will result in dividing the overall rectangle into fourths. Now that you have your line divided into fourths, you have guidelines against which a foreshortened body can be drawn.

Second, an object looks shorter as it is tilted toward or away from the viewer. For example, even though the thigh is two heads long proportionally, it will look much shorter if the figure is seated, facing the viewer. In the preceding example of a character pointing directly at the reader, the arm will appear very short. This is called foreshortening.

FACT

You can see foreshortening in action. Hold a pencil at arm's length, pointed at the ceiling. Now rotate the point toward you. The height of the shape decreases as the pencil tilts toward your eye. When the pencil is pointed directly at you, the height is no more than the diameter of the pencil.

Balance It Out

Look at some of the action poses in the following illustration. Compare the angle of the shoulders and the angle of the pelvis. Unless the figure is off-balance, the angle of one is counteracted by the angle of the other. If one slopes up, the other slopes down.

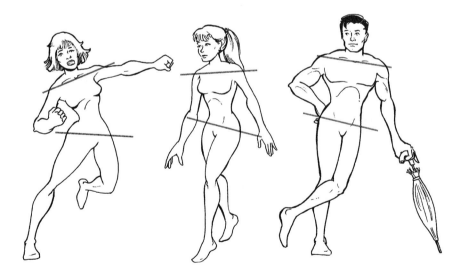

▲ The angle of the shoulders counteracts the angle of the pelvis, whether the action is intense or calm, as in the two poses on the left. Some poses (as the one on the right) are purposefully off-balance, in which case the slope of the shoulders and hips will be in the same direction.

You can see the effects of the counterbalancing angles of the shoulders and pelvis for yourself. Try to walk by swinging your right arm out at the same time that your right leg goes out and vice versa. It's difficult to walk that way, isn't it?

When drawing your initial stick figure, keep in mind where the weight of the body is being carried. Draw a vertical line from this point. Now, stop thinking of this as a cartoon character and simply think of it as a shape. If this shape were to be cut out of your sketchbook, would it be able to stand on its own—or would it tip to one side?

Put the Clothes On

Having studied the human figure, you're now ready to draw clothing with confidence. After all, the shapes and angles of the body parts you've been studying affect how clothing drapes and falls over the body. Drawing is somewhat like playing with paper dolls. First, you draw the body, and then you add the clothing.

Anatomy of Folded Fabric

Fabric folds into three distinct surfaces: Two sides and a top. Sometimes, the top drops in front of one of the sides, obscuring it, but there are always three surfaces. Most folds radiate in lines from a high point or area of support.

For shirts, the primary areas of support are both shoulders and across the chest. For pants, the primary support is around the waistline and, when the leg is bent, at the knee. These folds can also result from the effects of fabric being pulled across the body by motion.

The quantity and depth of the folds will be dictated by the tightness of the fabric across the body. Tight clothes will result in several short, shallow support folds. Looser-fitting fabrics will present fewer folds of a larger, draping nature.

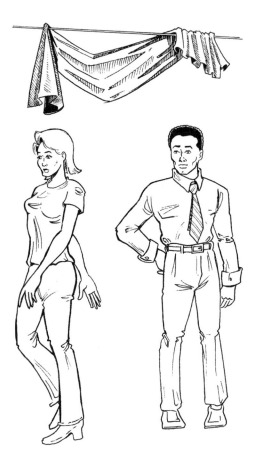

◄ Folds radiate in triangular patterns from the points of support. In clothing, this usually means the shoulders, chest, elbows, hips, and knees.

Drawing Folds in Clothing

When drawing folds in clothing, try to visualize the areas that are being pulled by the action of the body. These will radiate folds in the same way as support points do. Also keep in mind that folds are subject to gravity. They will hang straight down unless the body under the clothing is pulling the fabric in a different direction.

Pay particular attention to the waist when drawing a clothed figure in motion. As the body twists, the fabric is pulled across the abdomen, creating folds that seem to point in the direction of the action.

It's best to try to find some time to practice figure drawing every day, drawing from life whenever possible. When you can't sketch the people around you, study your mannequin or photos from magazines. As your knowledge of human anatomy develops, your final rendering of a clothed character will improve.

Also, notice how fabric gathers around the elbow as the arm is bent, creating triangular folds. The excess cloth gathers at the crook of the elbow and drapes outward along the arm. To a lesser extent, the same happens in the leg at the knee.

Chapter 8

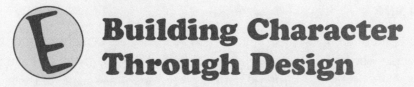

Building Character Through Design

You've been meticulous about drawing human figures in their correct proportions. You've taken time to practice sketching people. And you're wondering to yourself: When do I start drawing cartoons? Now that you're proficient at drawing realistic figures, you're ready to start warping the grid to create your own characters. But rather than simply morphing the figure for the joy of it, take some time to learn the effects of altering certain proportions. A good character design tells the reader more about your characters than any amount of words will.

The Psychology of Character Design

Much of how we respond to a character comes from our subconscious psychology. Some of this is rooted in nature, and some is accumulated through our reading experiences.

Body Type

One of the most predominant body stereotypes centers around weight. People who carry more weight are conceived as jolly, jovial, and avuncular. People who have less-than-standard body weight are suspect. People who are too skinny are often characterized as lazy slackers or fiendish schemers.

Even villains are less threatening when they are heavier. Of all of the Disney villains, who would you be less likely to choose to face in a dark alley—Cruella DeVille or Ursula from *The Little Mermaid*?

Another common body stereotype concerns a character's height. Tall people are more imposing than short people. Tall people can be threatening and even somewhat haughty. It comes through in our language: someone can't "look down their nose at you" unless they're taller than you.

▲ Notice how the character's personality changes depending on weight and height.

Likewise, short people tend to be less of a threat. It explains the predominance of friendly short characters in fiction—from munchkins to Smurfs,

from dwarves to elves. Few villains are shorter than the heroes they battle unless there are extenuating circumstances.

FACT

The presupposition of overweight people as jolly was even noted by Shakespeare, who notes in *Julius Caesar:* "Let me have men about me that are fat, sleek-headed men, and such as sleep o' nights: yond Cassius has a lean and hungry look; he thinks too much: such men are dangerous."

Age and Appearance

We think of young as more attractive than old—particularly with females. Many have linked this to the psychology of human sexuality. Speaking strictly in terms of propagating the human species, a younger woman is a more "valuable" mate in terms of the number of possible childbirth years ahead of her. After all, what else do silicone implants, liposuction, and collagen injections achieve, if not the appearance of a young girl?

This leads to a rather unsettling realization. In a typical drawing of an attractive cartoon woman, the eyes are made larger in relation to the skull, the nose is shortened, and the lips are made more pronounced and often shortened in width. All of these features mimic the facial features of an infant!

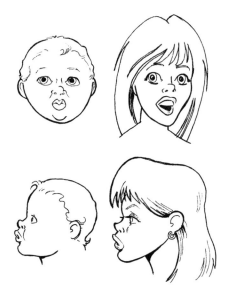

◄ An infant has several biological characteristics—large eyes, an upturned nose, and a compact mouth with strong lips; these same characteristics are often used in portraying adult females for a number of psychological reasons—not the least of which is the illusion of youth and innocence.

Of course, the argument can be made that, by creating characters that keep underscoring these values, cartoonists help establish a society that objectifies women. And it's true, relying on these sorts of visual cues emphasizes your female character's body over her other qualities. But to be completely honest, character design is all about using the body to describe personality—not the mind. In the end, it's a well-established way to communicate sex appeal quickly and efficiently, but it is not without its ethical baggage. And that's a matter of scruples that only you can decide for yourself.

Don't Forget Proportions

In the same way women tend to be drawn with toddlers' features to make them look younger, a character's body proportions will reflect his attitude. For example, a lanky man drawn with large hands and large feet will be seen as clumsy and unwieldy. These proportions are only a small exaggeration of the typical teenage boy. The awkwardness of this stage in life is transferred to the character through his proportions.

Playing with the Facial Features

Deviating from the standard features of the face can help define a character's personality. For example, a broken nose can hint that the face has been in a few battles. A thick forehead hanging over the eyes indicates roughness and a limited IQ. Thin lips can be a visual cue to a cold, dispassionate character. Oddly, big ears are not read as a sign of heightened perception, but rather as an indication of overall dopiness.

The Eyes

Eyes are often imbued with the intelligence of a character. Large eyes depict a sense of wonder and curiosity. Characters with large eyes look somewhat naïve. On the other hand, small eyes convey a sense of cunning and shrewdness. Characters with small, shifty eyes can often be somewhat dangerous.

Of course, in cartooning, there are several ways to draw the eyes. Cartoon eyes vary from balloonlike orbs to small dots on a face. Sometimes the "dot eye" is accompanied by a curved line that seems to indicate either the outer

edge of the eyeball or the eye socket. And, of course, don't forget the antiquated pupil-less ovals made popular by Little Orphan Annie.

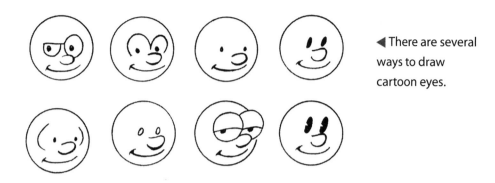

◀ There are several ways to draw cartoon eyes.

Before you decide on one way of drawing eyes over another, draw the eyes on a generic head. See how many emotions you can display without help from the other features such as the mouth or eyebrows. Choosing a limited style isn't necessarily "bad," but you will need to be aware of those limitations when drawing emotions through the character.

Did you know that a herbivore's eyes are spaced widely apart—usually on either side of its head—whereas a carnivore's eyes are close together, allowing it to focus on its prey? Distorting the spacing between your character's eyes can lend a similar air of passiveness or aggression.

Noses Galore

Surprisingly, the nose is almost as expressive as the eyes. A nose can be long and sharp, denoting a shrewd, calculating individual. A sharp nose is, after all, somewhat threatening and gives the face a somewhat unfriendly look. Alternately, a rounded, soft nose is more gentle and casual.

The length of the nose, too, can indicate something about your character's personality. A long nose on a face makes the face look more serious. It deepens any other serious features. Conversely, a short nose tends to give the face an air of innocence.

Chins and Jaw Lines

The chin is much like the nose. A long and pointed chin tends to be unfriendly. A short, rounded chin is much more gentle. Of course, a chiseled, blunt chin—with or without a cleft—belongs on an adventurous, handsome man.

The Dress Code

You need only a passing familiarity with cartoons to notice that 'toons rarely change their clothes. Day in and day out, Charlie Brown wears his zigzag T-shirt, Bart Simpson wears his red shirt and blue shorts, and Cathy wears a blouse with a heart on the front. And for characters like Beetle Bailey and Spider-Man, the outfit is an integral part of who they are. This is because a character's clothing plays an important part in expressing personality.

In Uniform

Uniforms aren't limited to occupational garb. Priests have "uniforms." So do pirates, Vikings, clowns, and vampires. A uniform is any combination of clothing that is immediately recognizable as a character type.

To get ideas on costuming, search the Web for stores that sell Halloween costumes. Halloween costumes tend to be simplified for an immediate effect—just like cartoons. For a more realistic approach, search books and Web sites devoted to theatrical or historical costuming.

It isn't even necessary for the entire uniform to be present. Put a cape on a person and she's a superhero. Put a horned helmet on a man and he's a Viking. Consider these partial costumes and the connotations they carry:

- Long, pointed hat: Wizard (or, less often, a dunce)
- Long, pointed hat with a wide brim: Witch

- Pocket protector: Nerd
- Long white lab coat: Doctor or scientist
- Crown: King or queen

Uniforms are very powerful because they immediately identify the character as belonging to a certain group. Furthermore, they carry an implication that the person wearing the uniform has the typical personality associated with people in that group. As a result, uniforms can be played against body type to create a unique character.

Just Clothes

But what if your characters are just normal people? Clothing doesn't have to be odd or unique to carry information about a character's personality. A character's choice in fashion is always a great way to express a facet of his inner self.

For example, a turtleneck can make the wearer look more studious. This is especially true if the shirt is not oversized like a floppy sweater. Add a tweed jacket with patches on the sleeves for a truly academic look.

For women, the hemline of a dress can migrate up or down according to her attitude. Long dresses tend to be worn by more serious characters. Shorter skirts imply a more frivolous disposition.

Sometimes the fit of the garment tells your audience something about the character. A loose-fitting flannel shirt will denote a casual, leisurely individual. A neat, well-tailored shirt or blouse describes a completely different person—one who is neat, tidy, and perhaps a bit formal.

The Hairstyle

An extension of the person's way of dressing is his or her hairstyle. Cartoonists should not treat hair as an afterthought—it can speak volumes about a character. Avoid a beginner's mistake of drawing your character bald, and consider other options.

Unfortunately, much of how your readers will react to your character's hair is rooted in attitudes from decades ago. For example, readers will not immediately identify a head as female if she has short hair. Conversely, a male with long hair is instantly perceived as a "hippie."

That's not to say that you shouldn't draw short-haired females or long-haired males. However, it's a fact you should be aware of as you're refining the design of your characters. Clearly, women can be drawn with closely cropped hair, but it would be wise to amplify some other female facial characteristics so new readers are not confused.

Hair is not limited to the top of the head. Facial hair, too, can convey attitude. A well-trimmed beard carries a look of sophistication. A goatee—once a sure giveaway for evil—now says "yuppie." There are dozens of styles of moustaches—each of which says something different about the wearer.

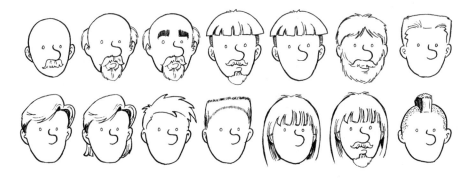

▲ Hairstyle and facial hair can help shape a character's personality.

Don't Forget the Props

Closely related to costuming are the props your characters may carry. A prop can give insight and added depth to your character's personality. An odd prop—a sock puppet, for example—can also take a fairly generic character and define him or her as unique.

Some of the most-used props are tobacco related. Put a calabash pipe in a man's mouth and you have shades of Sherlock Holmes. A cigar-wielding creature immediately comes off as a crusty curmudgeon. Cigarettes, too, add a shade of personality to their smoker—not only by their presence, but also in how they are held. Perhaps the most powerful props are eyeglasses. Immediately, glasses make the wearer look more intelligent. This is especially true of round, wire-rimmed frames with thick lenses. Glasses usually make the character more serious, more studious, and less physically threatening.

Some props are so powerful they remain part of the cartoonist's lexicon long after they've passed into history. Few doctors actually wear those headbands with the reflective metal disk in front . . . except in the comics. The same goes for Native Americans and feathered headdresses. Not all tribes wore them and some headdresses have serious religious significance. But, sadly, you'll rarely see a Native American cartoon character drawn otherwise. Other props are more subtle. Draw two generic characters. Draw a clipboard in the hand of one. Now, who takes orders from whom—and who has more information? The one with the clipboard is in charge.

ALERT!

Be careful when drawing glasses. If you draw the character's eyes—especially the aforementioned dot eyes—behind the lenses, there's a tendency to make the face look permanently surprised. If there are no eyes behind the lenses, the resulting face is often dispassionate.

Common Male Types

Cartooning has long been a field dominated by males—males drawing other males, in fact. It's futile to try to list all of the types of male characters that have appeared in cartoons, because there are too many. However, a quick discussion of the most popular types is useful in seeing how several different features combine to give an overall effect.

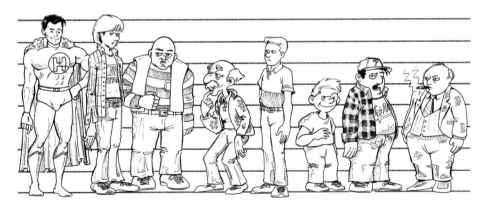

▲ Some common male types

The Hero

The hero type is, by far, the most popular male type in cartooning. He has a broad chest, attractive facial features, and a square jaw. Costuming can include a cape, a mask, boots, and for some reason shorts outside of pants.

The Slacker

Another celebrated male type is the slacker. In times past, these were called hippies and dropouts. In any case, they are often characterized by awkward proportions—either tall and gangly or short and heavy. These are typically young men with odd or unkempt hair and loose-fitting clothes.

The Heavy

This male type goes back as far as the hero. He is usually of better-than-average height and broad across the shoulders but not as physically fit as a hero and is often a little overweight. Almost always, he has no neck.

The Old Man

The old man is usually used as a source of humor. He is physically shrunk in stature—at or under the seven-head proportion found in most people. Bushy facial hair and exaggerated male-pattern baldness are the norm.

The Straight Man

Another popular sight, especially in newspaper comics, is the straight man. He is the everyman of the feature—the one we're supposed to identify closely with. His proportions fall short of heroic—especially his width. In terms of hair and costume, he's average in every way.

The Imp

The imp is a playful sprite who usually causes trouble for the hero or the straight man. Five heads tall or shorter, he personifies a puckish personality. His diminished size takes the threatening aspect out of the fact that he's a source of aggravation. Childlike features make him even less of a threat.

The Blowhard

This guy is a slob and a bit of a bully. He is almost always overweight. His head is connected directly to his shoulders; he is somewhat of a threat.

The Authority Figure

This man is the boss. He is older than the rest of the cast and usually heavier. Cigar smoking and male-pattern baldness are his common traits.

Common Female Types

Due to the history of male dominance in cartooning, the portrayal of women has been disturbingly limited. Thankfully, this is changing, with more and more female cartoonists adding their voices every year. But for now, there are about five recognizable female types. It's up to you to broaden this spectrum.

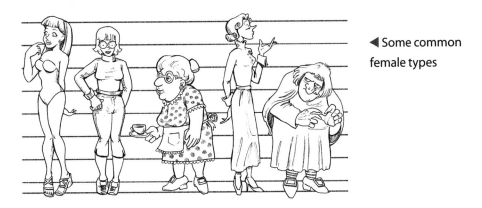

◄ Some common female types

Sex Kitten

This is, by far, the most common portrayal of women in cartooning. She is drawn to idealistic—if not heroic—proportions. The bustline and hips are amplified. Hair is long and luxurious. Clothing is usually based on current fashion, but always provocative.

Utility Woman

This is the antithesis to the sex kitten. She is not as attractive. She usually exists as a utility to the plot, either through her intelligence or some other talent. Her clothing is much more conservative.

Mother Figure

This older woman is often either very heavy or very slender. She is typically drawn at a four- to five-head proportion. Her hairstyle is about ten or more years out of date.

Socialite

This is usually an older woman. She is typically very svelte—to the point of being uncomfortably thin. Her hairstyle and clothing are conservative and her facial features are petite and narrow. This character type can also be modified very slightly to present a schoolmarm or a spinster character, but both of these are somewhat dated references.

The Hag

The hag is often very short and stout. Her facial features are grotesquely distorted—with blemishes such as warts and scars thrown in for good measure. With some slight modifications in costume, this type can also be modified to represent the type of witch seen on Halloween.

QUESTION?

What about child types?
Child types are even more limited than female types. Almost every cartoon child is a small version of an adult type. They think adult thoughts and share grown-up concerns.

Preparing a Character Sheet

Once you've created your character, design one master character sheet that you can reference as you work. This should include drawings of the character from the front, back, and both sides—add more angles, if you like. Include notes such as how tall the character would be in real life, key costume aspects, and a general personality summary.

You can use this sheet for reference as you work on your cartoons. It will keep your work consistent and help you visualize different scenes. If you have more than one character, it will help you keep the details of each one from getting confused.

Sometimes, cartoonists with multiple characters will draw all of them on one additional character sheet. They will line them up against a height key—like a police lineup. This will help them to draw each character at the correct height. It's much easier to use visual references such as "Bill comes up to Jane's shoulder" than to try to guess correctly every time.

Chapter 9

Once More, with Feeling

It's not enough for your character to say that he's happy—he has to be happy. And sometimes he has to be sad. As if that weren't enough, he will also have to be shy and confused and stunned and afraid. Getting the proportions and the shapes correct is only half of the battle. The other half is using your drawing to convey emotion. In the preceding chapter, you studied how individual features helped form an overall character. Now, consider the part individual facial features play in building an emotion.

Mouth It Out

Despite all the "window of the soul" talk, the eyes are not the primary indicators of expression. That distinction belongs to the mouth. The mouth determines the overall nature of the expression—pleased, displeased, or neutral. That expression can be refined by other facial features, but it cannot be overturned.

FACT

Some facial features are crucial to expressing emotion. They are referred to as primary emotional indicators. These include the mouth, eyes, and eyebrows. Other features have specific properties to refine expressions further. Since they're not necessary for the majority of emotions, they're referred to as secondary emotional indicators.

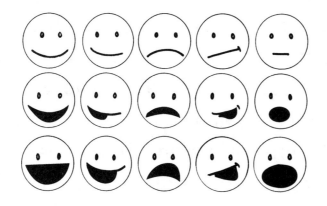

◀ The mouth is the overall indicator of emotion.

Smile or Frown

A mouth upturned at either end radiates pleasure. Any expression that's built around a smile will have that element of pleasure included. The higher the ends rise, the happier the expression. Even a mouth that's upturned at one end, a half smile, will have a small amount of contentment.

Conversely, a down-turned mouth generates displeasure. Some may assume a frown displays sadness, but displeasure is actually more accurate. A sarcastic look, for example, is built on a frown, but it's not exactly a sad

expression. Similarly, fright and anger are both based on a frowning mouth. A downturn at only one end of the mouth, a half frown, still generates displeasure—only not as much.

Slanted Mouth

As you might expect, a mouth that is slanted up or down across the face results in a mixed emotion. It's basically a frown and a smile at the same time—in perfect balance. Neither happy nor sad, this mouth position conveys a confused or quizzical state. This is not to be confused with the half smile or half frown, mentioned earlier.

Neutral Expressions

A mouth that neither turns up nor down at either side is said to be neutral. This kind of mouth will rely on surrounding facial features to show the small amount of emotion that can be produced on a neutral face. You will notice that a neutral mouth is so inconsequential in creating a cartoon expression that it is often left off the face entirely. In that regard, the mouth follows the "appear as needed" rule of secondary emotional indicators to be discussed later in this chapter.

Open Mouth

An open mouth amplifies the overall expression being formed by the mouth. Sad becomes loathing; happiness becomes joy. As the mouth opens wider, the amplification of the mood increases.

The shape of an open mouth can also help define the mood. A wide-open circular mouth is often used to convey surprise. Furthermore, a mouth can be open at one side to give a hushed tone to the dialogue. Used in conjunction with a half smile or half frown, this can be a very useful expression.

One method of exaggerating an open mouth is to draw the teeth as they curve around the inside of the jaw. If you can see a character's molars, she must really have her mouth open wide.

Expressive Eyes

The eyes act as an emotion intensifier. They can't change an expression from happy to sad, but they do help delineate the degrees between being pleased and being thrilled. Moreover, emotions range far beyond happy and sad—and the eyes can be the conduits for this transformation.

The direction of the eyes can also help shape the mood of the face. For example, eyes that look up can add a sense of detachment to the expression. This is useful when trying to express a look of innocence or nonchalance. Eyes that point down can signify shame or secretiveness. A mischievous schemer might have her eyes down as she hatches her plan.

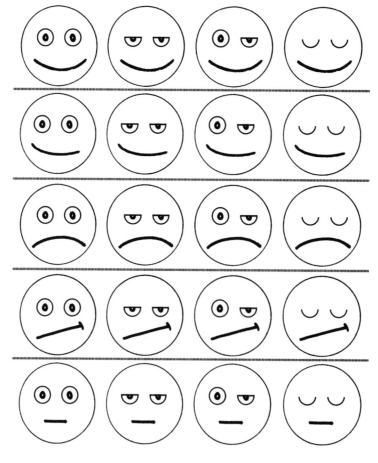

▲ Eyes modify the intensity of the emotion.

Wide Eyes

The eyes convey most of their emotion through their size. Large, circular, wide-open eyes lend a sense of excitement and urgency to the face. They have the effect of taking the general emotion on the face and adding a charge to it. Happy becomes ecstatic and sad becomes shocked or forlorn.

FACT

Dilated pupils—an effect of inebriation—are another example of how cartoon imagery has roots in human physiology. If the pupil is over-dilated, the character seems to have lost control of his emotion. Underdilated pupils can indicate shock or sickness. Uneven pupils signal confusion.

Half-Lidded Eyes

As the eyelid closes over the eye, the eye stops magnifying emotion and starts to diminish it. Small, squinty eyes have the opposite effect of wide eyes—they drain the energy from a facial expression. On a smiling face, squinting eyes can make a face less happy. An angry face turns into a brooding face when the eyes are partially closed. In each case, it's a muted form of the same emotion.

Uneven Eyes

"Uneven eyes" describe expressions in which the intensity of one eye does not match the intensity of the other. For example, one eye is wide open and the other is half-shut. Predictably, this adds a sense of confusion to the face. The sense of puzzlement grows in strength as the difference between the two eyes increases.

Closed Eyes

Closed eyes usually turn the emotion inward. The facial expression becomes directed at the person expressing the emotion. A smile becomes smug satisfaction when the eyes are closed; a frown becomes shame.

Raising Eyebrows

The mouth makes a face pleased or displeased and the eyes control the overall intensity of the expression. But this leaves an entire range of emotion, aggression, untouched. Although it would seem that eyebrows are directly linked to the eyes, they play a completely different role. The eyebrows regulate the amount of aggressiveness—or lack thereof—displayed on the face.

Interestingly, the closer the eyebrows are to the eyeballs, the more focused the overall emotion. When the eyebrows drift away from the eyes, the emotion loses focus and a neutral expression becomes quizzical or surprised.

Arched Down/Slanted Up Eyebrows

Eyebrows that slant downward toward the middle specify aggression. A formerly happy face grins with evil once the eyebrows arch. Similarly, a frown becomes an expression of anger.

Eyebrows that curve upward toward the middle of the forehead indicate the opposite of aggression. This feature makes the expression passive. This is useful for expressing an apologetic or helpless expression. If you'll notice, cartoon eyebrows can curve upward in two ways—as U shapes and as curved arches. Both modify the entire expression toward the passive, but the U-shaped brows seem to be more apologetic.

Straight Eyebrows

Eyebrows that form a straight line across the forehead are neutral. Sometimes the expression is so bland that two eyebrows merge into one. Paired with other neutral features, this helps to create a look of boredom. Eyebrows, like the mouth, tend to disappear when they're expressing a neutral emotion.

Uneven Eyebrows

Uneven eyebrows are usually an effect of uneven eyes. Therefore, they convey the same confused mood the eyes do. An arch in one of the eyebrows can add a touch of anger or puzzlement.

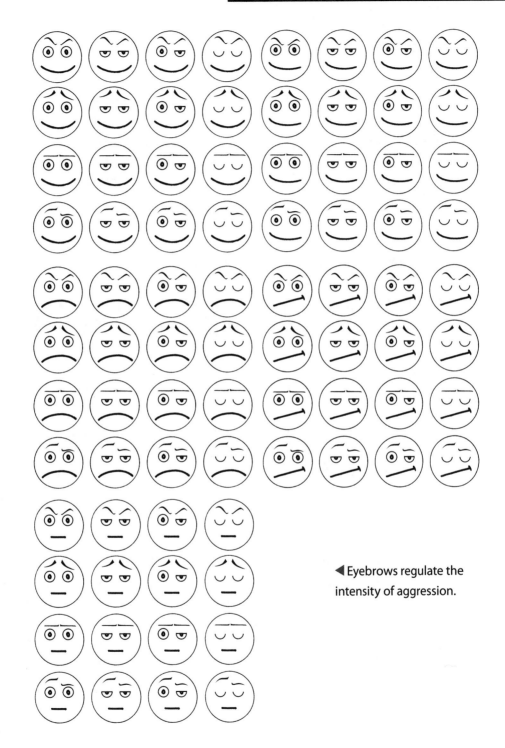

◀ Eyebrows regulate the intensity of aggression.

Secondary Emotional Indicators

The mouth, the eyes, and the eyebrows are primary indicators of mood. Respectively, they control the degree of pleasure, intensity, and aggression that come together to compose an expression. However, they cannot exclusively complete a full spectrum of facial expressions. Secondary emotional indicators are used to focus these expressions further until they communicate specific moods. The most frequently used secondary indicators are teeth, eye bags, and wrinkles.

Many facial features follow an "appear as needed" rule. When they're needed for an expression, they appear. Otherwise, they are not drawn. All secondary indicators fall into this category unless they are a specific part of the character design. As stated earlier, the mouth and eyebrows also follow this rule.

Showing Teeth

"Baring one's fangs" at someone is a sign of aggression that goes back to early mankind. Consequently, adding teeth to an expression can elicit a visceral response from your reader. Any expression that shows your character's teeth becomes intensified—more hard edged.

Eye Bags

Eye bags appear when the face is expressing illness or sleepiness. On a smiling face, they undermine the sincerity of the happiness being expressed. Crow's feet can often accompany eye bags. Of course, both of these features can also be used as part of the character design to indicate an elderly character. However, if you choose to go that route, be aware of the obvious effects it will have on all of the facial expressions your character forms.

Wrinkles

Cheek creases are the lines that form on either side of the mouth, extending from the sides of the nose to the sides of the mouth. These lines appear

only if the mouth is being stretched or shaped in a rigid fashion. Like eyebrows, the appearance of cheek creases intensifies an expression.

Forehead wrinkles appear when the character is worried or ill. They aren't necessarily straight. Most of the time, they follow the expression displayed by the eyebrows. However, they're not bound by physical law. They can become wavy or choppy, depending on the emotional demands of the face.

ALERT!

It's important to familiarize yourself with all of the facial features and how they help build an overall expression. However, it can be just as helpful to simply hang a mirror in your studio. This can be useful for illustrating complex emotions or ones that don't have a clear structure.

Societal Expressions

Learning the roles that different facial features play in forming a cohesive expression is valuable. However, to master a complete spectrum of expressions, you must consider the expressions that are given a specific meaning by society as a whole. A wink is a good example of this. A wink almost always makes the character seem flirtatious.

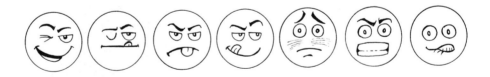

▲ A few common societal expressions

The tongue actually plays a part in three societal expressions. Stuck straight out, it denotes defiance. Curved upward on one side of the mouth, it can represent concentration. Curved upward and moving back and forth, a tongue signifies hunger.

Another societal expression involves blushing. The way our culture reacts to blushing has roots in human physiology. Blushing results from

increased blood flow to the head in a stressful situation. Usually this will be read as a reaction to an embarrassing or sexually charged situation. In a black-and-white cartoon, blushing can be suggested by light lines across the cheekbones.

Cartoon Expressions

In addition to expressions rooted in reality and societal expressions, a cartoonist also has an entire collection of expressions unique to cartooning itself. Seldom—if ever—seen in real life, these expressions are part of the lexicon of cartooning. Handed down by generations of cartoonists, these images are powerful indicators of specific feelings. These cartoon facial expressions—along with the symbolic shorthand to be discussed in Chapter 11—will give your character a complete range of emotion.

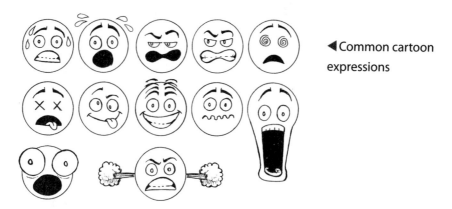

◀ Common cartoon expressions

Cartoon expressions, like societal ones, can differ from culture to culture. In American comics, fright or anxiety can be underscored by sweat running down a character's face in teardrop-shaped beads. As the degree of emotion rises, the beads of sweat have a tendency to get projected from the head. A very anxious character can be drawn with beads of sweat leaping off his head.

When the mouth is drawn in a shape that resembles a figure eight, the character is understood to be muttering. It's kind of a cartoonist's way of saying he's "talking out of both sides of his mouth." With the mouth opened wider and teeth showing, it becomes frustrated anger.

FACT

In Japanese comics (manga), artists employ a completely different set of visuals. For example, a bloody nose can indicate lustful thoughts. An anxious character doesn't sweat in beads—rather, one large bead forms at the side of his head. Sleep is represented with a bubble from the character's nose.

As you might have guessed, the eyes form the basis for many cartoon expressions. To portray a high degree of instability, the eyes can be drawn as concentric spirals. A character expressing surprise or fright might be drawn with his eyes projecting out of his head. If he is frightened to death, Xs might be drawn where his eyes had been. As you can tell, each of these expressions relies heavily on symbolism, not reality, to convey their message.

Body Language

Expressing mood isn't limited to facial features. Your character's posture and gesture will tell the reader as much about what's going on as the facial expression and dialogue. Don't get complacent and draw the figure in positions that are comfortable for you to draw. To exploit the full potential of your cartoon, you must make the body help convey the character's mood.

ALERT!

Take advantage of any opportunity to learn more about body language. Some colleges offer courses on the subject, and your bookstore will have several titles available on it. As you gain a deeper understanding of body language, you'll be able to pose your characters more constructively.

Much of your character's body language will come to you quite naturally. For example, shaking a fist sends a very clear message. So does turning one's back to another character who's speaking. Closed posture—such as crossed arms or hands on hips—tends to be negative. Open posture—such as hands outreached—tends to be positive. Many gestures involving

moving the hand to the face serve to draw attention to the face as an emotional medium—amplifying or diminishing the facial expression.

If you're having trouble finding the correct body language, try acting the scene out. Whenever possible, ask a friend to help. When two people role-play together, they start reacting to each other, resulting in totally unexpected gestures. Through role-playing the comic, you may find that your exercise goes beyond determining body position and becomes much more like choreography.

Feel free to exaggerate gestures—especially in action or superhero comics. Sometimes a gesture can diminish when it is drawn in two dimensions. Amplifying the gesture will compensate for this and keep your illustrations dramatic and exciting.

It's a good idea to jot down a simple one- or two-word description of a character's emotion as you're roughing in the images. Then, as you're firming up the illustration, you can concentrate on the details that communicate this emotion. As you improve, you'll find that you don't need to use as many word balloons—your characters' bodies are doing their fair share of the talking.

Using Props to Convey Emotion

A character's face, posture, or gesture isn't necessarily the only means for expressing emotion. There are ways to convey a character's mood that go beyond her body. How a character relates to her surroundings will also tell the reader volumes about how that character is feeling.

The classic example of this is a character that whips his glasses off his face as he is yelling. This is very seldom seen in real life, but it is regularly used in cartoons and movies. The resulting effect is one of urgency and alarm. Oddly, a pensive character may remove those same glasses and chew on the earpiece in quiet reflection.

Props can subtly alter a character's emotion, adding a degree of depth to the circumstances. For example, hands that act separately from the character's words and actions indicate a mind that is busy on other matters.

A villain may fidget with a chess piece as he plans his strategy against the hero. Or he might stroke a satisfied pet. Of the two, the loving pet owner stands to be the more complex character.

Reviewing Common Mistakes

Many beginning cartoonists—and too many intermediate practitioners—tend to limit the emotional spectrum of their characters. Some find themselves concentrating so much on the mechanics and proportions of drawing that they disregard emotion. Still others fall into the habit of drawing the same figures the same way, assembly-line style. In either case, the biggest mistake in drawing emotion is failing to draw it in the first place.

Another mistake is rooted in character design. Often a character is designed with huge eyes that, even when half-lidded, tend to communicate shock and surprise. If you find yourself stretching the skull vertically to support the massive eyes you've designed, you may want to consider drawing the eyes smaller. It's like having a stereo that has two settings: loud and louder. You need to consider your character's quiet time, too.

Try to extend your emotional vocabulary by one expression a day. In your sketchbook, try to draw one face expressing an emotion you pick at random from a dictionary. Or try to draw an expression for each letter of the alphabet, once a day. Again, draw the face only. It will broaden your experience and help you to keep emotions in mind as you draw.

A third mistake is overusing a certain gesture or facial expression. For example, many manga-influenced comics have a tendency to overuse the wink. In American comics, it's the index finger sticking straight up to make a point. Both are very useful in expressing emotion. However, they can lose their potency if repeated over and over again.

Chapter 10

In Perspective

All cartoonists work in a two-dimensional medium (paper) and have to fool the reader's eye into seeing a three-dimensional scene. This requires several tricks that fall under the heading of perspective. Using perspective, cartoonists can draw believable scenes. Without perspective, flat people and flat objects float around a room unanchored. Learning a few simple rules can help you master this technique.

Understanding Perspective

Look at the illustration of the soda cans. You'll notice several cans drawn one above another. In the middle is a line, known as the horizon line. This illustrates one of the two basic principles of perspective.

As an object moves vertically, its relation to the horizon line determines how it is drawn. The horizon line can also be thought of as the viewer's eye level. As the cans rise above the eye level, the viewer sees the bottoms of the cans. As the cans sink below eye level, the viewer sees the tops. As the center of the can lines up with the eye level, the viewer sees neither.

The other basic principle of perspective describes an object as it moves farther and farther away from the viewer. This is best exemplified by railroad tracks. If you've ever looked down a length of railroad track, you know that the two rails are clearly separated, and yet it looks as if they meet on the horizon. When drawn in proper perspective, objects get smaller and recede to a common point, called the vanishing point.

Much of the perspective you will learn in this chapter will feel very much like geometry. You will be drawing several lines that have no purpose except to help you position objects in your drawing correctly. However, you can indicate perspective in your illustrations without ever grabbing a ruler. The following rules of perspective are very useful for simple scenes:

- When two objects overlap, the one in front is closer.
- Shading an object will make it recede farther than a nonshaded object.
- Drawing an object smaller and with fewer details will make it seem to be farther away. A larger, more detailed object will seem closer.
- As objects move away, they also move up (vertically) on the page. As objects get closer, they are drawn farther down on the page.

Simple perspective is achieved mainly through composition and the execution of line work. Sometimes the principle of altering shading is applied to the lines—with the same effect. For simple drawings, artistic perspective is sufficient.

◀ As the cans rise above the horizon line, you can see their bottoms. Below the horizon line, you see their tops. In the middle you see neither.

▲ Four examples of artistic perspective

Linear Perspective

The first step in drawing a scene in linear perspective is to establish a horizon line. As mentioned earlier, this is assumed to be the reader's eye level. If you start out with a high horizon line, the scene will look as if the viewer were flying overhead. A low horizon line will result in a scene in which the scenery and characters tower over the reader.

FACT

The concepts of linear perspective were originated by Filippo Brunelleschi. He was a Renaissance architect and engineer who lived in the fifteenth century. The rules you will learn in this chapter come directly from his work—done well over 500 years ago.

All perspective lines will be drawn to some point on the horizon line—a vanishing point. Scenes typically have between one and three major vanishing points. However, depending on the scene, you may be establishing several other points—reference points—to help you draw other objects to their proper perspective.

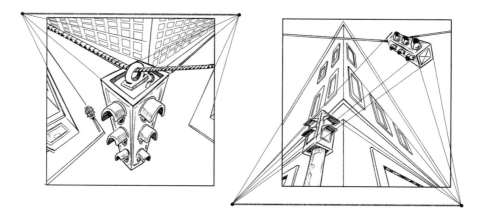

▲ Raising the horizon line (indicated by the heavy dotted line) raises the viewer's eye level. Lowering the horizon line lowers the viewer's eye level.

One-Point Perspective

This is the easiest composition to arrange in linear perspective. All of the perspective lines converge on one vanishing point on the horizon line. You can use one-point perspective when you illustrate looking down railroad tracks or straight down an elevator shaft.

◀ In one-point perspective, all lines converge on one vanishing point.

One-point perspective is very simple, but it's also powerful—it guides the eye directly to the vanishing point. When used correctly, as in the example of the elevator shaft, it can give the reader a sense of falling down the

shaft along with your hapless heroes. However, if the composition of the drawing doesn't have something of importance located there, the illustration will feel awkward.

Two-Point Perspective

Two-point perspective is based on two vanishing points—each at opposite ends of the horizon line. This results in a much more natural-looking scene. The vertical lines do not go to a vanishing point—they remain perpendicular to the horizon line. One way to achieve the illusion of proximity is to put the vanishing points close together. The farther apart the vanishing points, the more you can make the objects in the back recede.

▲ In two-point perspective, lines converge on one of two vanishing points and vertical lines stay vertical.

Three-Point Perspective

Two-point perspective becomes three-point perspective when you establish a vanishing point for vertical lines. In three-point perspective, the formerly vertical lines converge on a point high in the sky or far below on the ground. There's no rule for placing this third point, but the higher or lower you place it, the more striking the perspective.

▲ In a three-point perspective, nonvertical lines converge on one of two vanishing points while the vertical lines vanish toward a third point, off the horizon line.

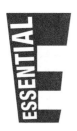

To draw some scenes—especially landscapes—realistically in two- and three-point perspective, the vanishing points on the horizon line need to be far apart. In some cases, this means placing the points off your paper. In these cases, draw a dot on two small pieces of masking tape. Position your T-square at the horizon line and position the dots accordingly.

Adding a Reference Point

Linear perspective is an excellent way to draw a scene in which all of the items are angled in such a way that they line up with their respective vanishing points. However, things get slightly more difficult when one of those items is angled differently than the others. Look at the two drawings of a living room. In the upper example, the scene is drawn at two-point

perspective. All of the furniture is drawn squarely against a wall. Everything fits nicely in two-point perspective.

But what happens when we decide to angle some of the furniture for a more natural composition (as in the second illustration)? Now, some of the furniture is based on lines that don't connect with one of the two vanishing points. In this case, reference points are established on the horizon lines for these "renegade" objects.

▲ Adding reference points makes the scene more natural.

Deciding where to place the reference points takes a little more confidence. It's helpful to rough in the footprint of the furniture first, based on your best guess of the proper perspective. Draw lines out from the footprint to the horizon lines to place your reference point for the item. Then, use these reference points to draw the entire object.

Often, beginners will draw entire scenes in which all of the objects line up with the primary vanishing points. Challenge yourself to draw at least one object in every scene that is referenced from different points on the horizon line.

Isometric Perspective

Isometric perspective is a bit of a misnomer, since it isn't really "perspective" at all. In isometric perspective, none of the lines recede to a vanishing point, and the eye level is fixed. However, it's a quick and easy way to create a believable scene.

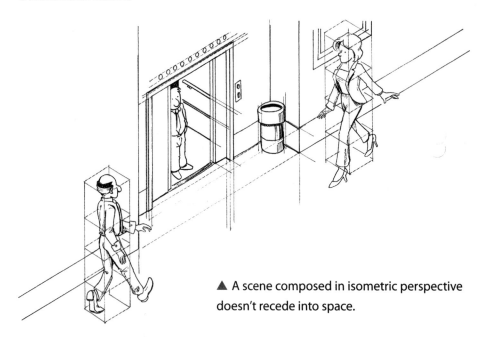

▲ A scene composed in isometric perspective doesn't recede into space.

In isometric perspective all of the lines that would usually recede are simply parallel to one another. Lines that would recede to a left-hand vanishing point are parallel—as are the ones that would normally recede to the right. Vertical lines remain vertical.

Of course, the drawback to drawing in this way is that all of your scenes will tend to look static. The reader's viewpoint will never change. Each scene will look like the one before it—resulting in predictable, boring storytelling.

Isometric perspective is often used by cartoonists who draw on their computers. If they are able to maintain the same angles in their perspective, they will be able to reuse objects continuously. They simply keep a library of objects and cut and paste them into new scenes.

Drawing Complex Shapes

Linear perspective is very easy if all of the objects in your scene are squares and rectangles. But drawing complex shapes tends to be more intimidating. That is, it's intimidating until you realize that most shapes can be found within a rectangle of some sort.

A circle will fit inside a perfect square. An oval will fit inside a rectangle. A triangle can easily be found inside a rectangle once you know where the center of the rectangle is. Look at the illustration of ants at a picnic for examples of each of these.

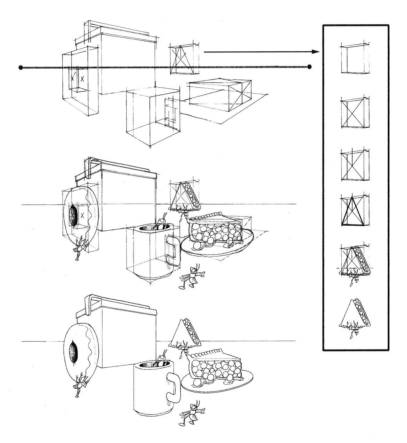

▲ Many geometric shapes can be found within a rectangle. This is especially easy if you remember to find the center of the rectangle by drawing lines that connect opposite corners inside the rectangle (as seen in the detail on the right side of the illustration).

Therefore, it's a good idea to try to use rectangles—drawn in perspective—to establish the general proportions of the object you're drawing. These rectangles can be turned into three-dimensional boxes to help you get the correct depth. Connecting the shapes by drawing lines to the vanishing points will result in nonrectangle geometric shapes, drawn in perfect perspective.

Your Characters in Perspective

Linear perspective has more applications than drawing backgrounds. In fact, the same principles that helped you create a believable space will help you place people to inhabit that space. If you've executed the perspective correctly, the people will occupy their space in such a way that the entire composition will be pleasing.

Placing the Master Figure

Once again, the first step is a leap of faith. You must draw one person who is properly proportioned and occupies the correct space. All of the other figures in the illustration will be guided off this one "master" figure.

The key dimension to hit with your master figure is the height. After you establish the height, you can divide it into quarters (or thirds, depending on the gender). All of the other people in the space will guide off this figure for their correct proportion.

Sometimes it helps to draw a master figure directly next to something in the illustration that helps you to properly gauge the figure's correct height. In a room, this might be a door, a chair, or a window. Outside, it might be a car, a mailbox, or a building.

ALERT!

You don't have to necessarily draw the master figure into your final illustration. He could simply be a figure that is conveniently placed to help you establish proper perspective. When you ink the drawing, he will disappear like a helpful ghost.

Placing Other Figures

As you recall from Chapter 7, the human body can be roughed in along a line that is divided into either quarters or thirds. These divisions help you to position key parts of the body correctly, guiding you toward drawing the body in proper proportion. Your master figure has been built from these divisions.

To place another person in the scene at the correct perspective, simply decide where his feet will be and mark that spot with a dot. Draw a line from the master's feet, through this dot, to the horizon line, thereby creating a new reference point. Draw a second line from the reference point, back to the top of the master figure's height. Drawing a vertical line from the dot to this second line will establish the new figure's height. Divide the height according to the figure's perspective (or draw lines from the master figure's divisions to the reference point, passing through the new figure) and draw the figure to the correct proportions.

Once you have more than one figure in the illustration, you can use any of them as a master for additional figures. Placing the dot above a master figure's feet will place the new figure farther away than the master, and vice versa. Each figure will have its own reference point, and each figure will have to relate to the others in terms of its proportions. This holds true even if one is standing on the ground, another is on a ladder, and another is peeking out of a manhole.

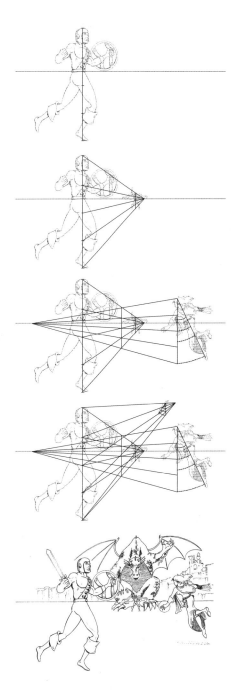

▲ Use the master figure to find the right proportions for any new figure.

Hanging Figures on the Horizon Line

A quick way to check your accuracy is to see if all of the figures "hang on the horizon line." In other words, if all of the figures are about the same height, the horizon line will intersect them in the same area of their body—no matter where they're standing—as long as they're all in similar poses, such as standing or sitting.

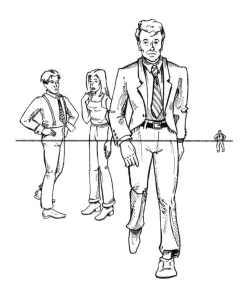

◄ The horizon line should hit the characters in the same place, no matter where they're standing.

ALERT!

As you're checking to see if your figures hang on the horizon line correctly, remember women are generally drawn shorter than men, so they will hang on the horizon at a slightly lower level than the men.

Foreshortening

Employing techniques such as using a master figure and hanging the figures on the horizon line is crucial to good illustration. However, cartooning deals with subject matter that goes far beyond people standing in the living room. Superheroes, for example, are constantly dashing directly at the viewer at angles that are difficult to account for with a standing master figure. These poses require a good working knowledge of foreshortening.

The Linear Perspective Aspect

The process for drawing foreshortened figures is quite similar to drawing in perspective. First, start with a line indicating the character's height, remembering that, due to foreshortening, this line will be shorter than the character's normal height. Across the front of the line, draw a perpendicular line indicating the width of the shoulders. Now draw lines from the ends of this shoulder-width line to the horizon line. At the bottom of the height line, draw a perpendicular line connecting the lines that reach the horizon.

Now you have a rectangle that represents the general area your character exists in. Dividing it into quarters is simple: Draw an *X* from the corners of the rectangle to find the middle, and then draw an *X* in each of the resulting rectangles to find quarters. If you feel it would help, make the rectangle into a three-dimensional box, using the same reference point. Now that you have the guides for your figure, you should be able to rough in the character—according to the correct perspective.

Drawing a woman in the same foreshortened perspective is slightly more difficult (see the following page). There is no simple geometric trick to play, as you did with the *X*s—you'll have to eyeball it. You can't measure it with a ruler because the object is receding into space and, therefore, the thirds will not be equal measurements on the page. The closest third will be the longest segment of the line, the next one slightly shorter, and the next one slightly shorter yet.

The Artistic Perspective Aspect

Linear perspective is very useful in helping to draw the body in such a way that it occupies the correct space in a setting. However, in matters of dramatic perspective, a cartoonist will allow herself to be guided by artistic perspective. In particular, you will be exploiting the rule that states that objects get larger as they get closer.

In the following illustration of the woman hanging off the ledge, you'll notice that linear perspective was used to find the rough proportion of the arm. However, the hand was drawn using artistic perspective and the artist's best judgment. A dramatic perspective such as this cannot be drawn by the timid. Force yourself to exaggerate the closest body part a couple of degrees more than you're comfortable with. You'll be very pleased with the results.

Perspective tends to intimidate beginning cartoonists—especially if they did poorly in geometry class. However, if you stick with it and try to incorporate it into your daily drawings, you'll find that it comes quite naturally. And it's important. Although the reader may not be able to articulate a perspective error in a cartoon, she will respond to the awkwardness of the drawing immediately. A little bit of extra planning will make your illustrations jump with life and believability.

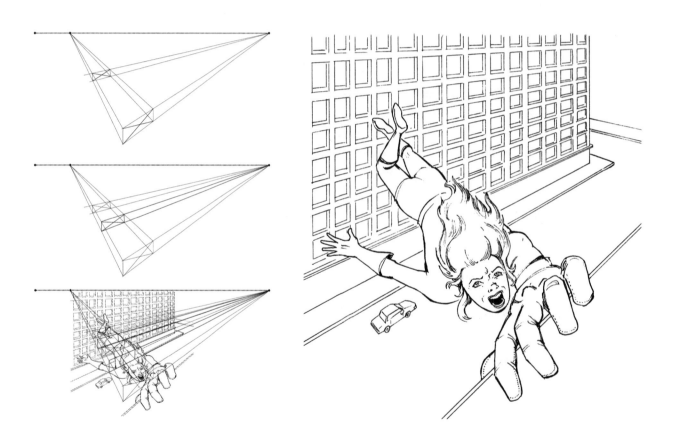

▲ Drawing a figure in perspective

Chapter 11

'Toon Shorthand

Cartoonists through the years have developed a symbolic language that has been handed down through the years. These symbols represent motion, ideas, sounds, and other concepts that are difficult to depict visually. They are easily assimilated by the artist and readily understood by the reader. Along with drawing and writing, they round out a cartoonist's arsenal of narrative tools. And with new symbols constantly added to the cartoon vocabulary every day, the storytelling possibilities are infinite.

Word Balloons

Word balloons are, by far, the most recognized form of cartoon shorthand. In fact, they're practically definitive of the art form as a whole. Draw a word balloon—a simple object consisting of a spherical shape that encloses the text and has a tail pointing to the speaker—and most people will instantly associate it with cartooning.

Like sound effects, word balloons can be designed to help express the voice of the speaker. A jagged shape is often used to represent a digitized voice—such as one transmitted over radio or television. Word balloons can be drawn soggy to represent drowsy speech or icicles can hang from them to represent a cold attitude. The ratio of word balloon to text can also indicate sound. For example, a huge word balloon with one small word inside can depict awe.

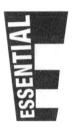

Your word balloon should reflect your drawing style. A perfectly shaped, geometric word balloon would not go very well with a comic strip like *Peanuts,* and a hand-drawn balloon would not fit a sleek science-fiction comic book. Experiment to see which works best with your work.

Some word balloons have become adapted for specific uses. For example, the thought balloon is a kind of word balloon that depicts a character's thoughts. It is usually drawn as a cloud with bubbles taking the place of the usual word balloon tail. Other specialized word balloons are the whisper balloon (a word balloon drawn with a dotted line) and the shout balloon (a word balloon drawn with uneven, jagged, or hard-edged lines).

The Tail

The tail of the balloon should point toward the speaker's head or mouth whenever possible—never to an odd part of the body. Moreover, the tails from two word balloons should never cross. A tail should be a clear, direct conduit from the words to the speaker.

The tail can be adapted to help describe sound and voice. For example, a pointy, lightning-bolt shape can indicate an excited speaker—or in some cases, a mechanical one, such as a robot or recording. A wavy, droopy tail denotes a weak voice. A tail that ends in a starburst instead of a point can indicate a voice that comes from behind another object—such as someone speaking from behind a door.

◀ Word balloons can be drawn in a way that underscores the emotion behind the words.

Open and Closed Balloons

There are as many ways of drawing a word balloon as there are artists drawing them. In general, though, there are two basic types: open and closed. The closed kind consists of a shape containing text and a tail extending from that shape. The open word balloon features text floating above the speaker with a line pointing from the text to the speaker.

Closed word balloons are a little easier to use than open ones, because they completely separate the dialogue between two speakers in the same panel, so there's never any confusion. Open balloons require the artist to plan for plenty of space between the text of two or more characters—lest the different texts merge into one.

Another advantage of closed word balloons over open ones is that you have greater control over pacing. You can break a character's speech into two balloons, indicating a pause or a change in thought. This has the same effect as a comma does in a sentence. The two balloons can be connected by a modified tail, or in some cases, the two balloons can partially merge into one another. If two balloons are connected by a modified tail, it is possible

to insert another character's word balloon over the connecting tail without causing confusion.

▲ Using word balloons to indicate a pause

◀ Compare the open balloon (on the left) and the closed one (on the right).

Creating Digital Word Balloons

To create uniform, geometric word balloons in Photoshop, you can use this handy system:

1. Change the setting of the text layer from Normal to Darken.
2. Create a new layer behind the layer that has text on it.
3. Using the Oval Marquee tool, draw an oval that completely encircles the text.
4. Using the Polygon Lasso Tool and holding down the Shift key, draw a tail pointing to the speaker.
5. Fill the selection with black.
6. Go to Select in the menu bar, go to Modify, then Contract.
7. Choose six pixels and OK the dialogue box.
8. Fill with white.

You can adjust step 7, experimenting with larger or smaller numbers, to get word balloons with thicker or thinner lines.

Narration Balloons

Narration is kind of a word box for a disembodied guide to the comic. Unlike dialogue balloons, it is almost always drawn as a rectangle with no tail. It contains background information to help the reader understand the comic.

Narration boxes are predominantly used in comic books, but they can also appear in other types of cartoons. Use narration boxes sparingly in a comic strip or panel, though, unless they are absolutely necessary for the reader to comprehend the action.

Sound Effects

Animation aside, cartoons are a silent medium. Nevertheless, you can use cartoon sound effects to create an illusion of sound and thereby to enhance the aural experience for the readers—if only in their imagination.

Onomatopoeia

Onomatopoeia is a classification of words that are pronounced like the sound they represent. For example, "buzz," "hiss," and "crackle" are onomatopoeic words. These words are valuable in describing sounds in your cartoon.

You should not let yourself be limited to the words you can find in the dictionary when writing your sound effects. Use your imagination. Instead of "pow," for example, try "Kerrr-BANG!" Say the word out loud and see if it elicits the desired response.

Pay attention to the manner in which sounds form words. You'll find that vowels and consonants have personalities as distinct as words themselves:

- Short *u:* Watery sounds such as "splush," "glub," "ker-plunk"
- Short *i:* Crisp sounds such as "sizzle," "hiss," and "pssst"
- *Oi:* Bouncy sounds such as "boing" and "sproing"

- Short *a:* Sharp sounds such as "whap," "tap," and "rat-a-tat"
- *S* and *sh:* Quickly moving air in words like "shhhhhh," "hiss," and "whoosh"

Creative Lettering

Another way to make the sound come alive in your cartoons is to use the appropriate lettering. Stylized lettering can help describe the sound as much as the words can. Combined with a well-thought-out onomatopoeic word, your reader will clearly hear the sound in his imagination.

ALERT!

If you are using a computer font to letter your comic, you can also buy specialized sound effect fonts. Both Comicraft (✎*www.comiccraft.com*) and Blambot (✎*www.blambot.com*) offer some terrific fonts to choose from.

There are many ways to make the lettering reflect the sound, but the best ways are the direct ones. Wet sound effects, such as "Ker-Sploosh" could be lettered in a loose, dripping wave of letters. A hot "sizzle" could be created with sharp, edgy letters with flames dancing around them. Finally, a loud "BLAM" could be lettered in a large, exploding style that underscores the sound both in size and expressiveness.

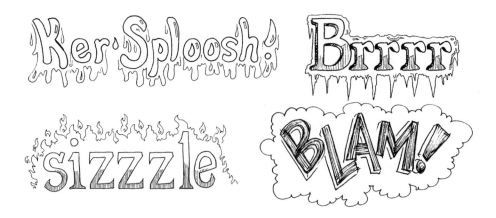

▲ Sound effects rendered with creative lettering

Volume Controls

You can vary the volume of the sound effect by controlling the size and style of the lettering. A large font, in all capital letters, will "sound" louder than a smaller sound effect that is written in upper- and lowercase letters. You can also spend a little extra time on stylizing the font to make it more expressive. This might take the form of shading the letters or adding decoration around the word.

You'll notice that punctuation marks are seldom used in sound effects. After all, if you've taken the time to design expressive lettering that personifies a sound effect, adding an exclamation mark is somewhat bland in comparison. Punctuation tends to lose its potency next to a well-designed sound effect.

Correct spelling is important in all aspects of cartooning—except sound effects. If you feel the need to draw out the sound of part of a word by adding letters, don't feel bound by the dictionary. Let your imagination take control.

Showing Action

Cartoons would be very static if cartoonists didn't have a way of indicating action. This includes showing simple motion, back-and-forth movement, a double take, and impact explosions.

Motion Lines

Motion lines serve their purpose in a deceptively simple way. A line is drawn from where an object was, follows the path the object traveled, and ends at the place where the object is.

Motion lines have a tendency to gain a life of their own. Although they don't represent an object that occupies physical space, they can be opaque or translucent. Furthermore, they can indicate rate of speed in the way that they're drawn. Heavy, confident motion lines suggest swift movement. Lilting, wavy motion lines translate as floating, fluttering motion.

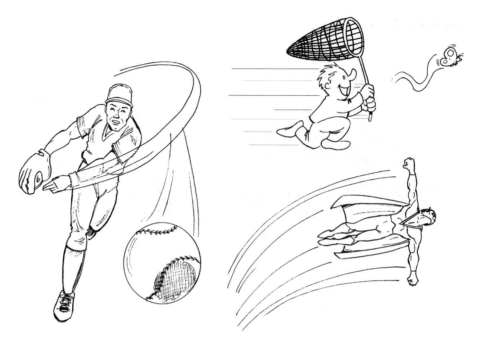

▲ Motion lines indicate movement and speed of motion.

Quiver Lines

Quiver lines are motion lines that stick closer to the outline of the shape. They don't indicate a motion from one point to another—rather, they imply back-and-forth movement. For example, quiver lines might be drawn around a character who is shivering in the cold or quaking with fright. Several quiver lines bunched around an object make the object seem to vibrate. A few loose quiver lines indicate more casual motion. Quiver lines can be combined with motion lines to add detail to the motion being portrayed.

FACT

In American comics, the motion lines follow an object from where it was to where it is, and sometimes that object is drawn blurry to show swift movement. In Japanese manga, the background becomes blurred to indicate motion. In a sense, the background comprises motion lines while the moving object remains in sharp focus.

Since quiver lines are more closely associated with a body part or small object, they can mimic that item's shape. For example, quiver lines around a hand can be drawn in a partial hand shape. This is especially useful to indicate a rotation of the body part/object as it is in motion. Further, a quiver line might mimic the shape of one part of the entire object. This enables a character to shake an angry finger at another, instead of looking as if she's moving her entire hand.

▲ Quiver lines can indicate more precise back-and-forth motion.

A Double Take

Motion lines and quiver lines can be paired with a unique piece of cartoon lexicon to produce an effect known as a "double take." A double take occurs when a character swings his head back and forth in amazement. This produces a particularly humorous effect with a lot of energy.

The character is drawn with two heads—each looking in a different direction. The motion lines indicate a swiveling path around the neck, and quiver lines radiate around the head. The character can be made to look as if he's done a single head swing by limiting the motion lines to one side of the head.

DID YOU SEE HANK'S NEW HAIRPIECE?

WELL, I HEARD IT WAS CHEAP, SO I CAN ONLY IMAGINE...

HI, FELLAS!

◀ A double take is indicated by two heads, motion lines, and quiver lines.

Impact Explosions

In comics, one object striking another is represented by a jagged shape that radiates around the point of impact. Impact explosions can illustrate sharp contact or they can be paired with sound effects to enhance the effect of the collision. The impact explosion is not necessarily placed next to an object that has been struck. It could, for example, remain floating in air where the object was before it was struck. In the case of two characters fighting—with one swinging his fist and the other propelled backward by the blow—the impact explosion might hang in the air at the place where the fist struck the jaw, even though both body parts have moved to different areas in the illustration.

SMAK!

◀ The impact explosion is linked to the area of contact, rather than to the object that has been struck.

Symbolic Shorthand

There are hundreds of cartoon symbols that have come to represent specific concepts. And each of these can be redesigned to represent new ideas. If symbols such as motion lines and impact explosions compose a cartoon's vocabulary, the following are cartooning clichés. And unlike their written counterpoints, these symbols should be embraced, enhanced, and employed.

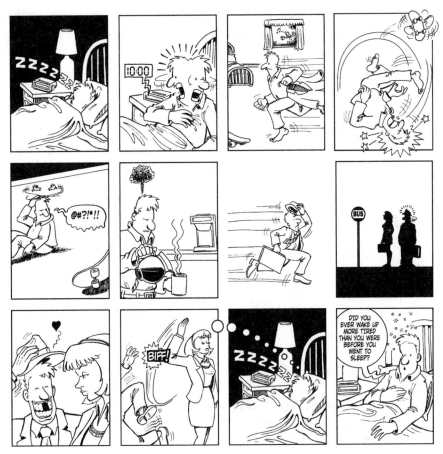

▲ Cartoon shorthand symbols facilitate the story being told.

Orbiting Birds

Birds circling the head of a character indicate the character is dazed. Over the years, this symbolic representation has been modified to replace

the birds with stars or planets. Today, just about any strange objects orbiting a character's head will signify that the character has been stunned.

Smoke from Ears

Smoke pouring out of a character's ears symbolizes furious anger. Often motion lines are used to show the smoke blowing out forcefully and gathering in clouds on either side of his head. Similarly, a character can be shown to be in a foul mood if the cloud of black smoke is shown gathering above his head, with only a wispy tail of smoke pointing to the top of his head.

Pain Stars

Injury can be represented with a star floating above the wounded area. The greater the pain, the more stars hover over the wound. Sometimes a short line floats between the star and the hurt body part to further identify the pain. Pain stars can also be emitted from an "impact explosion," denoting a painful impact.

Love Heart

On the opposite end of the spectrum from the pain star is the love heart. A heart shape hovers above the head of a love-struck figure. As with the pain star, sometimes a line will be drawn to the character, and the number of hearts increases with the character's ardor. If the heart is torn in half or ripped, the character is, obviously, brokenhearted.

Drunk Bubbles

Drunk bubbles were originally created to depict an inebriated character. They float and pop around his drunken head. Over the years, mainstream cartoons have reacted to alcoholism less as a source of humor and more as a cause for pity. In effect, this symbol has been expanded to include not only drunkenness, but confusion and bewilderment as well.

Shock Lines

Lines that radiate outward from around a character's head, called shock lines, indicate extreme surprise or stress. These lines can be straight or wavy, depending on the nature of the emotion. Usually, shock lines come from the head area, but in some cases, they surround the entire body—as if the person as a whole were in shock.

Floating Zs

A group of Zs floating over a character's head indicates sleep. The Zs can take on a life of their own, drifting around the room as the character dozes. Sometimes a small illustration of a saw cutting a log will be added for the extra sound effect of snoring.

Smell Lines and Smoke Lines

Wavy lines that waft upward from an object can indicate either smoke or a foul odor. In this case, the reader makes the distinction based on the object the wavy lines appear over. To further ensure that the lines indicate smelly instead of smoky, sometimes the cartoonist adds hovering flies to complete the visual.

Swearing

This is perhaps the best-loved symbolic shorthand in cartooning—indicating foul language through symbols. There are no rules, but generally, typographic symbols (@, #, !, ?) are used liberally. In building a good symbolic swear word, it's important to balance the kinds of symbols you choose. For example, @#&!?! is much preferred over !?!!@#!!. The punctuation should never come at the beginning—even in this nonsense grouping. Also, avoid having more punctuation marks than typographic marks such as @ and &.

ALERT!

Cartoonists sometimes try to indicate actual foul language in their cartoon profanity. It's not difficult: @ can read as *A*, $ can read as *S*, and so forth. The idea is to use fake swearing for the prudes while maintaining actual swearing. However, when your readers decipher it, you risk alienating some of them.

The wonderful thing about cartooning's symbolic shorthand is that it is very much a living language. New symbols are constantly being created, and old ones are being rethought and repurposed. A mastery over basic cartoon symbolism can help you develop your own version of the language—your own dialect. And just as a speaker's accent can add depth and meaning to her words, your personalized handling of the cartoon lexicon will make your work unique and distinctive.

Chapter 12

Making a Scene

Composition is the process of deciding how to position the elements of your cartoon for maximum effect. If competent illustration and the skillful use of cartoon symbolism make up the language of cartooning, then composition can be thought of as grammar. A poorly composed cartoon is like a poorly written sentence: The words may be perfect, but the meaning will be lost. Luckily, composition is not as complicated as grammar. The understanding of a few general concepts will equip you to make good design decisions in your cartooning.

How a Reader Reads

The basic purpose of composition is to direct the reader's eyes across your cartoon in the path you want them to follow. In order to do this, you need to understand how the reader's eye is going to move naturally. Once you understand this, you can learn ways to direct it. Once you master directing your reader's eye, an entire world of possibilities is available to your storytelling—both dramatic and comedic.

Eye Motion

Readers read cartoons in the same way they read text. Readers of American cartoons read from left to right and from top to bottom. Cultures that approach reading in different patterns will approach a cartoon based on their cultural bias. Unless you're designing cartoons for a publication marketed at one of those cultures, you'll want to concentrate on readers who follow English-language reading patterns.

FACT

Japanese is often written right to left—opposite from English; Arabic and Hebrew are always written right to left. Therefore, comics that are designed for people who read those languages (such as Japanese manga) will adapt their design to reflect the eye movement of the reader.

The urge to read left to right is greater than the urge to read top to bottom. For example, if there are two word balloons in a panel, one in the lower-left corner and one in the upper-right corner, the reader will read the one in the lower left first, then move upward to the next one. If your punch line is in the lower left, your joke won't make sense.

Text over Image

All things being equal, a reader will notice the text before looking at images. You'll notice that single-panel cartoons generally appear with the caption printed under the cartoon. That's because the caption often adds a humorous spin to the image, either revealing a surprise in the image or

explaining the image in an offbeat way. If you read the caption and then look at the illustration, the element of surprise will be drained away. Generally, a reader reads a single-panel cartoon by looking at the illustration, reading the caption, then looking at the illustration again.

▲ In the third panel, the punch line on the left catches the eye before the setup in the upper-right corner—resulting in a confusing dialogue.

High Contrast

The reader's eye will be drawn to any areas of high contrast. Black against white is the most powerful means of attracting and holding a reader's eye. Unfortunately, it's also the most misused element of composition. Many beginning cartoonists add areas of black indiscriminately. This can direct the reader's eye away from the important parts of your illustration.

◀ A high-contrast area used well (on the left) and poorly (on the right)

Pointing the Way

Did you know you can simply point to where you want the reader to look next? You can do this overtly, with a character's extended arm or leg literally leading the eye to the next compositional element. Or you can use

a more subtle gesture that doesn't involve the use of a finger. A character's entire body can act as a pointer, especially if it's bent or twisted in the direction you want to lead your reader.

FACT

You can learn something about composition from Federal Express. Next time you look at the FedEx logo, ask yourself why it seems to have a sense of motion to it. Unlike the Nike logo, with its kinetic swoosh, there's no visible "motor"—unless you count the arrow formed by the space between the *E* and the *X*. That is composition used to its maximum effect.

Another way of pointing the readers in the right direction is with the use of triangular shapes. Most readers are accustomed to following an arrow to where it aims. As long as the triangle has a point (one side is shorter than the other two), the eye will follow the triangular shape in the intended direction.

▲ Several compositional elements direct the reader's eye in this comic strip. In the first panel, the speaker's hand leads directly to the subject of his dialogue. In the second panel, another gesture (the speaker's elbow) does the pointing—along with the ceiling, which forms a triangle. Both of these elements in the second panel, as well as the vanishing perspective along the wall, point to the space between the two characters' heads in the final panel.

Composing an Emotional Effect

A secondary function of composition is to accentuate emotion in a scene. The way a cartoon is designed can impact the feeling portrayed in the comic. Readability issues aside, emotive composition is a simple, direct method of making your work stand out from that of others. Many cartoonists are so engaged with the act of drawing itself they forget to compose the scene to reflect emotion. The resulting work has a repetitive, static feel to it.

ALERT!

Directing the reader's eye is still the primary function of composition. Composing a cartoon for emotional value should never be considered more important than proper readability.

Eye Level

The reader's eye level—discussed in Chapter 10 as the horizon line—can have a great impact on the cartoon's emotional charge. A high eye level, called a bird's-eye view, tends to separate the reader from the action, creating emotional distance. A low eye level, called a worm's-eye view, presents a much more dramatic scene, in which the figures seem to tower over the viewer in a threatening way.

Close-Up

When you draw one of your characters in a close-up, it helps establish emotion in two ways. Obviously, it allows you to concentrate on the facial expression of the character presented in close-up. More importantly, the face frames the remaining space inside the panel, creating a very powerful effect. If the face is pointing toward the framed space, the objects in that space will receive a great deal of focus. If the face is pointed away from the leftover space, the objects in that space become isolated and remote.

◀ A close-up emphasizes the facial expression and frames the remaining space in a dramatic way.

The closer the reader gets to the scene, the more emotionally charged it becomes. You will notice this used often in opening scenes in comic strips and comic books. The first image may be an exterior of a building or a wide shot of a landscape. Aside from establishing narrative elements such as time and place, this approach also serves to start the story on neutral emotional ground.

Tilted View

Tilting the viewpoint of the reader can also have a dramatic impact on how the reader reacts to a cartoon. For example, tilting the scene to the right, so the left end is higher, will emphasize the items on the left. When two people are standing eye to eye, a tilted view will make the person on the left loom over the person on the right. Even a scene with a lone character takes on a sense of anticipation.

◀ Tilting the scene adds drama—especially to the side that gets tilted higher.

Planning Ahead

Take composition into consideration when planning your images in the thumbnail stage. This is especially crucial in comic strips and comic books. Too often, a cartoonist will skip this stage and produce final art in which the composition makes it difficult to properly place an important element such as the word balloon containing the punch line.

As you're sketching your thumbnails, try to identify at least one key element—image or word balloon—in each panel. Draw lines from one key element to the next. Now, ask yourself:

- How can I make the reader's eye move the way I want it to?
- Does this composition help the reader to read the text in the correct order?
- Is my composition ambiguous—is it possible to navigate it in more than one way?
- Can I tweak the composition to get more emotion out of it without affecting the readability?

If you get stuck, consider moving the elements around so natural eye movements can be used to your advantage. Natural eye movements (left to right, top to bottom) will always be your most powerful tools in perfecting your design.

ALERT!

Cartoons rely heavily on the interplay between words and images. Don't fall into the habit of composing the image and then fitting the words into the leftover space. As you're thumbnailing, you should be considering how words and images will work together as a unit.

Background Check

Cartoonists often underestimate the potential of their backgrounds, and you will see that many omit them completely. The background can be as important as the foreground in designing a cartoon. Subtle and not-so-subtle

compositional elements in the background can help the reader to navigate the cartoon as well as shape the reader's emotional response.

Literal Background

One way of helping the reader navigate a cartoon is to use objects from a scene's background. Keep them subtle, by using either a lighter line or shading. Unless there are special circumstances, the background should never compete with the foreground for the reader's attention.

You can control composition by adding people into the background who aren't necessarily part of the narrative—incidental characters. A large group of people can act as one shape to direct the eye where you want it to go. In a more understated way, one of these incidental characters can help lead a reader's eye to a certain area. For example, an incidental character's gaze—his line of sight—could guide the reader to an important area in the design. Or an incidental character might use her body language to point the reader in the proper direction in one of the ways discussed earlier in this chapter.

A background need not be very detailed to be useful in a cartoon's composition. Sometimes, a simple element—a doorway or a baseboard along the bottom of a wall—can help move the reader's eye along. Doorways can be particularly useful for emotional composition—separating one character from a group, for example. In outdoor scenes, clouds, trees, and buildings are used the same way.

QUESTION?

How can I learn to compose backgrounds more effectively?
Watch a movie by Alfred Hitchcock. He often used backgrounds to compose scenes. Turn down the sound and watch the images. You'll see elements such as a shadow from a window falling across a figure, making the figure appear trapped in a spider's web.

For a more detailed background, you may find yourself searching for photographic references. Anytime you have a camera handy, take a few photos you might be able to use someday to help you draw a cartoon. You can also do image searches on Internet search engines such as Google.

Some cartoonists scan photos in and use them as backgrounds in their cartoons. Ethically, this is not a problem as long as they use their own photographs. But although they are achieving a realistic background, their storytelling suffers from predetermined viewpoints and angles.

▲ Use objects in the background to guide the reader's eyes. Notice how the shape of the tree and the clouds form a focused high-contrast area for the text.

Abstract Background

Depending on the nature of your cartoon, it may not be necessary to include a background in your drawing. You may be able to communicate a perfectly believable scene with foreground images.

▲ Abstract backgrounds are often used in comic strips to underscore the mechanics of the gag: Setup, misdirection, and punch line.

A gray tone or muted color is best used in abstract background shapes. Using black is powerful—but dangerous. When you use a solid black shape in the background, you create a high-contrast area between the black shape and the white space left over. This is going to attract the reader's eye, and if there's nothing there for the reader, the attraction becomes a distraction. If there is white space above and below the black shape, the scene tends to flatten and you'll lose the depth you created with your use of perspective.

In Silhouette

When an object is filled in with a continuous tone, hiding some of the visual aspects of an object, that object is "silhouetted." A silhouette is a wonderful design tool because it has the effect of reducing objects to pure compositional elements, allowing the artist complete control over the reader's navigational path.

▲ Silhouettes can be used as powerful design tools. They can evoke a mood or help frame a composition.

Silhouettes are usually black, but this is not a requirement. A white figure against a black background is also considered a silhouette. As long as most of the figure's details are obscured by a solid tone—or even a continuous pattern—the effect is the same as a silhouette.

Silhouettes have tremendous compositional capabilities. When an item in the background is silhouetted, it can become an effective frame for a foreground image. As a background image, a silhouette creates a focused area of high contrast, into which you can place items of importance. A silhouette in the foreground can also become a frame, or it might simply become a focus point.

Easter Eggs

Easter eggs are visual treats that a cartoonist inserts into his background. This might be a little gag such as a cleverly worded headline in a newspaper being read by an incidental character in the background. Or it might be a surprising visual element such as a cat chasing a dog in the distance.

Easter eggs are wonderful elements to add into a composition as a treat for the attentive reader. However, they should not be attempted without a solid foundation in the principles of composition. Poorly composed Easter eggs can become distracting.

FACT

The undisputed king of the Easter egg is Dan Piraro. In his syndicated cartoon panel, *Bizarro,* he will hide any number of the following images: An inverted bird, a crown, an eyeball, "K2," a slice of pie, an alien in a spaceship, a bunny, a shoe, an arrow, and a fish tail. Check out his Web site: ✍*www.bizarro.com.*

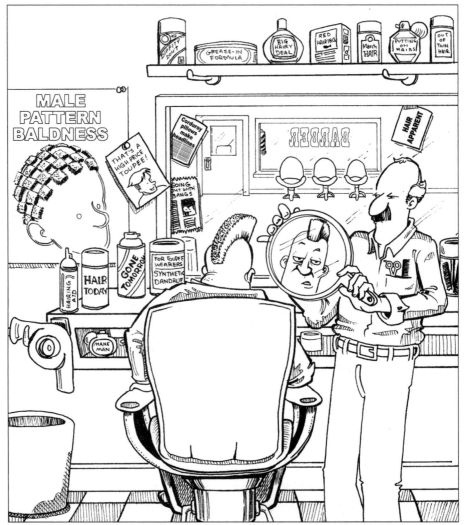

NEVER TALK POLITICS WITH YOUR BARBER.

▲ Easter eggs are a great addition to a comic but should not distract from the composition. In this example, the Easter eggs are labels and newspaper clippings using hair puns.

Don't be fooled by the simplified nature of cartoon drawing and the light-hearted nature of cartoon writing. Cartooning is a sophisticated and complex method of communication. Only when you become proficient at essentials such as composition will you learn to exploit your work to its fullest potential.

Chapter 13

Anthropomorphic Characters

The application of human characteristics to animals, called anthropomorphism, has resulted in some of the most familiar faces in cartoons, such as Yogi Bear, Bugs Bunny, and Mickey Mouse. The talking animal is one of the most readily accepted flights of cartoon fantasy. However, creating an anthropomorphic character isn't always as simple as getting an animal to stand on two feet and slapping a pair of three-fingered gloves on it. There are several factors to consider before you get furry.

Let's Start at the Zoo

Before jumping into drawing fully anthropomorphized characters, it's a good idea to spend some time familiarizing yourself with the basic differences in animal anatomy. This comes in handy when drawing a "normal," nonanthropomorphized animal such as Marmaduke, or an animal with human characteristics that apply only to its mental capabilities, such as Scooby-Doo.

FACT

Fans of anthropomorphic cartoons are sometimes called furries. They are to anthro cartoonists what Trekkies are to *Star Trek,* gathering for special conventions that feature anthro cartoons and cartoonists. The term "furry" can also be applied to an anthropomorphic cartoon.

Walking on All Fours

The most obvious difference between humans and animals is that many animals walk on all fours. As a result, they use their limbs differently. You cannot draw a cat with four human legs connected to its torso—the result will be very disturbing. Understanding how the animal carries its weight will help you understand how to correctly draw the legs.

Animals that walk on their metatarsals are called plantigrade. Metatarsals are the bones—such as a human's feet and hands—that extend from the wrist or ankle. Humans, primates, bears, most reptiles, and amphibians are plantigrade. If you look at their skeletal structure, it's very similar to that of a human walking on all fours.

Other animals bear weight on their phalanges—fingers and toes. This is referred to as digitigrade. Digitigrade animals include carnivorous predators such as dogs, cats, birds, and most dinosaurs. If you look at their skeletal structure, you'll see the animal's heel is quite far from the ground—making the animal look as if it has knees that bend backward. This appearance is even more pronounced in birds, since a bird's leg only visibly extends from the body below the knee.

Still other animals walk on their fingernails and toenails, in a manner of speaking. Actually, they're hoofs. These animals—such as cows, horses,

and pigs—don't have separate fingers and toes, but it helps to think in these terms to get the angles correct. These hoofed animals—unguligrades—carry their weight on their hoofs, which attach to the ends of phalanges, which are at the ends of their metatarsals.

◀ Human (plantigrade), dog (digitigrade), and deer (unguligrade), from left to right, share common structural features in their legs.

Flying Creatures

As with the legs of a four-legged animal, a bird's wings share common basic structures with human anatomy. As with hoofed mammals, the digits (phalanges) are fused into one unit, but the joints bend as you would expect them to. It is easy to understand the structural similarities between human and bird when the bird's wings are outstretched, but when a bird's wings are folded close to its sides, it gets more difficult. In this position, the edge of the wing you see extended along the length of the bird's body is actually from the bird's "wrist" down—the rest of the arm is folded underneath.

◀ A bird's wing is similar to a human arm, except the bones that comprise human fingers are fused into a single unit at the end of the bird's wing.

ALERT!

The most common mistake in drawing animals is to draw the head too large. Don't hesitate to research reference photos on the Internet or take your sketchbook and camera to the zoo.

In the Water

The major structural anatomy of a fish is guided off the fish's spine, located near the top of the body. Most people remember to draw the dorsal fin along the spine, the pectoral fins on the sides, and the tail fin. However, the ventral fins and anal fin are often neglected. Note that a fish's gills are placed directly behind the eye, not farther down the body.

◀ A fish has eight fins: two dorsal fins along its back, two pectoral fins (one on either side of its body), two pelvic fins (under the pectoral fins), one anal fin on the underside of its body, and one tail fin.

Fish swim by sweeping their tail fin back and forth, using their other fins mostly for steering. This movement is common to all fish—even sharks. Dolphins and whales—swimming mammals—move their tail fins in an up-and-down motion.

Insects and Spiders

An insect's body is separated into three parts: the head, thorax, and abdomen. Insects have six legs—three opposing pairs. When drawing insects, always attach the legs to the thorax. Also, notice how the back legs point to the rear, the middle legs point outward, and the front legs point to the front, forming a radial pattern around the body when seen from above.

Spiders and scorpions are arachnids. As such, their bodies are separated into only two parts. Arachnids, of course, have eight legs. In the same way an insect's legs radiate around its body, so do the legs on an arachnid.

◀ Insects have three body segments and six legs. Arachnids have two body segments and eight legs, not counting the pedipalps (sensory feelers for tasting food).

Anthropomorphic Characters

As noted earlier, some anthropomorphic characters are drawn with accurate anatomy—it's their intellect that reflects human characteristics. However, the vast majority of anthropomorphic characters are animals that reflect a blending of human and animal physiology. Not only do they talk like people, but they walk like people, as well. This assumes a combined anatomy complete with convenient alterations.

Leg Structure

The first obstacle to drawing an anthro character is to reconcile the leg structure. The aforementioned structures of digitigrade and unguligrade animals will look awkward on an erect figure. Moreover, it will make drawing the character in action difficult to do. Therefore, the leg is most often drawn to general human proportions.

Anthro feet become an interesting amalgam of the species' own and human body structure. Most often, the shape of the foot follows cartoon norms, but certain animal details are retained. However, even here there is room for a great amount of flexibility. Feet can be structured according to human standards, with a dominant big toe, or animal standards, with a rounded "paw"

shape to the toes. The toes themselves can reflect the physiology associated with cartoons, animals, or humans—three, four, or five toes, respectively.

◀ The character on the right has human leg structure; doing otherwise (on the left) results in awkward posing.

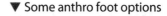

▼ Some anthro foot options

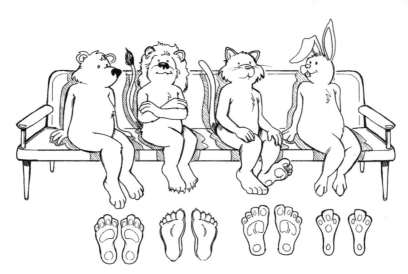

Up in Arms

Arms will most often reflect human proportions in anthro characters. More importantly, human-style shoulders are added. Without the shoulders, all gestures performed by the character would be confused by an unintentional shrug.

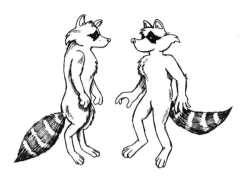

◀ Furry characters work best with human-style arms and shoulders (like the raccoon's on the right).

An anthro character's hands often bear the least resemblance to those of the species. Usually, the hand structure reflects either cartoon or human norms, with three or four fingers, respectively. The most important addition, of course, is the human opposable thumb.

One of the reasons for the broad appeal of cartoon talking animals is that the cartoonist can comment on the human condition without using actual human types. Avoiding overt references to such divisive topics as race and religion, artists use talking animals to explore interpersonal relationships without singling out any one group.

However, it is possible to design an anthropomorphic character whose hands retain the characteristics of the species—using a little artistic license. For example, hoofed animals such as cows tend to grow an opposable thumblike appendage at the base of their hoofs when they need to pick up an object. When not in use, the thumb disappears. Furthermore, anthro bird characters can be designed with wings in place of human-style hands. The front wing feathers tend to morph into long feather-fingers when necessary.

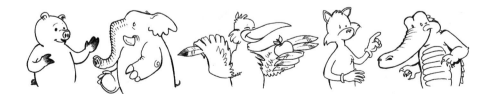

▲ Drawing anthro "hands"

Heads and Tails

The primary structural difference in anthro characters' heads is the neck. Looking at the original skeletal structure for most animals, the head connects to the neck near the base of the skull. In furry characters, that connection is humanized so the neck connects under the skull.

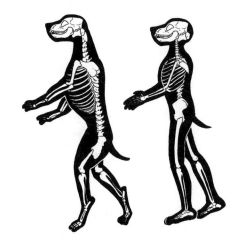

◀ Skeletal differences between neck structure of a real dog (left) and an anthro dog (right). The anthro dog's skull is connected to the neck at the base—like a human's—whereas the real dog's skull is attached to the neck at the back. The rest of the skeleton of the anthro dog is more closely related to that of a human.

As for the tail, it's often left looking fairly realistic, though it's not unusual for it to get modified to the character's advantage. For example, Mickey Mouse's tail is hardly the long, flesh-toned tail associated with actual mice.

Drawing Textures

Drawing textures is a consistent part of drawing anthropomorphic cartoons. Most of the characters will not have smooth skin like humans do. However,

▶

Using a broken line and selective texture to draw a furry character

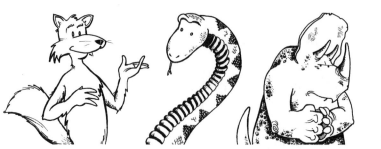

you don't want to waste time drawing every feather. You can use a number of cartoonists' techniques to indicate different textures.

Broken Lines

The simplest way to indicate fur is to draw the outline of the character's shape in a broken line. A few breaks in the line that sprout off as tufts of hair will give your character an overall hairy appearance. It's not necessary to overdo this—a few tufts will do the trick.

Selective Texture

When drawing a texture that covers a large part of the body, such as scales on a fish or feathers on a bird, it is not necessary to actually cover the object with the texture. If you indicate a texture in some well-placed areas of the body, the reader will assume the texture spreads over the entire shape.

The best placement for selective texture is in areas that would normally fall into shadow. The exception to this rule is in dark-colored areas. In these cases, texture the areas that would get the most light.

Skin

Smooth textures are indicated in the way they reflect the light. The smoother the surface, the more pronounced the divisions between light and shadow will become. Conversely, pebbly or rough surfaces—such as rhinoceros skin—will create small nooks and crannies for the shadows to fall into.

What to Wear

Choosing clothes for your anthropomorphic character is perhaps one of the oddest choices you're going to make. Society's rules of modesty don't apply. In the first place, anthro characters are seldom drawn anatomically correct. Furthermore, many of the body parts that would usually be covered by clothing are now covered in fur, feathers, or scales.

The costuming decisions you'll make—if any—will be primarily based on projecting a personality for the character. This explains the plethora of furry characters that wear only half of a standard outfit— shirts and no pants, for example. Generally speaking, anthro characters tend to have just enough clothing to project a personality trait, and not a single thread more.

ALERT!

If you're using clothing to indicate the gender of an anthropomorphic character, try to avoid some of the visual clichés. Too often, a bow is placed atop a character's head as a sign of her femininity. Likewise, neckties—usually tied around shirtless collars—have become over-done. Find some other ways to express gender.

Of course, there are no hard-and-fast rules here. But it can be observed that the level of clothing on a furry character rises and falls with the number of human traits bestowed on the character. The more a character walks, talks, and acts like a human, the greater the tendency to wear at least some clothing. The more a character identifies with its animal side (Snoopy, Garfield, and Calvin's friend Hobbes, to name a few), the less apt it is to wear clothing.

Indicating Personality Through Species

The wide appeal of anthropomorphic cartoons is not limited to character design. Furry characters come complete with a certain amount of personality based on a set of preconceived notions about how that animal behaves.

You can use those assumptions to add dimension to your character's personality, either by underscoring it or by contradicting it.

The main distinction between animals is in their eating habits. Herbivores eat plants, and carnivores eat other animals. Basing a character on a carnivore—such as a lion or a wolf—gives that character an aggressive or dangerous nature. Conversely, herbivores are usually smart and resourceful, outwitting the carnivores at every turn.

Another distinction between animals is that of being warm-blooded or cold-blooded. Cold-blooded reptiles such as alligators and crocodiles are often presented as having less emotional sensitivity than warm-blooded creatures do. The term "cold-blooded" is even used to describe a person who is lacking emotion.

Animals also have personalities based on familiar stories, fairy tales, and myths. Consider some of the following:

- A lion is the king of beasts.
- Storks bring babies.
- Elephants never forget.
- Groundhogs predict the weather.
- Owls are wise.
- Bats are blind.
- Cats are cool.
- Foxes are sly.

FACT

One of the most unique approaches to indicating personality through species comes from Bill Holbrook in *Kevin and Kell* (✎*www.kevinand kell.com*). In the daily comic strip, herbivores actually get eaten by carnivores. That makes family life difficult between Kevin (a rabbit) and his wife, Kell (a wolf)—and their children—but it provides a useful storytelling platform for Holbrook to discuss the modern blended family.

Playing off of these anecdotal personalities can also be a powerful source of inspiration for your character. There is a long list of furry characters that base their personalities on these preconceived notions.

Writing an Anthropomorphic Cartoon

Basing a character design on an animal/human combination is only the first step to creating an anthro cartoon. In the same way that a character's personality can be based on anecdotal factors, the writing of the strip can revolve around facts about the animal. Researching the animal you're anthropomorphizing can be a valuable source of inspiration when writing the cartoon.

You will draw more effective anthro cartoons if you start by learning more about the habitat of the animal you're using for inspiration. If nothing else, this may give you ideas for settings and backgrounds. One of the classic comic strip examples of this is Walt Kelly's *Pogo*. Kelly's main characters all originated from Georgia's Okefenokee swamp. This setting became a unifying factor in all of the plots Kelly spun.

Animals' behaviors can be used for ideas in writing your furry comic. Basing your writing on zoological facts will resonate with your readers— and perhaps educate a few. It may also provide inspiration for new gags and plots.

Finding the social setting in which an animal lives can also be used for creative stimulation. For example, bees present a ready-made social structure to employ in your storytelling. The same can be said of several species—lions, penguins, kangaroos, dolphins, and so on. An anthro character can have a readily understood social structure that helps determine its behavior, and that can be used in creating jokes or stories.

FACT

Anthropomorphic cartoons tend to be very popular with readers. Even beyond the "furry" community, Americans seem to be drawn to animals. Need proof? Barbara Bush's book about her dog, Millie, was on the bestseller list for twenty-nine weeks.

Other social settings for animals can be man-made. For example, a zoo presents a widely recognized social setting for a wide variety of animals. A circus is another example. Your anthro comic might have a setting that is analogous to one of these man-made groupings of animals.

Chapter 14

Caricatures That Work

Caricature is one of the most difficult forms of cartooning to attempt. The object of a caricature is to exaggerate the features of a person's face until it looks totally unique—without losing the original likeness of the person. Needless to say, it's a complex skill. However, there is a wide array of newspapers, magazines, and other organizations eager to put those talents to work.

The Basic Concept

The word "caricature" (pronounced CARE-a-cah-chur) refers to drawing that exaggerates a subject's distinctive features to produce a grotesque or comic effect. A caricaturist takes the very features that make a person's face recognizable and exaggerates them to a point almost beyond recognition. The first—and most important—goal is humor. Nowhere in caricature does it say the final product should be attractive.

But there is a secondary goal. A good caricature often looks more like the subject than her photograph does. That's because those features that give a face its personality are emphasized, while less-important features—distractions—are eliminated. The result is a sort of distilling of the person's face.

To achieve this effect, a caricaturist must learn which facial features to emphasize and which to diminish (or omit completely). It is here that the drawing process taught in Chapter 5 gains a new application. Any facial feature that deviates from the standard grid is a prime candidate for exaggeration.

ALERT!

No one walked up to Batman creator Bob Kane and insisted, "He doesn't look like *that*." But that's the attitude a beginning caricaturist must contend with. The biggest challenge is not in the drawing, it's in dealing with the frustration of trying to draw something that *does* and *doesn't* look like your subject.

Sizing Up a Face

The first thing a cartoonist must do in starting a caricature is study the subject's face. Try to mentally superimpose the standard grid onto the face. Try to find areas that deviate from the "norm." Here are a few questions to direct your observation:

- Do the eyes seem to fall in the middle of the head or are they higher/lower?
- Does it look as if there is a space of "one eye" between the eyes or is that distance longer/shorter?

- Does the nose take up more or less than a quarter of the head's height?
- Does the mouth seem wider/narrower than the width of the eyes?
- Do the ears protrude from the skull or lie flat? Are they longer or shorter than the distance from eyes to nose?
- Are any of the facial features shaped oddly?
- Are there any identifying marks on the face?

From Sketch to Caricature

It may help to do a quick "realistic" sketch of the subject before attempting a caricature. Actual people will rarely have faces that follow the grid. Therefore, to draw a believable portrait, you'll need to exaggerate the features slightly anyway. After doing this—and ending with a good likeness—you can then take the process one step further and draw a caricature.

Caricature follows the rules of facial emotion taught in Chapter 9: If it's not important, it disappears. In the case of caricature, if it doesn't help to make the face recognizable, omit it. The remaining features won't have to compete with unimportant ones.

Go through a newspaper or magazine and superimpose a standard grid onto the faces in the photos. Very few will adhere to the grid. This will help you spot the small deviations that help make each face unique. Practice this until you're able to do it mentally.

Recognizing Facial Feature Types

Any caricaturist who has worked on a number of faces will admit that she keeps a running library of body parts. Each time a new one is encountered, it gets memorized. Later, when that feature appears on a different face, it's a simple case of applying it—and adapting it, if necessary—to the new caricature. Therefore, it's useful for you to stock up on some types of facial features before you start caricaturing.

Head Shape

The jaw line is generally the dominant factor in determining the shape of the head. Above the ears, the head usually is a fairly consistent dome. Don't forget to identify structures like the cheekbones and chin when observing the jaw line—they play a big part in the overall personality of the jaw.

Jaws can be square, round, or pointy. Cheekbones are usually less prominent on round faces. A dominant chin can result in what some call a lantern jaw. Look for the presence or absence of a cleft in the chin.

In the few cases where the upper half of the head is dominant, it's usually because of a receding hairline or very short hair. The visual effect of this is to emphasize the forehead. The jaw line can still be definitive, but it won't be as dominant.

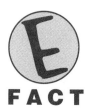

FACT

It's best to practice caricature on live models, but you won't always have volunteers willing to pose for you. Photographs are the next best option. However, try not to base a caricature on just one photo. Try to get several different photos of a subject and study them all before attempting a caricature.

Nose and Eyes

The nose and eyes are also definitive features. The nose can be long, short, narrow, or wide. It can be smooth and straight or it can be crooked and bent. Furthermore, the nostrils can help indicate a nose that points down or one that tilts up.

Eyes come in many sizes and shapes, but you'll find that the defining factors of the eyes are the types of skin around them. Eyelids and eye bags, eyebrows and crow's feet tend to be the identifying characteristics of eyes. Aside from that, eyes become individualized in their size and spacing on the face.

Mouth and Lips

The mouth can be wide or small. The lips can be full or thin. More importantly, the mouth can help accentuate a weak chin when the bottom lip hangs

over. Pay particular attention to teeth. Even a small gap between teeth can be exploited into a huge chasm without losing familiarity. Also notice the smile lines and cheek lines—are they pronounced enough to be amplified?

Ears and Hairline

The size of the ears is the most easily exploited feature on the head. However, ears can help define the head in other ways. Don't forget the shape and angle to the head.

Hair should be amplified only when it helps to make the face recognizable. Don't emphasize hair that really doesn't add to the overall effect. Furthermore, don't stop at rendering a hairstyle. Take the texture, thickness, and neatness into account, exaggerating those as well when called for.

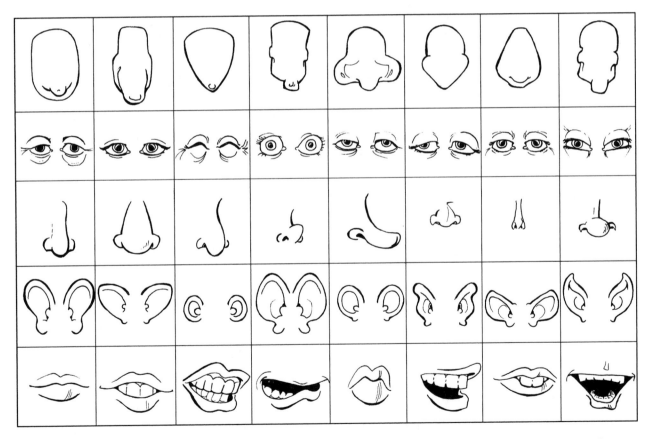

▲ Here are a few examples of the many different types of exaggerated head shapes, eyes, noses, ears, and mouths.

Drawing a Caricature

Drawing a caricature is based on the same grid discussed in Chapter 5. However, that grid will no longer conform to consistent proportions. In fact, the very shape of the head itself will not be a standard egg shape. Don't attempt to warp the grid until you've spent plenty of time mastering it. Only after you can draw a "standard" face reliably can you attempt a caricature.

Find a Dominant Feature

As you're designing your caricature, try to focus on one dominant feature that you think defines the entire face. This may be something less obvious, such as the jaw line. Dominant does not mean "big." A dominant feature is one that seems to draw attention away from the rest of the face—like a prominent nose or small, close-set eyes.

After that, settle on a few secondary features to exploit. These will be features that get slightly exaggerated, but not as much as the dominant feature. All other features will be drawn to the standard grid or disappear completely.

Remember, the key word in caricature is "grotesque." You are not out to find a flattering way to portray this face. If a feature stands out, your job as a caricaturist is to make it obscenely large. If a feature is small, your job is to make it ridiculously small.

Prepare to Draw

When you prepare to draw the caricature, rough a grid onto the head shape. It will not necessarily fall in the middle of the head. You may choose to nudge it up or down, depending on the effect you want to create. Also, it will not be a standard grid. It will be warped to account for the dominant feature you've chosen. Keep this in mind: Any feature you enlarge or reduce will affect the entire grid—unless the head shape is enlarged or reduced accordingly.

Take a look at the three examples shown on page 163. In each case, you begin with a photo, then progress to a fairly realistic drawing of the face. Next is a face with the features somewhat exaggerated. On the right is the finished caricature.

In each case, drawing a portrait likeness helps in developing a plan of attack in executing the caricature. If you're finding that your caricature falls short, you may have picked the wrong dominant feature. Re-examine your portrait for clues. Is there another feature that would make a better dominant feature? Are you exaggerating too many features?

◀ It's helpful to do a realistic drawing of your subject and then exaggerate some of the features more and more until you've arrived at an effective caricature.

Photos by Bob Laramie, ☜www.rjlphoto.com

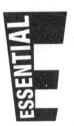

Celebrities are the best subjects to practice caricature on. For starters, there will be an abundance of photographs of the person. Celebrities are also defined by widespread recognition, which will help you and your friends judge the quality of your work.

Caricature Strategy

As you continue to get better at drawing caricatures, you will develop your own personal approach. You will learn that a good caricature strategy is

essential in designing a good caricature. Sometimes these strategies are obvious, such as accentuating an oversized feature. Sometimes these strategies are more understated, such as when dealing with someone with very delicate features. Here are some good strategies to remember:

- When accentuating a large feature like a nose, draw heavy shadows underneath to help project it out toward the viewer.
- When dealing with a large head, shrink the facial features to make it seem even larger.
- If the person squints when she's smiling, draw the eyes closed and curved into thin slants, arched by the cheeks.
- Use a neck (or absence of such) to indicate a thin or heavy person.
- To accentuate jowls, draw the bottom half of the head in one sloping curve, right down to the collar. Then plant a separate chin under the mouth.

Caricaturing a pretty face is the most difficult challenge of all. You have to really examine the face carefully to find the dominant feature. When you find it, treat it carefully. A face with beautiful features will allow a much smaller degree of exaggeration in a caricature. In these cases, sometimes the most unlikely feature—such as the hair or makeup—will become the focal point.

QUESTION?

Should I practice caricature on my family and friends?
Only if they can be trusted to fill two roles: First, they must be willing to sit for a personal sketch. Second, you must be able to find the right mixture of honesty and support that you'll need to build your confidence.

Showing Personality

Even the most diligent, studious caricature will fail if the personality of the subject doesn't shine through. A good caricature expresses emotion as well as likeness. This is especially true of celebrity caricature, in which part of what the viewer expects is the celebrity's personae.

Expression

Part of making your caricature emote is finding the right expression. A smile should not be a predetermined fact in your caricature strategy. The facial expression should match your subject's primary demeanor. If they're not a typically cheerful person, don't draw a broad smile across their face.

Since they are generally known for how they play certain roles, this is particularly crucial in drawing an actor's caricature. For Al Pacino, it's intensity. For Jack Black, it's nuttiness. For Humphrey Bogart, it's a morose stare.

On Best Behavior

Your caricature must behave in the same way the subject behaves. For example, no Elvis caricature is complete without the trademark lip curl. A Rodney Dangerfield caricature must fidget, sweat, and tug at his collar. A Jack Benny caricature must fold his arms, with one hand held up to his cheek.

In some cases, you'll find that it is necessary to add a body to the caricature to make the caricature complete. In these cases, it's perfectly acceptable to warp the correct proportions so the emphasis stays with the head. In many instances, the head will account for half of the figure's total height. If you do add a body, though, make sure that its gestures and posture express the same amount of personality as the face. If they don't, the body shouldn't be included.

Don't Forget the Right Props

Sometimes a good prop can make a good caricature great. You may have nailed Groucho Marx or George Burns, but it's not really done until you add that cigar. The prop is part of the personae.

Eyeglasses are excellent props because they say so much about a person's attitude. Glasses that are too big for a person's face will often become the dominant feature, overpowering the rest of the features. In the same way, small, dainty glasses can perch on a nose like a bird on a branch.

Even props that are secondary to a person's character can be used to hone the caricature. For example, a caricature of David Letterman or Jay

Leno can often be improved by the addition of a tabletop microphone such as the one they use in their desk interviews. A prop can also be an unexpected touch, such as E.T. peeking out from behind Steven Spielberg.

Profiting from Your Skill

One way to use your artistic ability to make some extra money is to take a job as a caricaturist at a theme park or carnival. You can also make yourself available to work special events. You may get paid by either the subject of the drawing or by the organization running the event.

Here, caricature becomes part drawing and part performance art. You will be drawing people as they walk up for a sitting. And you will be suffering immediate rejection if your caricature misses the mark—especially if the subject has paid for the drawing. The money is good, but it's not a job for the faint of heart.

On the other hand, you're expected to do several drawings per hour. Besides the stress, this can take a toll on your drawing style in general. To do this kind of caricature, it's necessary to repeat a number of stock facial features. Unlike the mental library mentioned earlier, you will tend to use

▲ Use trademark phrases, gestures, and props to help identify celebrity caricatures.
From left: Britney Spears, Joan Rivers, Bill Cosby, Jay Leno, David Letterman, Frank Sinatra, Sammy Davis Jr., Dean Martin,

these features as an end rather than a beginning. Sometimes this method of drawing can overtake your general drawing style until everything you touch looks like a carnival caricature.

ALERT!

Caricature is a highly subjective art. You may not want to accept caricature assignments until you are completely confident in your abilities. Even then, choose the client carefully. Don't work with clients who may not comprehend what a caricature is. One rule of thumb is, "if they can't pronounce 'caricature,' they don't really want one."

Caricature is very much in demand by publishers. It is often preferred over running a boring photograph. Some magazines such as *Mad* and *Cracked* rely almost exclusively on caricature—much of it freelance art. Even if your career plans center more along the lines of comic strips or comic books, you will find caricature useful in inserting celebrities into cameo roles in your cartoon. If nothing else, you can use it to make some money on the side while you're pursuing your dream.

Sarah Michelle Gellar and James Marsters from Buffy the Vampire Slayer, *Martha Stewart, and Rodney Dangerfield.*

Chapter 15

Editorial Cartooning

The art of an editorial cartoon is usually rooted in caricature and the writing relies on sharp satire and parody. Editorial cartoonists use the cartooning medium to comment on society and politics. To do this genre justice, you must have a broad understanding of news and politics, as well as strong opinions that you want to share. And those opinions had better be heartfelt, because the editorial cartoon usually draws heavy fire from readers. This is not an occupation for someone who backs down from a confrontation.

On the Job

Editorial cartooning—also referred to as political cartooning—has traditionally been a newspaper-related job. Editorial cartoonists are usually full-time employees of a newspaper, often serving on the paper's editorial board. The editorial board is responsible for the Opinion section of the newspaper, where news is commented on rather than reported factually. As a member of this department, the editorial cartoonist typically provides one cartoon per day for the paper's Editorial page, and sometimes illustrations for the Sunday Opinion section.

There are a couple of myths about editorial cartooning. The first is that an editorial cartoonist takes orders on subject matter from a higher editor. In many papers, the cartoonist has sole responsibility over the opinions expressed in her cartoon. An editor may argue for a viewpoint or suggest an angle, but the cartoonist is generally not under any obligation to comply.

However, that doesn't mean the cartoonist has complete autonomy and can publish whatever he chooses. That's the second myth. In reality, an editorial cartoonist must have his work approved by a higher-ranking editor, who may choose not to run the cartoonist's work that day. In these situations, there are three possible outcomes:

- The cartoon is discussed and a compromise is agreed on.
- The cartoonist creates a different cartoon.
- A syndicated cartoon is run in the cartoonist's spot the next day.

Editorial cartoonists often gain additional income through syndicates. They create the cartoon for the newspaper, and then send it to the syndicate for distribution to other newspapers. Newspapers that subscribe to the syndicate may run the cartoon as early as the day after the original is published.

Of course, that last option is the worst for everyone involved and is the least preferred outcome. It's typically indicative of a poor working relationship

between editor and cartoonist and should be avoided. To get around this, newspapers generally hire cartoonists who are sympathetic to the paper's political slant.

In effect, a cartoonist is a visual columnist. She is free to formulate her own opinions but still answers to the management of the newspaper. Unhappy readers may send their complaints to the Letters page, but *very* unhappy readers may end up visiting the editor's office. Smart editors know that the time to decide whether the cartoon is right for their pages is before it's printed, not when an angry protest group is at the door.

Do Your Research

Since an editorial cartoonist's job revolves around news and current events, a strong grasp of current news, politics, culture, and entertainment is a must. An editorial cartoonist is expected to comment on all types of news stories. This means you need a firm grasp of international events as well as those at the national, state, and local levels.

Current Events

Stay abreast of current news. That means reading the newspaper cover to cover. Actually, that means reading *several* newspapers—and staying tuned to CNN, Internet news sites, news magazines, and news radio.

FACT

All of this emphasis on knowledge and learning is not an attempt to prove your superior intellect. It's a simple strategy of self-preservation. An editorial cartoonist usually does six cartoons a week. You are only going to be able to survive a few months with general knowledge. At some point, you'll need to dig deeper into the news for your ideas, or face a deadline with nothing but old material.

You have to be a news junkie. News has to be a part of what excites you. If your concept of good television is a night full of sitcoms, then you may not be an ideal candidate for editorial cartooning.

Historical Background

Understanding current events isn't enough—you also need a good grasp of the history behind them. Every news story has a background—events that lead up to the current situation. Understanding history helps you understand the news. Many of the news stories that dominate today's headlines are rooted in a long history of conflict. You must understand that history before you can comment on the situation with intelligence. For example, attempting a cartoon on Israel without some study of the history of the Middle East would be unwise. This goes for the conflicts in Ireland, Pakistan, and Iraq as well.

Finally, you're probably aware of the adage that "history repeats itself." The more history you learn, the more often you see the same themes played out. This may help you to compare a new situation to an old one, putting it in a unique perspective.

Pop Culture

Popular TV shows, music, movies, and celebrities can be very useful to an editorial cartoonist. At the very least, they can be the basis for a good analogy, such as comparing a news story to a popular movie.

◄ Referencing popular culture can be an excellent tool for bringing home an opinion. When George Bush Sr.'s administration appeared to be considering military action as an attempt to rouse patriotic spirit just before a presidential election, the poster for the *Terminator* sequel provided some interesting parallels. Former president Clinton's many alleged extramarital dalliances are enumerated using a widely recognized promotional photo from the NBC sitcom *Friends*—a hit during the Clinton administration.

For most people, the editorial cartoon is the first place their eyes land when they turn to the Opinion page of their newspaper. For many, it's the only place. An editorial cartoonist is the most important (if not the only) source of social commentary an average newspaper reader experiences.

Make up Your Mind

A brain full of information is not the sole prerequisite for an editorial cartoonist. In addition to the other obvious necessities—like good drawing skills and the ability to write humor—there's one additional asset that no editorial cartoonist can excel without: passion. Not only do you need to understand the issue, you need to feel strongly enough about it to form an opinion.

Passion is what will drive your work. You must feel strongly enough to suggest social improvements, rage against injustices, and expose hypocrisy. It is this fervent zeal that leads you to put your opinion out there for the entire community to comment on.

Turning Opinion into Humor

As important as opinions are to the cartoonist, it's not the primary interest of the reader. Readers read editorial cartoons for the jokes. Humor is the hook that keeps the reader returning day after day. Without the jokes, readers would tire quickly of your visualized soapbox. Of course, the beauty of editorial cartoons is that, whether readers are aware of it or not, your opinion *is* being expressed. Political cartoons have the ability to make people laugh now and think later. They're coming for the chuckles, but leaving with an exchange of opinions.

Finding the humor in a news story is not always a simple task. In many cases, it helps to follow a four-step process: Clarify, Identify, Exemplify, Amplify.

1. Clarify your opinion—write it as a sentence if it helps.
2. Identify the involved parties.

3. Exemplify one situation in which the parties interact to prove your statement of opinion.
4. Amplify one or more parts of the example until it's humorous.

FACT

The Association of American Editorial Cartoonists (✒*http://info.detnews.com/aaec*) is open to full-time, part-time, and student editorial cartoonists whose work is published regularly. Along with its quarterly publication, *Notebook,* the AAEC's Web site is an excellent resource for news, tips, and comments on editorial cartooning.

Clarify Your Opinion

This is the easiest part. As you take in the news from several sources and perspectives, it's hard *not* to form an opinion. Your opinion comes naturally. The important part is to clarify exactly what your opinion is.

It should be able to be written in one clear statement. Notice, the goal is not to simplify, but rather to clarify. Everyone thinks theft is bad, but your opinion should include why it's bad.

The best editorial cartoonists do not dabble in the gray areas of public discourse. They see things in terms of black and white. Either they support an issue or they're against it. Middle-of-the-road thinking makes for weak cartoons.

Identify the Participants

Every issue has at least two participants. Participants can be people as well as institutions, businesses, ideas, groups of people, and so forth. Some issues have several participants, and it helps to take each and every one into account. Write them down in a list next to your statement if it helps to keep track of them all.

Exemplify a Situation

Now that you have your opinion and have identified the participants, try to think of a situation in which the participants interact to prove your

opinion. Some of the many ways to do this are covered in depth later in this chapter.

For example, you might have the opinion that Republicans and Democrats are equally beholden to big business, to the disadvantage of the average taxpayer. Your participants are: Republicans, Democrats, big business, taxpayers, and greed. On a sinking ship, how might the players act their parts?

Amplify the Situation

Once you have your scenario, amplify one or more of the elements to make it more humorous. Exaggeration will turn a wry comment into a funny gag. Remember, you're not striving for an objective presentation of fact—there are other places in the newspaper for that. Your primary target is the funny bone.

◀ Find a situation that fits the topic you wish to address. In this case, the sinking ship is an apt metaphor for the citizen who feels betrayed by his elected officials.

The difference is: I *want* there to be room for you.

Making the Point Visually

In completing the four-step process of turning opinion into humor, the "exemplification" step is the most crucial for the cartoonist. A good choice here can lead to a dynamite punch line (covered thoroughly in Chapter 19). There are many ways editorial cartoonists commonly arrive at a good visual analogy. It's useful to study a few of them.

ALERT!

Be careful when choosing your analogy. Use analogies that are fresh and bring a different perspective to the subject. Avoid tired references such as drowning in quicksand and swimming with sharks. Try to find imaginative analogies that breathe new life into old subjects.

Familiar Stories

Using a scene from a recognizable story for an analogy, you can make an unfamiliar concept easier to understand. The plot from the story will be already understood by most of your readers. The issue you're addressing is seen in terms of that story. This is particularly useful for concepts that may be difficult to understand or issues that aren't widely publicized yet.

There are many places to find familiar stories and scenes. Consider some of the following:

- Movies
- TV shows
- Fairy tales, myths, and fables
- The Bible
- Classic literature

Choose your story carefully. Remember, the analogy has to fit as completely as possible. You can't shoehorn an issue into the story of David and Goliath if you're missing a player who fits the Goliath role. Also, try not to pick obscure references or ones that could have ambiguous interpretations.

Metaphors

A metaphor is similar to an analogy in that you are making a comparison between two seemingly unrelated entities. But instead of comparing your subject to a recognized story or character, you are putting the subject in a familiar situation. Some common metaphors:

- Being stranded on a desert island
- Trying to keep from drowning in a large body of water

- Hunting/fishing
- Courting/dating
- Holidays and holiday characters

It's essential to know how to draw government buildings such as the White House as well as important chambers inside those buildings, monuments, and important statues. You can find photos, but vacations to Washington, D.C., and your state's capitol are much more effective. Bring a sketchbook and a camera.

Metaphors are best used in editorial cartoons when there is an expected outcome. Not only does this place the issue in a familiar setting, but in reversing the expectations, you can increase the effectiveness of your cartoon. For example, setting up a hunting scene in which the intended prey has the upper hand makes an effective metaphor.

A metaphor can be a characterization of a person, as well. For example, politicians who legislate programs that specifically benefit their local constituents—a practice known as pork barrel politics—are often represented as pigs. A politician who plays up his patriotism might be a metaphorical eagle, and one who has an aggressive personality might be a pit bull.

▲ Metaphors can also be objects. Landmarks, for example, can be used in many ways to represent political entities. Here, the Capitol Dome is used to represent Congress as (from left to right) a chalice, a carousel, and an hourglass.

Clichés

Clichés have the same impact as familiar stories or analogies in that their familiarity makes them a good tool for communication. But clichés also have the advantage of carrying a very specific meaning. For example, "to kill two birds with one stone" has a very definite meaning—getting two objectives done with one effort.

Consider some of these clichés:

- Bull in a china shop
- Pearls before swine
- Look a gift horse in the mouth
- A drop in the bucket
- Born with a silver spoon in his mouth
- Painting oneself into a corner

You can clearly see the additional benefit of choosing an appropriate cliché: striking imagery. The colorful language used in clichés can be translated to a powerful visual statement. Furthermore, clichés often describe actions—actions that don't need an explanation to be understood.

Political Jargon

Much of the jargon used in government can be used, like a cliché, to build a visual statement. These can be words used by government officials in describing bureaucratic processes, such as

- "Whitewashing"
- "Redlining"
- "Shuttle diplomacy"
- "Intelligence leak"

Likewise, certain words tend to get incorporated into political discourse. "Watergate" is the prime example, spawning derivatives such as "Nannygate," "Monicagate," "Twinkiegate," and "White Watergate." These, too, have excellent uses as the basis for an editorial cartoonist's central image.

Symbols

Political discussion is rife with symbolism. Beyond the obvious Democrat donkey and Republican elephant, there are myriad symbols at your disposal. Some of these can be directly related to the government, such as government buildings and flags. Others can be general, such as the scales of justice. Symbols can be extremely useful when morphed into other analogies. The dome of the Capitol Building is a terrific example of this. It could be a Jell-O mold, a citrus juicer, or a hat, or turned upside down, it could be used as a chalice.

Straight Gags

Of course, none of the preceding devices are indispensable in an editorial cartoon. Sometimes a good cartoon can be built around a well-written punch line. In these cases, the image simply serves to provide an appropriate setting for the gag. This is often the case when the irony or shock of the news story is so high that mixing it with imagery would serve only to confuse the matter. Often, this setting involves one or more people either reading a newspaper or watching TV news. This incorporates a convenient way of introducing the topic—it can be described in the headline of the newspaper, for example.

ALERT!

Be careful when introducing a news headline by placing it on a newspaper being read by a character. If the person is facing the left side of your panel, the newspaper will be held in such a way that the *back* page of the newspaper would be visible. Face these characters to the right.

Use of Labels

Sometimes a visual analogy is perfectly clear. For example, an eagle will symbolize America in virtually every usage. However, for cases in which the analogy may not be so clear, editorial cartoonists use labels.

Labeling is the practice of writing the names of the participants directly on their corresponding characters in an analogy. For example, if you're using a whale about to swallow a boat to represent the effect inflation will

have on economic recovery, no one will understand your point without the appropriate labels. However, if you find yourself working with more than two or three labels, take a hard look at which ones might be superfluous. Too many labels can make an analogy trite and pointless.

Handling Serious News

There's an adage in comedy that says "humor is tragedy plus time." But as an editorial cartoonist, you don't have the luxury of waiting for the sting to wear off a tragedy. Sometimes you will be called on to deal with some very serious, heartbreaking, unfunny issues.

This is when your mettle as editorial cartoonist is truly tested. You need to make an appropriate, respectful statement—and humor is seldom an option. In these cases, try to find a phrase or a thought that seems to sum up the story—like a quote from a slain leader.

City of Angels

▲ In 1992, when people in the city of Los Angeles rioted in reaction to the Rodney King trial verdict, it was more appropriate to reflect on the serious nature of the situation with a somber message.

Make sure your image reflects the somber tone of your words. This is not the place for harsh caricature. These are the cartoons that really touch people, reminding readers of the power of this art form. A well-designed cartoon during serious turmoil can become a lasting image of your newspaper's coverage.

Career Outlook

The editorial cartoonist's job is primarily linked to newspapers. Unfortunately, newspapers in America are experiencing serious financial hardships. In other words, this is not a career with enormous growth potential.

There aren't many more than ninety full-time cartoonists employed by newspapers in America today. When one of them retires, gets fired, or dies, it creates a vacuum at a newspaper that is filled by one of the others. A domino effect ensues, resulting in an opening for a full-time editorial cartoonist at one of the smaller newspapers. In some cases, newspapers don't fill the position left by a departing editorial cartoonist. After all, in a climate in which newspapers are pinching every penny, an editorial cartoonist is an unnecessary liability. Obviously, it's a nonessential full-time position. Plus, every time the cartoonist runs a piece on local subject matter, there's tremendous risk of insulting a potential advertiser.

FACT

Often editorial cartoonists include a small character near their signature. The character often makes a final, acerbic statement—a second punch line. These characters are called dingbats. Pat Oliphant's dingbat was a small penguin. Tom Toles's is a small self-caricature sitting at a drawing desk. Dingbats quickly turn into an editorial cartoonist's mascot.

Using cartoons from syndicated cartoonists is not only a less-expensive alternative, but it's also a safer one. On one hand, the paper doesn't use cartoons to comment on local issues. That means fewer local people get offended. That's a huge gain for today's cash-strapped newspapers. Also,

subscribing to a syndicate allows an editor to pick and choose the commentary, avoiding potentially controversial topics.

However, any eulogies for editorial cartooning are woefully premature. Many editorial cartoonists have taken their work to the Internet. Self-publishing online has given this art form a new lease on life. Few cartoonists are making enough money to be self-sufficient, but the future looks bright.

Chapter 16

Single-Panel Cartoons

The single-panel cartoon is similar to an editorial cartoon in that a single image rather than a sequence of illustrations is used to illustrate the text. Although sequential cartooning—such as the comic strip and the comic book—tends to get more attention, single-panel cartoons have a longer history and continue to dominate the magazine market. This kind of cartoon often relies heavily on a well-crafted punch line. For that reason, it is sometimes called a gag cartoon.

Standard Size Requirements

Single-panel cartoons don't have rigid size requirements. Sometimes they are a horizontal rectangle or even a circle. The predominant choice, however, is a square. This is partly due to the ease of designing a page with a square cartoon. The neutral shape does not conflict with any of the other visual elements on the magazine page. Also, if all of the gag cartoons take up an equal amount of space on a newspaper's Comics page, it's much easier to stack them, rearrange them, and even replace them when necessary. Most cartoonists work at about 7" × 7". Their final work will often appear under 4" wide. The caption is not included in this measurement.

Often the newspaper or magazine will transcribe the caption into one of the fonts it uses to print. It is unlikely that it will change the wording, only the font. In any case, the cartoonist's caption is always included as extra space under the panel—either hand lettered by the artist or typeset in a font. Since one cartoon may appear in several publications, the cartoonist usually picks a common font—such as Helvetica or Times—that will be more likely to blend with the publication's design.

FACT

One of the most widely known single-panel cartoonists is Gary Larson of *The Far Side,* a single-panel cartoon that was printed in about 1,900 newspapers and translated into seventeen different languages. Scientists have even named both a louse and a butterfly in his honor. Larson's work defines the modern single-panel cartoon.

Subject Matters

Single-panel cartoons do not tell stories, they tell jokes. Concepts such as plot progression, storytelling, and three-dimensional character development are unnecessary. It's all about the punch line.

Single-Subject Cartoons

Some single-panel cartoons use a constant cast of characters to present humor that revolves around a central theme. This would seem to imply that

a story would develop around those characters. However, in almost every instance, this is simply not the case.

Having a central theme to your single-panel cartoon is especially useful to beginning cartoonists trying to break into publication. For example, offering a series of single-panel cartoons on the subject of raising children will instantly appeal to magazines such as *Parenting, American Baby,* and *Child* as well as newspapers trying to reach that particular demographic. Your worth lies more in your perceived ability to connect with the publication's target audience than in your ability to catch the eye of an editor.

Omnisubject Cartoons

Much more popular are the omnisubject cartoons such as *The Far Side,* in which any subject may be addressed. These single-panel cartoons are unquestionably focused on humor rather than other facets such as characterization and plot. The only central visual theme is the artist's drawing style. Aside from that, the subject matter may be cavemen one day and teacups the next.

An omnisubject cartoon has tremendous marketing potential. Instead of focusing on demographics, these cartoonists try to appeal to a general audience. Every subject you address is going to appeal to at least a small part of that group, and the others will keep reading for the next time that you find that topic that tickles *their* funny bone.

Drawing Style

The style a cartoon is drawn in can also help present the gag in a certain tone. A polished, fine-tuned drawing can give an air of sophistication to the cartoon; a loosely drawn sketch can make an informal gag feel more friendly and inviting.

Don't feel obliged to emulate the styles of other single-panel cartoonists. James Thurber's style would never have worked with Charles Addams's sense of humor. And neither of these cartoonists could have done justice to a gag written by Gary Larson. You'll find that if you let your style develop naturally, your writing and style will begin to converge until it forms a united presence.

Most importantly, your style should be clear and legible. Your drawing should be a conductor of the humor, never a barrier to it. This is usually achieved through finding an appropriate level of detail to include in your drawing. Too much detail leads to clutter and too little leads to confusion. Your goal should be to provide enough visual detail without adding unnecessary pen strokes.

Choosing the Moment

Since a single-panel cartoon relies on one image to carry the visual message, choosing that image is crucial to the outcome of the cartoon. One of the most important decisions that has to be made is "when" to draw. In other words, should you draw the action before, during, or after it happens?

Since "action" tends to be a loaded term, it should be pointed out that sometimes the action in a cartoon is closer to inaction. In other words, sometimes the action illustrated is simply one person speaking to another. The words exchanged—not the activity—form the gag.

Before the Action

Choosing to illustrate the moment before the action indicated in the punch line works best in cases in which guessing the action itself is part of the gag. In these cases, the realization of what happens next adds to the humor. This amplifies the sense of surprise in the punch line because the reader is engaged in piecing together the consequences.

When you illustrate the moment before an action, you are allowing the reader to fill in the resulting action in his imagination. Be sure

WHAT KIND OF HOROSCOPE IS THAT?!
"ARIES: WATCH OUT!"

▲ Illustrating a scene "before the action" tends to heighten the tension before the punch line.

to include all of the visual elements the reader will need to do this. The reader should not have to add elements on his own to make the cartoon complete.

In Action

This is perhaps the scene single-panel cartoonists use most often. In this case, the cartoon illustrates the punch line action as it happens. As stated earlier, single-panel cartoons have a tendency to be focused on the joke. That being the case, the illustration simply exists to facilitate the cartoon-reading process. It gives the reader a scene or a setting, provides a tone and a mood, and then allows the humor in the caption to deliver the laughs.

Aside from the obvious uses, it's indispensable in presenting humor that relies heavily on a slapstick element. Slapstick humor is energetic and expressive and, therefore, can be truly presented only with an energetic, expressive drawing. Choosing to depict a scene before or after the moment of slapstick should be done only when the punch line is strong enough to exist without the slapstick.

◄ Most single-panel cartoons depict the action implied in the caption.

After the Action

Depicting a scene that occurs after the action is most often used to present the reader with an unexpected outcome or one that is humorous in a visual way. These cartoons usually present an ambiguous scene—one that does very little to arouse suspicion. Almost always, the punch line twists the

reader's perspective in such a way that she is forced to look at the illustration again with new eyes. This is a terrific tool for misdirection, in which you lead the reader to one expectation and then turn reality inside out, surprising the reader.

Y'KNOW... I KIND OF THOUGHT IT WAS AN ODD REQUEST
WHEN YOU MADE IT.

◀ Depicting a scene after the action described in the caption is an excellent tool for misdirection. The reader is presented with a confusing scene that is explained by the punch line.

ESSENTIAL

It's easy to get into the habit of illustrating the action of the caption. As you work on your thumbnail sketches, remember to try a before-and-after scene. Sometimes you'll discover a much better way to present the cartoon, or the illustration may suggest a better caption.

Composing the Scene

Single-panel cartoons have only one chance to get it right. Once you've chosen the right moment to illustrate, you must compose the scene to its maximum effectiveness. Where a comic strip artist might think of himself as a movie director, you must consider yourself a photographer, posing your subjects for a single frame.

Since emotion is not as important as the gag in a single-panel cartoon, close-ups are rarely used. The typical view is a horizon line that falls mid-panel and foreground figures that appear in the scene from the waist up, if not from head to toe. However, there are some compositional strategies that will make your single-panel cartoon communicate more clearly.

Composing for "Easter Egg" Punch Lines

Composition can also be used to underscore or explain the punch line. This is similar to hiding an Easter egg for your reader. But in this case, the Easter egg is not incidental to the humor; it is central to the point.

This is especially effective if the punch line is open-ended in some way; for example, asking a question or making a confusing statement. The answer can be hidden in the composition.

This can usually be done through simple contrast in shades—making the answer white in a field of gray. You don't want to hide the answer too well, making it hard to find. It should be inconspicuous at first glance but easily found after reading the punch line. This produces a wonderful double-take experience for the reader.

◄ Hiding the answer in the composition often generates a double-take response from the reader, who is likely to miss the visual clue the first time.

AND AMAZINGLY, THE SNIPER IS ONLY TARGETING PEOPLE WHO STAND BEHIND LIVE NEWSCASTS AND WAVE INTO THE CAMERA.

Visual Tension

Drawing visual tension into a composition means arranging the objects in the drawing in such a way that it looks as if action is imminent. This is particularly useful if you're illustrating a moment before the punch line, because it heightens the sense of impending action. For example, a stack of books may be drawn to look as if they're ready to tumble to the ground. The greater the visual tension, the more energy is built into the punch line. Don't be afraid to exaggerate a scene—even bending the laws of physics if necessary—to heighten the visual tension.

GIANT LOBSTER, EH? WELL... WE'LL SEE ABOUT THAT... GIANT LOBSTER, EH? WELL... WE'LL SEE ABOUT THAT...

▲ Notice how the visual tension is increased in the panel on the right.

An effective Easter egg trick for single-panel cartoonists is to hide a subtle reaction in the composition. For example, one person out of a group might react—slightly—to a rock plummeting toward the crowd. That person becomes a focal point for the reader once she reads the caption and is clued in.

Visual tension can also be exaggerated by using an extreme horizon line—a bird's-eye or worm's-eye view. A bird's-eye view can be used to rush

a viewer's eye downward toward a chosen area. Likewise, a worm's-eye view can send the reader's eyes to the top of the panel. A worm's-eye view is doubly effective, since the reader tends to identify with the action from that viewpoint.

Writing the Caption

Since single-panel cartoons focus so strongly on the gag, it's extremely important to view your writing with a critical eye. Your writing needs to be crisp and concise—and funny. You will not be able to rely on your character's personality to carry a joke. Instead, you must craft the joke, hone it, and perfect it. Otherwise, the cartoon will fail.

The Quantity of Words

Reading a single-panel cartoon is a lightning-fast process. It's that quick jolt that adds energy to the humor. Your goal is to speed the reader along to the punch line as quickly as possible. Of course, this is useless if the punch line itself is clogged with verbiage.

Although he wasn't expecting it, Dr. Timson stumbles across the patient's pituitary gland.

Dr. Timson discovers why it's called the pituitary gland.

▲ The caption on the left is too wordy; good editing improves the cartoon.

In general, single-panel cartoons should be written using as few words as possible—in both the setup and the punch line. Often, you can decrease your total word count by choosing words that need fewer modifiers to convey their meanings. For example, choose "omniscient" instead of "knowing all things." The more fine-tuned your words, the fewer you will need to use. Follow the "less is more" adage. Edit your cartoon carefully to determine if it could be written in fewer words—or if words are superfluous entirely.

The Quality of Words

Since you're editing so closely, the words you choose must do double duty. Obviously, they must set up and execute the joke clearly and quickly. But further, they must carry the voice and the attitude necessary to give the gag added punch.

It pays to strengthen your vocabulary. Since you may be writing in the voice of a mad scientist today and a pirate tomorrow, it will behoove you to study how different people speak. Watch movies, read books, and attend plays with an ear cocked to noticing how different people use language. Pay particular attention to the words people from different backgrounds use. A great single-panel cartoonist has an ear that is finely tuned to the ways people use language.

The Absence of Words

Following the "less is more" theory to its logical conclusion, there will be some instances in which no words at all are needed. Sometimes the drawing itself is sufficient to carry the humor. There's no need to shoehorn a witty line into these cartoons; simply allow your drawing to convey the point unhindered.

Don't discount the use of a simple thesaurus as a humor-writing tool. Sometimes a good punch line can be made terrific if the words are tweaked to reflect the "voice" of the characters. A thesaurus can help you find words that more closely model the personality of the character.

Good composition is vitally important in cartoons that have no caption. Because the punch line is not presented in word form, it must occur in the path the reader's eye takes through the composition. Visual gags are very difficult to master, but their humor is universal since language barriers are eliminated.

◄ Some of the humor in a single-panel cartoon can be solely visual—with no written punch line.

Using Word Balloons and Narration

A single-panel cartoonist can use two layers of text before the caption to set up the gag. A narration box can be used to establish a topic or introduce a scene. Also, word balloons can be used in the panel if a dialogue is needed. One or both of these may be used to set up the punch line.

In most cases, narration boxes are extraneous. They can be easily replaced by text included in the drawing. For example, rather than include a narration that says, "One day at the Miller Golf Ball Factory," you could simply include a "Miller Golf Ball Factory" sign in the composition somewhere (perhaps as a plaque on a wall or a sign atop a building).

Likewise, a word balloon should be included only when it is vital to help set up the punch line. If the gag endures without the word balloon, then omit the balloon. Irrelevant dialogue will only dilute the value of your punch line.

Single-panel cartoons find their power in their directness. There is no plot or characterization, just pure, distilled humor. Writing humor proficiently is essential since there is room for little more than an illustration and a gag. But the result is a cartoon that strikes quickly and accurately. This energy fuels the cartoon, making for some very powerful reactions from readers.

FACT

Watching comedians perform is a wonderful way to study setup and punch line delivery, but stand-up comedy does not often translate easily into cartoon format. Stand-up comedians use attitude and inflection, both of which are difficult to achieve in a single panel. In short, listen to the words, not the tone they're delivered in.

Chapter 17

The Comic Strip

The comic strip is one of a handful of art forms that originated in the United States. Through the comic strip, cartooning is taken to a higher level of sophistication. Since separate panels indicate the passage of time, stories can unfold and plots can be developed. Characters are no longer simply instruments of the punch line. Rather, as their personalities develop day after day, they form a special relationship with the reader. Not surprisingly, comic strips have spawned some of America's best-loved fictional characters, including Snoopy, Pogo, and Garfield.

Standard Size Requirements

Comic strips tend to fit into a very regimented shape. Inside that shape, many variations are possible, but the outer dimensions remain the same. This standardization of size makes it easy for newspapers to format their comics pages easily and make substitutions seamlessly.

ALERT!

If you're trying to break into newspaper comics, designing your strip as an evenly spaced four-panel comic could increase your chances. Doing so enables an editor to stack the first two panels on top of the last two. This way, your comic can be placed into a space that would otherwise demand a single-panel comic.

Outer Dimensions

Since most cartoonists work about twice the size their art will appear in print, most comic strip artists work along the following dimensions (all dimensions will be given in width times height):

- 13" × 4" for the entire image.
- Each panel of a four-panel strip will be about 3" × 4".
- Each panel of a three-panel strip will be about 4" × 4".
- The gutters between the panels will be about ¼".

In print, the strip will be 6" × 1.84", with each panel being 1.4" wide for a four-panel comic (1.84" wide for a three-panel comic). Gutters are about $^3/_{16}$".

Measuring Four Panels

Since the 13" width is easily divided into quarters, measuring the panels of a four-panel strip is simple:

- Draw a rectangle, 13" × 4".
- Make three hash marks across the width, one every 3.25".
- Line up the ⅛" mark of your ruler with the first hash mark.

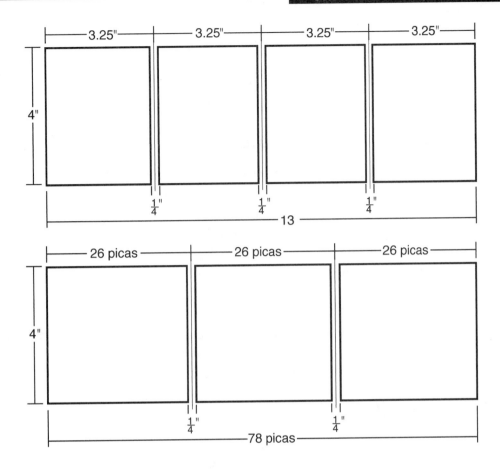

▲ Preliminary measurements for a four-panel and a three-panel strip

- Place a dot at 0 and one at ¼".
- Repeat for the next two hash marks.
- Draw vertical lines from the dots, dividing the rectangle into quarters.

Measuring Three Panels

Preparing a three-panel strip is slightly more difficult. Since thirteen is not easily divided into three, use the pica side of your ruler instead:

- 13" is 78 picas.
- Make two hash marks across the width, one every 26 picas.
- Flip your ruler back to the side that measures inches.

- Line up the ⅛" mark of your ruler with the first hash mark.
- Place a dot at 0 and one at ¼".
- Repeat for the next hash marks.
- Draw vertical lines from the dots, dividing the rectangle into thirds.

Other Panel Configurations

There are even more ways to divide a comic strip into panels. For instance, you can create a two-panel strip. Sometimes this is done with a short panel followed by a long panel. The first panel acts as an introduction, and the second panel, in effect, becomes a single-panel comic. Still others skip the intro panel and design single-panel comics to fit a comic strip's outer dimensions.

Of course, there's no rule that says that all of your panels have to be evenly measured. You can choose to have as many panels as can legibly fit into the space. If you want to size each panel independently—and size them differently from day to day—that's your prerogative.

Strip Design

The typical comic strip consists of three or four panels ruled with solid black lines and a gutter between each panel. However, there are several other design possibilities at your disposal. As you design your comic strip, try not to fall into the habit of automatically ruling off three or four panels, then filling them with illustrations. As you do your thumbnail sketches, consider how the design of your strip might help tell your story in a more interesting way.

Open Panel

Comic strips are printed very small in newspapers. One way of introducing an airy feeling into your strip is to decrease the number of panels formed by solid black lines. For this technique to work properly, it should be applied only to one of the middle panels, not the first or last one. If there is a solid-ruled panel on either side of the middle panel, you can omit the solid lines that form that panel, letting the neighboring panels form the boundaries.

▲ Interior panels don't have to have solid lines, but exterior panels should.

Oddly Shaped Panels

Another way to add some extra space into your comic strip is to make one of the middle panels an odd shape—usually a circle. Again, the panels that start and end your comic should be rectangular. Not only does the circular panel add some much-needed space into the design of your comic strip, but the circular panel also tends to gain emphasis—similar to a spotlight effect—which can be useful in your storytelling.

▲ Another option for an oddly-shaped panel is a heart shape.

No Ruled Panels

Another option is to omit entirely the black rules that define your panels. This takes careful planning, but it results in a very open-feeling design. You will need to leave a little extra room for the gutters, since they are the only delineation between your panels. This is especially effective for soliloquies

delivered by a lone figure. Consider unifying the composition with a continuous background for a very sophisticated effect.

Keeping the Gutters

Regardless of the choices you make about panels, one thing is going to be constant in your strip design: gutters. You should always include gutters of some sort between your panels. Panels that butt up against one another are awkward and difficult to read. Also, any vertical lines that go from the top to the bottom of a panel will create unintended separations.

▲ Gutters are a must. When panels bump up against one another, the strip becomes difficult to read because background lines can be mistaken for panel borders.

Gutters serve an additional purpose. You can insert important information into a gutter. This is often preferable to cluttering the panel with unnecessary type. This is a perfect place for your copyright announcement. You can also use a gutter to include an e-mail or Web site address.

Subject Matters

There are absolutely no limits to the subjects that can be addressed in a daily comic strip. Unlike single-panel cartoons, which tend to focus on the punch line, a comic strip has the ability to develop plots and cultivate character personalities. Conversely, the cartoonist may decide to use the multi-panel format of a comic strip to tell jokes and never choose to deepen his characters' personalities—if there are recurring characters at all. In short, there are no restrictions. The entire scope of cartooning possibilities is open to an artist working in a comic strip format.

However, a good comic strip artist knows that every day someone is viewing his comic for the first time—with absolutely no idea about what's going on or who the characters are. If you want to increase your daily audience, you have to make sure your comic is accessible to these newcomers. To that end, if your comic strip tells a story over several days, each individual day should be able to stand on its own merits.

If you write a comic in which a story unfolds day by day, consider the reading habits of your audience. For example, newspaper circulation usually goes down on Saturdays, so don't build a story line to a climax on that day. Friday is a better day for a climax, leaving Saturday for a dénouement or conclusion.

Composition

A comic strip requires the reader's eye to be directed around a panel and the word balloons in proper order. This jumping from panel to panel can create some unique compositional challenges. If you're not carefully composing each panel—as well as composing the entire strip as a unit—you may find that word balloons are read out of order and illustrations fail to live up to their maximum potential. As always, a short time spent planning in the thumbnail-sketching phase will translate to better comic strips with more communicative power.

Directing Dialogue

Consider a comic strip in which two characters are speaking. It's wise to put the first speaker on the left. That way, the dialogue can be read naturally. If the exchange continues in that order (left speaker speaking first), or if some of the panels feature a solitary word balloon, your composition should carry the strip comfortably to its conclusion.

If both characters speak in the next panel and the right-hand character begins this time, you have to consider your strategy carefully. One way to handle this is to extend the word balloon of the first speaker all the way across the top of the panel, with the second balloon below. Placing the word balloon this way ensures the reader will read it first. Another approach might be to combine the dialogue from the second panel into the first panel so the second panel starts with the left-hand character's dialogue once more.

ALERT!

Don't swing the viewpoint around 180 degrees. For example, imagine two characters standing on a compass—one is on North, the other on South. The viewer sees the action from the East. Switching the viewpoint to the West causes a jarring shift of perception. Shift the viewpoint 90 degrees or less at a time.

Characters Repeated in a Panel

Don't think of each panel as a separate illustration. A panel is simply a convenient way to indicate the passage of time or a change in scene. Given the flexibility of accepted cartoon symbolism and the vast expanse of your imagination, there are some truly inspired ways to compose a comic strip that introduce drama and intrigue into a story.

First of all, realize that one character can appear several times in the same panel. This is especially effective in showing someone speaking as she rapidly walks across a room. Your readers will be savvy enough to realize that your character hasn't been suddenly cloned (unless cloning is a regular part of your plot).

▲ The strip on top is poorly composed, so you end up reading word balloons in the wrong order. ▼ The strip on the bottom uses two strategies to solve the composition problems. The first strategy consists of editing dialogue so the speaker on the left speaks before the speaker on the right. When the right-hand speaker begins the dialogue, the word balloon goes all the way across the top of the panel, making it the obvious first stop for the reader's eye.

Bridging the Gutter

A character can also appear in two panels at once. By bridging the gutter, a character can interact with the panels on either side of him. This works wonderfully when combined with a double take. Since the panels are read as different moments in time, it's an excellent way to show someone talking about another character—just as that character walks into the room.

▲ Straddling the gutter enables the character to interact with the panels on either side.

Even though a character may not bridge the gutter between two panels, she can still break her panel to influence an adjacent panel. Sometimes the break is obvious, like when an outstretched arm reaches into the next panel. In other cases, the break is less dramatic, with perhaps a small portion of the body overlapping the panel border, gently leading the reader's eye to an entry point in the next panel.

In the Background

The backgrounds you draw in each panel can repeat the same image, resulting in a repetitive rhythm that can be useful in setting up a punch line. However, the backgrounds can also work together to form a cohesive framework for the comic strip as a unit.

▲ The background can unify the panels, resulting in attractive composition.

Remember, even though panels are separated with gutters, the reader's eye will unify shapes that line up in adjacent panels. You can use this fact to help draw the reader's eye along your illustration. It's also a good way to unify some panels and isolate others in the same comic strip.

How to Control Pacing

Another advantage enjoyed by comic strips over other cartooning formats is the ability to control tempo. Controlling the pace at which a reader reads your work will intensify the effectiveness of your strip. Proper pacing can make a dramatic scene much more intense and transform the joke from funny to hilarious.

Stand-up comedians are excellent resources for learning pacing. Buy a comedy routine CD and listen to it repeatedly, until the jokes aren't funny anymore. Then, simply listen to how the comedian changes his pacing as he approaches a punch line. Certain jokes require different pacing than others. Listen, laugh, and learn.

Slowing Down

Inserting a "quiet panel"—a panel in which little or no dialogue is delivered—can slow down the action. Slowing down the action has the effect of building tension. (As you'll see in Chapter 19, building tension is a key element of comedy.)

Quiet panels can be very effective when paired with silhouetted images. The combination of the high-contrast imagery with the absence of a significant amount of text has a powerful effect on the reader. Most readers will take a substantial pause when they come across a quiet panel, before moving to the next panel.

Quiet panels are best used just before the last panel. This builds tension to its highest point before you release it in the last panel. Using it too soon

lessens its effectiveness, since the tension has a chance to level off before reaching the end.

▲ Use a quiet panel to slow down the tempo and build up the tension.

Speeding Up

Oddly enough, adding panels has the effect of speeding up the reader. This is especially effective if the images in the extra panels are repetitive. The effect is similar to that of looking at frames of a motion picture. The reader subconsciously speeds up to "animate" those frames in his mind.

▲ Speeding up the tempo

For example, consider a four-panel comic in which the first and last panels are standard size. If both of the middle panels are divided in half—resulting in a total of six panels—the reader will read the first panel, speed

through the middle four, and come to a rest in the last panel. Use this technique when a character is rattling off a list or building to a frenzied climax. You can add to the effectiveness of this method if the character gets more emotional with each panel.

The Sunday Comics

Comic strips that run in newspapers on Sunday follow a unique set of rules. Some are the result of decades of tradition. After all, the Sunday paper played a pivotal role in the birth of the comic strip. Other rules are the product of printing requirements faced by newspapers.

Sunday Subject Matter

Newspapers tend to be cautious of the topics covered by their comics. This standard becomes particularly strict on Sunday. Besides the religious significance of the day for many readers, Sunday circulation skyrockets for almost all newspapers. In short, there's a lot of potential income on the line, and editors are very careful about the entertainment they offer in the Sunday paper. Your Sunday comic will be expected to be strictly family fare.

Sunday Continuity

If your comic strip follows a continuous plot, it's not a good idea to include your Sunday strip in the regular continuity of your story line. Remember, some people read the Sunday paper only, and others read the paper Monday through Friday. The best way to handle this is to treat the Sunday strip as if it were an entirely separate comic. The characters and situations remain the same, but the Sunday plot does not affect—and is not affected by—the regular story line of your comic strip.

This may not be a workable solution for comic strips that focus on action or drama, such as *Mary Worth* or *Dick Tracy*. In these instances, it may be possible to make the Sunday strip overlap the weekday story line. In other words, any significant plot points covered Sunday are either points repeated from Friday and Saturday or points that will be repeated on Monday.

Sunday Structure

A single Sunday comic strip must be designed so individual newspapers can easily reconfigure it into one of three common formats. A Sunday comic strip may be printed to fill half of a page, a third of a page, or a quarter of a page. To allow for that kind of flexibility, you'll need to follow a strict structure in creating your Sunday strip.

Sunday comics are designed in three rows. It is not practical to work at twice the size for a Sunday strip, so lay out the Sunday strip as three rows of 13" × 4" dailies. Each row of panels is intended to be printed 11.5" wide. The total space the comic takes at this format is about half of a page.

Of course, it is more likely that your strip will actually be shrunk to a smaller size. To facilitate this, the entire first row must be disposable. In many cases the entire first row is cut off and thrown away and the remaining comic is reproduced at the size of a third of a page. Therefore, when writing the Sunday strip, don't include anything in this first row that is relevant to the following panels. Most cartoonists write two gags for Sunday—the first is considered a throwaway gag and the second is considered the actual Sunday strip.

FACT

Many cartoonists use a title illustration for three-quarters of the first row of their Sunday comic. They design a special illustration around the name of their strip and repeat it weekly. The last panel in the first row can be either a single-panel gag or an inconsequential lead-up to the main plot.

Second, the second row must be divided in the center. You can break up the space on either side any way you choose, but there must be a gutter in the very middle of the second row of panels. That's because some newspapers may choose to run your work at the size of a quarter of a page. In this format, all of the panels are used, but the entire comic runs over two rows instead of three. The first row and one half of the second row are placed above the other half of the second row and the third row.

◀ One Sunday strip can be published three different ways: (from top) half-page, a third of a page, or a quarter of a page. The trick to achieving this is to make the top row expendable and split the second row in the center.

Chapter 18

Comic Books

A comic book is an extension of the comic strip. Instead of delivering the story three or four panels at a time, the comic book delivers the story through several pages of panels. This opens the door to an entire universe of narrative techniques. Although dismissed for decades as strictly juvenile entertainment, comic books are being more widely recognized for their sophisticated storytelling qualities. Today, titles like *Maus* and *American Splendor* are used to tell gripping tales without superheroes.

Anatomy of a Comic Book

Most comic book artists use a sheet of 11" × 17" bristol board for their original illustration. This is because 10" × 15" is considered space that can safely be used without getting too close to the margin or bending into the spine. Of course, most comics are printed with a full bleed, meaning that the image can fill the entire page without leaving a border. However, important visual information should not be placed outside the 10" × 15" area.

ALERT!

Many professionals use bristol board with the proper sizes already printed on it. The printing areas are indicated in nonphoto blue, so they won't interfere with the printing process. Some indicate both the standard printing area as well as a bleed area. One source for this art board is Blue Line Pro at *www.bluelinepro.com.*

Page Count

A comic book can have any page count as long as it's divisible by four. Golden Age comics (comic books published in the 1940s and 1950s) tended to have about sixty-four pages. Today, the average seems to be closer to forty.

The number has to be a multiple of four because comics are actually printed two pages at a time, front and back, in a process called page pairing. The paper used to print a comic book is actually twice as long as the comic page (but the same depth). One page is printed on the left of the paper and another page is printed on the right, and the same happens on the back of the page. When it's finished, it is collated into the correct order, stapled in the middle, and folded in half.

FACT

To determine page pairs, use this formula: $T + 1 - P$. T is the total number of pages. P is one of the page numbers. For example, if it's a forty-page book and you're trying to find the page pair for page 36, the equation is $40 + 1 - 36 = 5$. Page 5 pairs with page 36.

◀ How pages are collected into a comic book: Page 1 is the front cover and the last page is the back cover, usually reserved for an ad.

On the Cover

The cover may very well be the most important element of a comic book. As a cover artist, you can't settle for creating an attractive image based on the contents of the book. Your cover must make a potential customer go from ambivalent to passionate. Further, since most comics tend to be sold on shelves next to other comics, your cover must compete with the others for the customer's attention.

A good cover is an exercise in marketing. Your cover must create a sense of urgency. Illustrating directly from the script is not the only solution. Sometimes a great cover will evoke a mood or an abstract theme from the story, resulting in an image that is not necessarily repeated in the book.

In designing your illustration, be sure to leave appropriate room for the necessities of the cover. For example, most comic book publishers will insist that the title of the book appear at a certain size. You will also be required to leave ample room for the publisher's logo, credits for the creative team, and

other publishing essentials such as volume and issue numbers. Finally, don't forget to factor in a 1" × 2" space for the UPC symbol.

◀ Comic book covers must generate urgency while including essentials such as the UPC symbol.

Splash Page

A splash page is a full-page panel meant to hook the reader into the action. The art should set the tone for the reader, giving her a sense of what to expect in the story. If your story is an action/adventure tale, for example, the splash page should be breathtakingly dynamic. If the story is a drama, the splash page should set an appropriate tone.

Just as a director may choose to place the opening credits after a few minutes of exposition, a comic book artist may delay the splash page for a few pages. This is a good way to build suspense and maximize the punch of your splash page. Waiting too long, however, may reduce the splash page's effectiveness.

Usually, the title of the book appears on the splash page. This is also a good place to include the names of the people who have worked on the book. The comic book splash page is analogous to the opening credits of a movie.

◀ The splash page is much like a movie's opening credits.

Last Page

It is also traditional to end the comic with a full-page panel. In the same way a splash panel hooks the reader into the story, the last page should entice the reader to buy the next issue. There is usually a place reserved at the bottom for a horizontal teaser for the next issue.

Pinups

Pinups are full-page illustrations that have nothing to do with the story whatsoever. More often than not, a pinup is an illustration of the main character in an action pose. Since it is highly unlikely that a collector is going to deface his comic by cutting out a page, the pinup can't be considered an effective promotional tool. It is more likely that a pinup is a convenient way to insert an extra page if the story does not fill the targeted page count.

On the Assembly Line

If you're working for a major comic book publisher such as DC, Marvel, Image, or Dark Horse, you'll find that creating comic books is a team sport. Independent comics are often created by smaller teams—and sometimes by one cartoonist. But largely, comic books are produced assembly-line style, with a specialist for every step of the way. This is the typical production schedule for a comic book:

- First, a writer writes the script, providing instructions for scenes.
- Next, a penciller sketches out preliminary drawings in pencil.
- If the words are being hand lettered, a letterer adds words to the penciller's work.
- An inker draws the final art directly over the penciller's breakdowns.
- A colorist scans the inker's work and adds color using a computer.
- If the lettering is done digitally, the words are added at this point.
- The digital files are sent to the printer to be assembled into a book and printed.
- Editors are involved at each step, ensuring accuracy and enforcing deadlines.

Breaking down the workload for a series of specialists is crucial to maintaining a monthly deadline. In reality, all of the members can be working concurrently. After the writer finishes writing, he does not have to wait for the issue to be completed to start writing the next one. All of the members of the team can maximize their time working continually on the things they do best.

The Writer

As the writer, you create the story that is told in the comic book. However, a comic book script goes beyond telling a story. The script is the blueprint for the comic itself, dividing scenes into pages of panels. Through dividing the action into panels, the writer controls the pacing and ensures steady storytelling throughout the book.

Beyond the dialogue, narration, and sound effects, the writer describes the scenes that the penciller is to illustrate. The amount of detail varies, but

in general, the writer conceptualizes the comic book. The illustrations are the artists' translations of this conceptualization.

Comic book writers are advised to write action. A dialogue-heavy script is not conducive to a good comic book plot. As you're writing, try to find visual ways to help tell the story—ways that don't rely on a written explanation.

The Penciller

A penciller takes the writer's script and begins roughing in the pages. His job is twofold. Certainly, he illustrates the action described in the script, but additionally, he designs the individual pages.

The writer designates a certain number of panels to a page, but the penciller's job is to arrange those panels on the page in an engaging way. A boring page design is going to adversely affect the story. Therefore, the penciller's first responsibility is closer to graphic design than illustration.

QUESTION?

How can I practice pencilling without a script?
You can find some on the Internet. You can also buy books such as *Panel One: Comic Book Scripts by Top Writers*. Choose scripts for comics you haven't read, then buy the comic and compare your solutions to theirs.

Beyond designing pages, the penciller lays down the basic structure for the illustrations. All of the anatomy, perspective, and viewpoints fall under the responsibility of the penciller. These are not rough thumbnails to be firmed up later. All of the perspective problems, anatomy issues, and minor details are addressed in this step.

Finally, the penciller must rough in all of the text. As a penciller, you will not measure out the text grid—more likely you'll jot down the text by hand—but it is important that you leave ample room for the text. Moreover, it is essential that you plan word balloons and narration boxes so they work as part of your coverall composition. Placing text so the reader reads the comic in the right sequence is vital. The same strategies you learned in the preceding chapter will serve you well here.

The Inker

The inker does not simply trace the penciller's work. That's a common misconception that drives inkers crazy. The inker uses the penciller's framework to do the final illustrations that will be seen by the reader.

Since the penciller has solved the rendering-related issues of the illustration (perspective, anatomy, scene selection, etc.), the inker is free to concentrate on style. The inker focuses on issues such as line quality, contrast, and shadow placement.

An inker must also be the final judge of the art. This means judging the level of detail, managing the amount of contrast in an image, and composing solid black areas in such a way that they assist the overall composition of the page. Very often, too much detail is more harmful than too little.

FACT

Many professional comic book inkers report they can ink about one or two pages per day—and many work very long days. Comics vary in length, but assuming an average-sized book of about twenty-four pages, that can be a very challenging deadline.

The Colorist

The colorist gets a computer file of the scanned art and adds color to it. Obviously, the colorist must be able to color the costumes of the different characters correctly and keep them consistent throughout the book. Furthermore, the colorist must be able to produce sophisticated lighting and atmospheric effects as well as evoke distinct moods through the use of color. Coloring will be addressed in detail in Chapter 20.

The Letterer

A letterer working by hand will enter the process before the inker does. More likely, the lettering will be done on the computer. In this case, the letterer comes in after the colorist.

The work is scanned in and imported into your computer's design software. The letterer then imports the text from the script and divides it into the appropriate word balloons. The letterer can also assist in the storytelling, both by font selection and in the way the balloons are designed.

ALERT!

If you want to work on comic books, you must be able to keep a deadline. That means knowing how long it takes you to complete certain tasks, scheduling those tasks accordingly, and working consistently throughout the week. Make a work log and chart your progress. It will help you stay on schedule and enable you to figure out how long you'll need for the next project.

Page Composition

A comic book page is easily divided into three rows of two panels—for a total of six. However, page after page of the same static layout would be tedious. The design of the page should be as exciting or dramatic as the illustrations themselves are. There are several possible solutions for each page design, and the penciller must find the one that best suits the story.

Varying the size and shape of the panels is sometimes a product of necessity—drawing a landscape, for example, requires a horizontal panel. Some scenes simply cannot be contained in a standard panel that takes up one-sixth of the page. Sometimes a panel will have to stretch to the full width or full height of the page in order to present the visual information well.

Sometimes varying the panel size is a product of storytelling. An obvious example of this is the increasing of a panel's size to emphasize the action in that panel. Furthermore, you can speed up or slow down the pacing by adjusting the size and frequency of the panels. The same pacing techniques used by comic strip artists apply here as well.

As with comic strips, you should consider panels to be a convenient method of marking time and nothing more. When appropriate, characters

▲ Notice how the improved layout on the right makes the page much more appealing.

should be able to reach beyond the borders of a panel. This is especially useful in directing the reader to an important area in an adjacent panel.

Remember the discussion from Chapter 12 of how readers read print. This will affect the layout of your page as well. To ensure the panels will be read in the proper order, your panels should read left to right and top to bottom. A page in which the reader must make unnatural turns (reading the panels in a counterclockwise path, for example) can be confusing and annoying.

▲ The layout on the left is confusing—the reader could start at the upper left panel and continue either across or down. The gutters between the four top panels line up, making it an ambiguous design. In the middle, the vertical gutter is broken, leaving the long horizontal gutter intact. The long horizontal gutter acts as a border, encouraging the reader's eye to read across before coming down to the next row. The right-hand layout shows the same process reversed: The horizontal gutter is broken, leaving the vertical gutter to act as a border. As a result, the reader is encouraged to read down from the first panel and then start at the top of the second column.

Sometimes you'll see arrows used to try to direct a reader if the panel progression runs counterintuitively. The reader, concentrating on the text and illustrations, often misses these directional signals, making this a poor design solution. If you feel the need to include arrows in your design, you should rethink the layout.

Superhero Comics

Comic books find their roots in superpowered people flying around in tights and masks, so it's no surprise that the superhero genre dominates the comic book industry. However, that long history of success is due in part to an underlying psychology that permeates the nature of superhero storytelling.

Most superhero comics are based on the psychological concept of the adolescent power fantasy. Adolescents are peaking physically and mentally, but they maintain a secondary importance in society. Through superhero comics, the young reader can live vicariously through a character with greater powers than the most powerful person in the reader's own world.

The hero becomes an instrument through which the reader can work out the frustration of being powerless. Of course, superhero comics' psychological attraction wouldn't be complete without a means of expressing that power. Without a powerful villain, the hero is unable to demonstrate his superiority.

The power-fantasy aspect of superhero comics is neither a limitation nor an insult to the quality of the storytelling. Rather, it merely reinforces one crucial factor in creating great comic book stories: Superheroes are symbolic. If you look past the masks and capes, you can often find powerful drama and fascinating concepts.

FACT

The average age of the comic book reader is rising above the age of adolescence. Furthermore, a greater number of women are becoming comic book fans. Whether this is an extension of our feelings of powerlessness in modern society remains to be proven. However, one thing is obvious: To be successful today, comics must appeal to an older, more diverse audience than ever before.

Graphic Novels

Despite the supremacy of superhero comics in the marketplace, smaller independent publishers are constantly pushing the envelope to prove that this medium delivers powerful dramatic stories—even when the lead character doesn't wear a cape. These comic books are telling complex, fascinating stories in the traditional comic book format. Although superheroes are still present in some, graphic novels are just as likely to deal with mystery, erotica, humor, biography, historical fiction, and journalism.

And their popularity is escalating. Graphic novels now enjoy their own section in many bookstores—a fact that would have been unthinkable just a few years ago. Furthermore, mainstream book publishers are opening graphic novel divisions. Graphic novels have even been translated into popular movies such as *Ghost World, American Splendor,* and *The Road to Perdition.*

The major difference between a graphic novel and a comic book is the production schedule. A comic book, like a magazine, gets published monthly on inexpensive paper. A graphic novel is more like a book. It's a one-time purchase, has more pages, and is printed on glossy stock bound by a substantial cover. Some graphic novels are reprints of several consecutive issues of a comic book, but many are original stories being published for the first time.

FACT

Art Spiegelman is credited for creating the first graphic novel that gained mainstream acceptance. His Pulitzer Prize–winning *Maus,* published in 1987, was an account of the Nazi Holocaust reframed in terms of cats and mice. Its masterful comic book art and critical appeal thrust the graphic novel onto the literary scene. Since then, graphic novels have risen steadily in popularity.

Japanese Manga

Although comic books in America are just starting to go mainstream, they are a mainstay of Japanese popular culture and have been for decades. Japanese comics, or manga (pronounced mahn-gah), are published in weekly volumes the size of telephone directories.

Manga doesn't have the American stigma of being strictly for kids. Grown businessmen can be seen reading manga on the train ride to work. Furthermore, cartoonists—often on the lower rungs of the American entertainment celebrity ladder—can reach a tremendous level of fame in Japan.

A Different Drawing Style

Manga characters tend to have big, expressive eyes, lithe bodies, and Anglo-Saxon features. Their hair is usually quite bizarre—oddly colored and often sticking up in jagged spikes. The quality of the graceful line work is almost as important as the illustration itself.

The manga drawing technique has become wildly popular in America. The process of influence was even brought full circle with the appearance of a manga-style American comic strip artist—Aaron McGruder of *Boondocks* fame. Today, the art in many American comic books shows the obvious influence of manga artists.

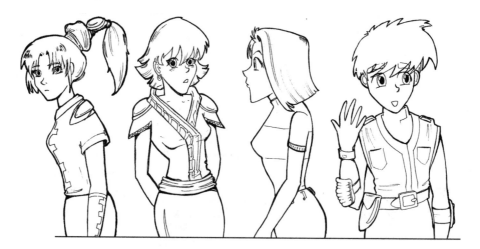

▲ Some distinctions of the popular manga drawing style include large eyes; small, pointed chins and noses; small mouths; and weird hairstyles.

Visual Shorthand

Manga has developed vastly different symbolism to depict characters' emotions. One of the most distinct differences is the use of *chibi* illustrations

to express lighter moments. A chibi is a character drawn in a very cartoony, silly way. For example, imagine reading a Batman comic book in which the characters suddenly look as if Charles Schulz drew them. In manga, the portrayal of reality is more based in emotion than in fact.

▲ A chibi illustration depicts a lighter, silly moment in an otherwise "realistic" comic.

Page Design

A final distinction of manga is based on the way Japanese print is read. Since the Japanese language is generally read right to left and top to bottom, manga pages are designed to be read that way. In Japanese comic strips, the panels are stacked vertically so the reader reads from top to bottom. The top panel can often be a title panel with a short introduction.

As American comic books push into the center of popular culture, it's not hard to imagine a time when Americans will have the same voracious comic book appetite that their Asian counterparts demonstrate. As that happens, artists and writers familiar with the medium will enjoy a greater demand—and earn more respect for their hard work. If you haven't been to your local comic shop in a while, it might behoove you to make the trip. You may be looking at the future of publishing.

Chapter 19

Make It Funny

"Analyzing humor is like dissecting a frog. Few people are interested and the frog dies of it." E. B. White's observation should not be mistaken for a discouraging comment. Rather, it's a good reminder of what happens when you try to scrutinize humor. Humor is indefinable. What makes one person laugh may confuse another, and if someone doesn't understand a joke, no amount of explanation is going to elicit the intended belly laugh. However, it's a topic central to the heart of cartooning—and therefore merits a dead frog or two.

The Nature of Humor

Three central concepts lie at the core of most humor: surprise, superiority, and syntax. Seldom does a joke feature just one of these three. Usually there is one dominant element, with traces of one or both of the others. Part of writing humor is being aware of these elements and exploiting them in your writing.

Surprise, Surprise!

Laughter seems to be hardwired into people's response to surprise. It's probably why so much of our entertainment—from roller coasters to haunted houses—is based on a theme of surprise. True, not all surprises are funny; some are scary. But most punch lines fall flat if the audience can guess them in advance.

▲ Punch lines aren't funny if they can be guessed—unless that's part of the gag.

The challenge of writing a good gag is to give the reader *just enough* information. If you don't do enough setup, the punch line will be confusing, and if you do too much, you'll give away the surprise (called "telegraphing the joke"). At some point in the writing process, you will need to take a leap of faith, believing that the reader has enough information.

A cartoonist has many opportunities to create surprise. Sometimes a surprise can be based solely on the text. Other times, it's the conflict between text and image that surprises the reader. And, of course, sometimes an image is surprising on its own. The important factor here is that the surprise

should be exploited by using all of the tools at your disposal, such as effective composition, solid punch line writing, legible illustration, and so forth.

A Sense of Superiority

A man slips on a banana peel. This is funny. Why? Because it wasn't *you*. Superiority is a double-edged sword for cartoonists. It's a potent component of humor, but if it's used carelessly, it may come off as sounding smug. A good humorist knows the difference between "laughing at" someone and "laughing with" someone. Unless your intention is satire or parody (if, for example, you're an editorial cartoonist), you'll want to make sure your humor laughs *with* rather than *at*.

Dumb characters are funny because the audience feels superior. However, the writer must be smarter than the audience to write the jokes. To improve your humor writing, improve your mind. Every subject you study—every fact you learn—is a gag waiting to be written.

English Syntax

Syntax is a fancy word for language. The English language is fertile ground for humor. Many words have several meanings and some words sound the same as other words with different meanings. Sometimes words are used in familiar patterns that can be shifted for humorous effect. This is only a sampling of the many properties of the English language that can be used to spark humor.

As a cartoonist, you should always be on the lookout for new words and phrases that you can use to build punch lines. The more you expand your vocabulary and your knowledge of current vernacular, the more possibilities you'll have to create humor. Using language well means knowing your audience and how they speak. Avoid assembling a gag around technical jargon unless your core readership understands that language.

I ASSURE YOU, OFFICER... I AM COMPLETELY EBRIATED.

▲ Language is often the basis for humor. In this example, the function of the prefix "in-" is explored. The opposite of "incomplete" is "complete," but that rule doesn't apply to other words such as "inebriated."

Tension and Release

There is one unifying factor in all comedy: tension and release. A humorist builds tension and then triggers its release. It's a fundamental rhythm present in all comedy. The higher you build the tension, the bigger the relief— and the laugh. A good cartoonist tries to build the tension as high as it can go before springing the release.

In cartooning, the building of tension is referred to as the setup, and the release is the punch line. A setup can be as complicated as a multiple-panel lead-in to the punch line, or it can be as simple as a few words. Single panels accomplish both tension and release at the same time.

Building tension does not mean prolonging the setup and punch line. Adding unnecessary words to your comic will not build tension. Rather, the extra verbiage will bore your readers. The tension comes from the ideas expressed by the words—their quality—not in the quantity of the words.

Crafting an Effective Punch Line

In every punch line, there is one word that contains the surprise. This "punch word" should come as near to the end as possible. This allows for a buildup of tension. As a general rule, the punch line should be the last sentence, and the punch word should be the last word of that sentence.

▲ The punch word here is "hole." It should come at or near the very end of the last sentence.

The punch line should be edited very carefully. Not only should extraneous words be removed, but particular attention should be paid to the rhythm of the words. To paraphrase Shakespeare, a good punch line should flow trippingly off the tongue. Say the punch line out loud and listen to the rhythm of the words. If the cadence of the words doesn't work, the gag will suffer.

One really good punch line is appreciated more than a scattering of humorous attempts. If you have written multiple punch lines on a subject, create several cartoons. Never try to cram more than one solid punch line into a cartoon.

Gag Types

In addition to understanding the underlying elements at work in a joke, it is also helpful to study how these elements come together to form humor. Most gags can be classified into a category of humor based on recognizable patterns. Once you're able to recognize how these patterns work, you will be able to reproduce them in your writing.

A Word on Wordplay

Words themselves are an excellent resource for humor. As you're preparing to write a joke on a topic, it's very useful to write down all the words related to that topic. Often, the words themselves will point the way to the humor.

Consider the following properties of the English language:

- **Synonyms:** Words with the same or similar meanings.
 She has an hourglass figure, but her face could stop a clock.

- **Antonyms:** Words with opposite meanings.
 Living it up can really get you down.

- **Homonyms:** Words with different meanings that sound the same.
 My girlfriend has been hinting at a traditional wedding. For breakfast every morning she serves me cantaloupe.

- **Rhymes:** Words that sound alike.
 A man's home is his hassle.

- **Double entendres:** Multiple meanings of a word.
 A: We took a trolley downtown. B: I know. They want it back.

- **Non sequiturs:** Pairs of phrases where the second phrase doesn't logically follow the first one.
 A: Doctor, I have a pain in my neck. B: It was your bright idea to get married.

As you can see, idioms (phrases that get used repeatedly) and clichés (overused idioms) are very useful in creating humor. Both carry expectations

that can be twisted, resulting in a surprise for the reader. For example, a twist on the familiar *Star Wars* catchphrase might become an air carrier's slogan: *Star Wars Airlines. May the fares be with you.*

▲ Interpreting a familiar idiom ("pack your bags") in a new way

Words are of vital importance to humor writers, and many make use of a small library of helpful books. Besides the fundamentals such as a dictionary and a thesaurus, be sure to include a book of synonyms and antonyms, a rhyming dictionary, a book of idioms, and a book of clichés.

It's a Pun

The most common form of syntax humor is the pun. A pun is a play on words involving homonyms—two different words that sound alike. Take, for example, the following: "Accused of embezzlement last week, the chairman of the American Dairy Association resigned in udder disgrace." "Udder" (the part of a cow's body that produces milk) sounds like "utter." The correct phrase is "utter disgrace," but since the subject is dairy, "udder" is substituted with *pun*ishing results.

Puns are most effective when the sentence resonates using either meaning of the word. Take the following gag: "He was a funny baker—even his bread was wry." It works whether you interpret the meaning as wry or rye. It doesn't have to make logical sense, but it should fit into the overall theme of

the sentence. Writing "that wry bread makes a good sandwich" is not funny because one of the meanings—wry—does not fit the sentence.

MOOSE-TERPIECE THEATER

▲ Puns are the most popular form of word-based humor.

Misdirection

To exploit the "surprise" factor in humor, a humor writer takes a cue from magicians. Magicians perform illusions by getting the audience to look in the wrong direction while important actions occur elsewhere. It's called misdirection, and it's an effective tool in magic—and in gag writing.

Misdirection takes advantage of a reader's eagerness to find patterns and logical sequences. If the reader is made to follow a sequence, he can assume the outcome. When the outcome is different from that expected, the surprise is humorous.

The misdirection often comes from using a familiar phrase that tends to emphasize one word or subject. The reader will follow the subsequent panels with the assumed emphasis or subject in mind. The humor in the punch line results from emphasizing an overlooked word or subject.

▲ Notice how the reader is misdirected in the opening two panels. The punch line emphasizes an unforeseen element of the sentence "The teacher called and said all four of my kids are in trouble."

Role-Shifting

The shifting of traditionally assumed roles is also a good source for humor. Whether it's ducks hunting hunters or men talking like women, the illogic of the role shift is funny. This was an underlying structure for much of Charles Schulz's work—children acting like adults.

Another way to shift roles is to show how the behavior of one type of character would be exhibited in another type of character. For example, if cows were vampires, you'd fend them off with a steak (which is also a pun). If dogs were paleontologists, they'd find dinosaur bones and rebury them.

Hyperbole and Understatement

Hyperbole or exaggeration can be used to create a funny situation. More frequently, it is used in conjunction with other types of gags to increase the overall humor level. If you're looking for a way to make a funny gag funnier, chances are, you can find the solution with an exaggeration. Equally important is the polar opposite of hyperbole—understatement. Understatement is exaggeration in reverse. Take a wild situation and write about it calmly. The

illogic of the understatement will provide most of the humor. This is some-times referred to as dry wit. British comedians—including troupes such as Monty Python—are renowned for their mastery of understatement.

Juxtaposition

Juxtaposing two unrelated concepts can bring about fantastic comedy. It's a very simple, yet effective concept. Take two unrelated topics, put them together, and imagine the outcome. Often, you can brainstorm these topics by asking yourself "what if" questions:

- What if cowboys flew the space shuttle?
- What if Godzilla tried to stomp New York?
- What if soda bottles placed personal ads?
- What if the main characters from *The Wizard of Oz* had to get through airport security?

▲ Juxtaposition is pairing two unrelated subjects and imagining "what if." This cartoon answers the question "What if the *Wizard of Oz* characters had to make it through airport security?"

Attitude Adjustment

Changing a character's attitude to contradict the situation can create humor. One way of doing this is to write a gag in which your character does something odd in a perfectly natural way. Often called deadpan humor, the

illogic of the situation is exaggerated by the fact that at least one of the characters is going about the behavior as if it were an everyday occurrence.

FACT

Some of the best examples of attitude adjustment humor come from Charles Addams. Many of his cartoons for *The New Yorker* are wonderful examples of mismatched attitudes. This style of humor can also be seen in the TV series his cartoons inspired, *The Addams Family*.

Conversely, doing something normal in a strange way is equally humorous. Moreover, a twist on a common occurrence has a way of resonating with your audience—especially if they regularly experience that everyday event. This is an especially useful tool for single-panel cartoonists putting together material for a theme magazine such as *Cooking Light* or *Golf*. Looking at the magazine's topic in a funhouse mirror will certainly appeal to the readers.

Writing Habits

Good writing will always save substandard art. But great art can never compensate for poor writing. Your ability as a humor writer will define you as a cartoonist. Therefore, it's important to address your writing as seriously as you address your illustration.

First, set aside a specific time for writing. Whether it's a little bit every day or an extended stretch on one given day, you need to get into the rhythm of creative writing. Once it becomes part of your routine, your brain will automatically prepare for the activity.

Make It a Habit

Embrace your own writing rituals. What makes you comfortable when writing? Do you write best at the computer or on a sheet of paper? Where do you do your best writing? Determine the factors that contribute to your success and repeat them.

Avoid tying yourself into an unnecessarily complex ritual. Sometimes you can spend more time gathering objects and waiting for specific times

and places than you do actually writing. Stay flexible. Remember these rituals are there for you—not the other way around.

Warm-Ups

Take a few minutes to warm up. Like any activity, you'll use your time more efficiently if you don't dive into it cold. Try this warm-up technique:

- Write down some random subjects on small pieces of paper and put them in a box.
- Write some random situations on small pieces of paper and put them in a different box.
- Choose a slip of paper from each box.
- Write a simple gag based on the juxtaposition.
- In two minutes—whether you've written a gag or not—choose two new slips.
- Begin again.
- Repeat for about ten minutes.

Of course, you can develop your own warm-up technique. The important thing is, keep the activity light and quick. Don't get bogged down in trying to work out complex gags. And don't obsess over one topic. If it doesn't flow, move on.

Writer's Block

Writer's block is horrible. It happens to everyone, so don't let yourself get frustrated. The key to fighting writer's block is identifying it early and taking steps to snap out of it.

Sometimes free association can help break through writer's block. Start writing whatever pops into your head and then follow your thoughts around. Write freely, without direction. If everyday anxieties—bills, rent, relationships—are at the root of your block, this may help to satisfy your subconscious urge to address these issues, at least momentarily.

Sometimes a mere change of scenery is all it takes to break out of a block. Take a walk or move to a different room of the house. If you typically work in a quiet setting, go down to the coffee shop. If you write in the morning, try again later that night. You just may stumble into a new writing ritual that works even better than your current one.

Finally, don't be too quick to declare yourself blocked. Writing is seldom a quick and easy process. It takes time. Stick with it for a solid forty-five minutes before you start to fear a block. Then, take a short break—maybe a walk around the neighborhood—and return for another attempt.

Writing from Life

As with all forms of writing, the perennial advice for humor writers is "write what you know." There's a wealth of humor in the world around you. Chances are, you're just not paying close enough attention to realize it. Tune in to your surroundings. You'll find enough material for several strips.

As a collector of humor, you will find you're able to do much better if you refine your collection process. Get into the habit of carrying a small notepad and a pen with you wherever you go. Even if you're completely confident in your ability to recall the gag later, make a note of it anyway. It doesn't have to be detailed, just enough to spur your recollection.

Be especially vigilant about keeping your notebook by your bedside. Your subconscious mind is incredibly powerful, often working out problems that have you puzzled during the day. If one of those puzzles happens to be the perfect gag for a cartoon you're working on, you'll want to be prepared to retain it.

Brainstorming

When you are trying to write gags to fit a specific subject and the lightning doesn't seem to be striking, you need to do some storming of your own. Brainstorming is a process of throwing around as many ideas as you possibly can, and then sorting through the results for something that could be polished into a great gag. You will seldom find a finished joke through brainstorming, but it can often lead you in the direction of an effective solution.

There is only one rule in brainstorming: no negative thoughts. No idea is bad. No word association is stupid. No concept is too lame, too puerile, too wacky, or too bizarre to be considered.

This is not a linear thought process. Brainstorming is an exercise in organic thinking. Every concept is a link to another concept, which links to even more possibilities. Instead of progressing further away from the central theme, the links often circle back, forming new and unusual relationships with the others. In short, never censor an idea because you think it's inferior. You may be blocking a link to a truly inspired idea.

The Word Web

One method of brainstorming is to write down all of the words related to the subject you're addressing. This is an exceptionally good way to write a punch line for a single-panel cartoon. For example, if you're writing a gag about cooking, you'd write down all the cooking-related words you can imagine. Don't limit it to the act of cooking itself. Be sure to include subtopics such as:

- People who do it (chefs, the lunch lady, short-order chefs)
- The places they do it in (kitchen, restaurant, diner)
- Tools they use (spatula, butcher's knife, pots, Crock-Pot, grill, stove, pit)
- Language they use (sauté, brown, flavor, julienne)
- Raw materials (fruits, vegetables, chicken, wheat)

Once you've assembled an extensive list, go back and start brainstorming words that are related to each word on your list. Write down synonyms, antonyms, homonyms, and spontaneous word associations. If familiar phrases include some of the words on your list, jot them down as well.

Choose a few gags and sketch them out in cartoon form. Then, stop working on the project. Work on something else for the rest of the day. The next day, come back to your topic. Are the gags you found funny still humorous? Did you overlook some gems? You'll find you are much more able to make good decisions after giving your brain a break from the topic.

▲ Cascade brainstorming

Cascade Writing

Another brainstorming technique is called cascade writing. This method is particularly effective for writing comic strips. It's designed to take advantage of a multiple-panel setup.

Start by writing the dialogue for the first panel. Don't sweat the details—this dialogue may change later. Underneath, write the dialogue for the next panel. Repeat for the rest of the panels.

Sometimes, the gag will flow naturally from the setup. Usually, however, you'll need to go into an earlier panel and look for words that could be pivotal in a joke. Look for double meanings, possible misdirection, idioms, word play, and so forth that could be injected along the way.

Each time you see a possibility, branch the dialogue off next to the appropriate panel. For example, if you see some wording that could be changed in the second panel, write the new wording next to the old second panel and continue down. As you play with the words, humorous associations will form, leading to a gag.

Sometimes it takes changing only one panel to inspire a punch line. In many instances, you'll develop a great punch line and then work backward through the setup. This allows you to fine-tune the setup, making sure that there's enough tension or misdirection to support the gag.

Understanding Desktop Publishing

Chapter 20

Processing Final Art for Print

Ultimately, your goal as a cartoonist is to put your work in front of as many people as possible. In many cases, that means getting your cartoon printed. Just a few years ago, that would have meant sending a finished illustration to a printer's engraving department, where they would handle the many aspects of getting the illustration ready for publication. Today, it's your responsibility to prepare your work for print.

Understanding Desktop Publishing

Today, most publishers work digitally; that is, they assemble the pages of their publication on a computer. They will not ask you to mail a finished illustration. More likely, they will request a TIFF or an EPS file of a specific dpi to be sent via e-mail or FTP. Half the battle is simply becoming familiar with all of the terminology.

File Formats: TIFF and EPS

The two major file formats you will use are TIFF and EPS. A TIFF (Tag Image File Format) is one of the most widely accepted file types in print publication. A TIFF file is not compressed, and it delivers very good image quality. Avoid applying compression of any type (such as LZW or ZIP) to your TIFF file if you're using it for print.

ALERT!

JPEGs, PNGs, and GIFs should not be used in the printing process. These file formats compress the image to decrease file size. They are better suited for storing archival material or low-resolution media such as TV and the Internet. These file formats will be covered in detail in Chapter 21.

An EPS (Encapsulated PostScript) file is the second most popular file format in printing. You will use an EPS file only in certain circumstances, however. An EPS is appropriate in an image file that contains a vector shape of some sort. For example, if your cartoon is drawn in a vector application such as Adobe Illustrator or Macromedia FreeHand, it will be output as an EPS file.

Resolution: DPI

The dpi (dots per inch) measures the resolution of your image. In the printing process, ink is distributed over the paper in dots. The more dots per inch, the more difficult it is to notice the individual dots. Therefore, the higher the dpi, the better the image quality. Some computer applications

measure resolution in terms of pixels per inch (ppi). This translates directly to dpi. The two can be used interchangeably.

Printers usually ask for 300 dpi for photographs and illustrations with color or gray tones. Black-and-white line drawings should be 600 dpi or higher. When in doubt, always scan your work at a higher resolution. You can later reduce the resolution without harming image quality.

If you need to increase the resolution of an image in Photoshop, be sure to deselect Resample Image in the Image Size dialogue box. This allows Photoshop to compensate for the increased resolution by reducing the actual size of the illustration. The final product will be smaller, but the image quality will remain the same.

File Size and Image Size

A digital image has two sizes: the file size and the image size. The image size is the size the image would actually be if it were printed out without reduction or enlargement. This can be measured in inches, picas, or any other unit that measures physical size. A digital file also has a file size—the amount of memory it occupies on your computer. File size is typically measured in bytes (K) or megabytes (MB).

Preparing Line Art for Print

The easiest and most common print-preparation task is preparing line art. Line art, as defined in Chapter 4, is art that is composed of solid black lines. There are no gray tones in line art.

Initial Scan

First of all, scan the line art in as grayscale at 600 dpi. If your scanner has a special setting for bitmap or line art, ignore it. Choose either Grayscale or Black and White Photo. The file size of the initial scan will be extremely large, but don't worry—it will be reduced to a fraction of that in the end.

Setting a Threshold

Open your scan in Photoshop. On the menu bar, go to Image, pull the cursor down to Adjust, and then over to Threshold. In the ensuing dialogue box, you will slide an arrow to the left or right, establishing a threshold value. All pixels darker than that value will become solid black, and all pixels lighter than that value will become white. After setting a threshold, there are no gray pixels—only black ones and white ones.

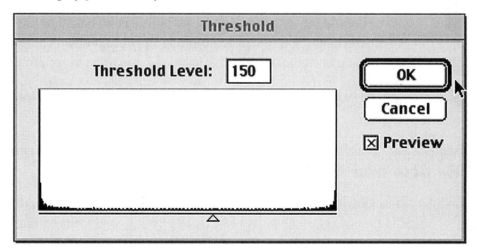

▲ The Threshold dialogue box

Experiment here. Pulling the arrow far to the right will cause your lines to get thicker. Pulling the arrow all the way to the left will leave you with wispy, spider web–like lines (these are not usually suitable for reproduction).

Unsharp Mask

Once you've set an appropriate threshold, go to Filter on the menu bar, pull down to Sharpen and over to Unsharp Mask. Enter 500 for the amount, 1.5 for the radius, and 10 for the levels. Click on OK. Repeat this step.

Converting to Bitmap

Now go to Image, pull down to Mode and over to Bitmap. A dialogue box will appear with many choices of Methods. Choose the 50 percent Threshold method. Save the final image as a TIFF.

If you find a mistake later, go to Image, pull down to Mode and over to Grayscale. Now you can easily manipulate the image using any of Photoshop's tools. Make your fix and then convert back to a bitmap—with no degradation of the image's clarity.

QUESTION?

This bitmap looks bad on my screen—should I worry?
The common perception of a bitmap is an image with jagged, "stair-step" edges. Your bitmap is at least 600 dpi, so the jaggedness is technically still there, but it's too fine to be perceived. Print it out on a laser printer if you need reassurance.

Coloring Line Art

Once you've processed your line art, you can go back into the file and add color or shades of gray. Simply convert the image from a bitmap mode to either grayscale or CMYK. You'll use grayscale mode for black-and-white reproduction. CMYK mode is for color work.

Preparing the Layers

After you've prepared the line art in Photoshop according to the directions in the preceding section, open the Layers palette. Double click on the Background layer. A dialogue box will appear. Rename this layer "Line art" and OK the dialogue box.

Select your Line art layer by clicking once on it in the Layer palette box and then click and hold the arrow on the right-hand side of the Layer palette box. You'll see several options. Choose Duplicate layer. When the dialogue box appears, name this layer "Color." You now have two layers: Color and Line art.

Click on the Color layer in the Layers palette and drag it so it's under the Line art layer. Click on Line art and then select Darken from the layer options (it's a roll-down menu that should currently read "Normal"). Now, select the Color layer by clicking it once. You will do all your color work on this layer. You will do nothing more to the Line art layer.

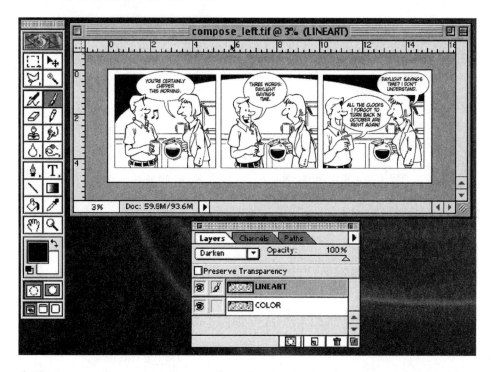

▲ The Layers palette, correctly set up for colorizing. Remember, once you set up the line art layer correctly, you will do all the colorizing on the color layer.

Using the Fill Tool

It's easiest to use the Fill tool to apply large areas of color. If you have drawn closed-off shapes, you can fill that area. You can close off open shapes with your brush tool.

You don't have to close it off in black, though. Use the color you're planning to use to fill in the shape. The image in the Line art layer will contain the actual black lines that will be seen in the final image.

▲ Use the fill color to close off shapes in the Color layer.

Advanced Techniques

Once you've established flat colors with the Fill tool, you can use Photoshop's other tools to add highlights and shading as well as more advanced visual effects. For quickest results, you can select the areas you want to refine with the Magic Wand tool. Once these areas are selected, consider using the Burn tool for highlights and the Dodge tool for shadows.

Final Processing

Save the file as a Photoshop document. This preserves the layers so you can go back and make changes later. For your final output, you can choose Save As from the File menu and save the file as a TIFF. The TIFF will be smaller, because the layers will be condensed onto one single layer.

Now that you've added shading, this may be a rather large file. You may need to sacrifice some line sharpness to gain a more acceptable file size. Go to Image and pull down to Image Size. In the resulting dialogue box, make sure the Resample Image box is clicked. Change the resolution to 300 dpi. If the image size of the Photoshop document slows down your computer, you could do this step earlier in the process without harm.

Processing a Halftone Bitmap

If you've added gray tones to line art for a cartoon that will print in black and white, you have two processing options. Obviously, you can simply use the 300 dpi TIFF, sacrificing some of the sharpness in the lines. Or you can opt to produce a halftone bitmap. The bitmap's advantages include a small file size and crisp lines. To process a halftone bitmap, you would follow the procedure for adding gray tones to line art discussed in the preceding section. However, you would *not* reduce the dpi. The dpi should remain at 600. This is a good time to save your work.

Converting to Halftone Bitmap

Once you're finished adding gray tones, go to Image, pull down to Mode and over to Bitmap. A dialogue box will appear with many choices of Methods. Instead of choosing 50% Threshold, choose Halftone Screen.

The halftone screen breaks down all the shades of gray into dots. Where there are many dots, close together, the gray will be dark. Where there are fewer dots, spread out, the gray will be light. The lines are still solid black.

ALERT!

Once you've converted your drawing from grayscale to halftone bitmap, you cannot convert back to grayscale. The conversion from gray tone to black dots is irreversible. For this reason, it is advisable to choose Save As after this step, saving your grayscale version for possible future modifications.

When you OK this dialogue box, a new one appears with fields for Frequency, Angle, and Shape. Frequency is measured in lines per inch (lpi). This is how many lines of dots fit into one square inch. One hundred lpi is a good frequency and will yield fields of gray that are not immediately noticeable as being composed of dots. At lower frequencies, the dots become more obvious. Choose 45° for the Angle to keep the art from looking mechanical. Choose Round for Shape.

◀ A halftone bitmap at 53 lpi (on the left) and at 100 lpi (on the right)

Resizing and Moiré Patterns

When the halftone screen is being created, the dots are arranged in an equidistant pattern—that is, there is the same distance between all dots.

If this didn't happen, your eye would perceive patterns between the dots—lines, circles, and so forth. That distracting pattern is known as a moiré (pronounced more-AY) pattern.

If your image is resized after the halftone screen is created, you will disrupt the equidistant spacing between the dots and risk creating a distracting moiré pattern. Always alert your client or your printer when you are sending a halftone bitmap. If the image needs to be resized, offer to do it for them from the grayscale version you saved before converting to bitmap. If this option is not viable, lower the halftone screen to about 53 lpi. This will result in a less-distracting moiré pattern if the image is resized.

Understanding Process Color

Color images can be produced in two ways, depending on whether the image is being produced by light or by paints. If the image is being created by light—for example, the image you see on your TV or computer monitor—it is called the RGB color. If the image is being created by mixing paints onto a physical object—for example, applying ink to paper—it is called CMYK or process color.

RGB Color

The RGB color model is named for the three primary colors of light that can combine in different ways to produce most of the visual spectrum. These colors are red, green, and blue. Mixing all of these colors of light together at 100 percent intensity results in white. For this reason, RGB color is sometimes called additive color. The RGB color mode should be used only for an image that will be displayed on TV or the Internet.

CMYK Color

The CMYK color model is named for the four inks that can be combined in different ways to produce much of the visual spectrum. These colors are cyan, magenta, yellow, and black. (Black is abbreviated as "K" to avoid confusing it with "blue.") Mixing cyan, magenta, and yellow together

at 100 percent intensity yields black (or very close to it). For that reason, CMYK color is also referred to as subtractive color.

FACT

Cyan is often used to strengthen black ink. In other words, deep black is often created by adding cyan. In earlier comic books, this procedure was often done for characters' hair. The cyan would sometimes show through in a highlight area, giving the character a streak of cyan running through his or her otherwise jet-black hair.

Process Printing

All printing uses the CMYK color model. In the print industry, it's referred to as using process color. Preparing images for process printing requires an awareness of the limitations of the CMYK color mode. The spectrum produced by CMYK color is smaller than that of the RGB mode.

For that reason, your image should always be converted to CMYK before it is sent to the printer. If it is not, you could be producing colors that look fine on your computer screen (an RGB medium) but are unable to be printed. It is best to work only in CMYK unless you are going to be using some of Photoshop's special filters that operate only in the RGB mode. It is not wise to switch back and forth between CMYK and RGB as you refine your image, as the colors will become gradually duller due to the repeated conversions.

Building Color in CMYK Mode

Many people get confused when trying to mix CMYK color. In elementary school, students learn that the primary colors are red, blue, and yellow, and that all colors can be created by combining these three. And that's true, to a point. The problem is that "red" really means magenta, and "blue," cyan.

Therefore, it is helpful to learn the CMYK makeup for some simple colors. Once you get the hang of CMYK color, it will be easy to manipulate the levels of the four inks to get any color you wish. Until then, use this chart to get started:

Color	% Cyan	% Magenta	% Yellow	% Black
Red	0	100	100	0
Blue	100	50	0	0
Green	100	0	100	0
Orange	0	30	100	0
Purple	60	75	0	0
Violet	50	80	0	0
Aqua	70	0	35	0
Brick	10	95	95	10
Olive	40	20	40	20
Taupe	35	30	45	20
Tan	20	20	40	0
Brown	0	30	40	50

To get less intense colors, simply reduce the percentages of the inks proportionately. For example, to get a light blue, cut the intensity of the inks in half: 50 percent cyan and 25 percent magenta. To get a lighter blue, reduce each percentage to a quarter of the original value: 25 percent cyan and 13 percent magenta.

QUESTION?

Where can I see process printing in action?
Look at the photos and graphics (especially the Sunday funnies) in your local newspaper through a magnifying glass. Since most newspapers print at a relatively low resolution (200 dpi), you can see the interplay between the inks with a magnifying glass.

Preparing Color Art for Process Separation

Process separation is the procedure in which an image is divided into the four colors that will be used to print the final image. Each of the four separations will be used to make a plate for the printing press. For example, in printing a solid blue box, two of the separations would be blank because there is no yellow or black ink used to produce blue. The cyan separation would have a solid box and the magenta separation would have a box screened at

50 percent. When used on the press, these plates would deliver the correct amounts on ink—in the correct areas—to produce a blue box on the paper.

In pixel-based software applications such as Photoshop, the color black is generally divided among all four separations. The result is a much richer black when printed. However, if your document has solid black lines or small black text—like most cartoons—you do not want the black divided among the four inks. If a cartoon were printed this way, each word printed in black would appear on each of the four separations. If even one of these separations doesn't line up exactly with the others, the image will appear blurry.

Therefore, you want the color black to be reproduced on the black plate only. To achieve this, you need to create a special color setting in your Photoshop preferences. The following instructions are written specifically for Photoshop 7. Earlier versions will allow you to create a special color profile, but the necessary commands will be found under different menu options.

1. Go to Photoshop in the menu bar and pull down to Color Settings.
2. Under Working Spaces, click on the toggle bar next to CMYK.
3. Select Custom CMYK.
4. Make sure GCR is selected.
5. Set Black Generation to Maximum.
6. Black Limit should be 100%
7. Total Ink Limit should be 400%.
8. Name the setting "Cartoon CMYK" and OK the dialogue box.
9. Go back to the CMYK toggle bar, click and select Save CMYK, and save this custom profile somewhere safe on your hard drive.

Keep your Photoshop color settings on their original profile whenever you're not processing cartoons. This is not a good profile for processing photographs or other illustrations. Before you begin color work on a cartoon, go back to Custom CMYK in Photoshop's Color Settings and click on Load CMYK. When the next dialogue box appears, path to the place you saved the Cartoon CMYK profile and select it.

Chapter 21

Self-Publishing on the Web

Not that long ago, a struggling cartoonist had only one hope for success—to get into print. The options were limited to newspaper syndication, freelancing for magazines, working for comic book companies, or trying to self-publish a comic book. And competition for those venues was fierce. If those options didn't work out, there was little chance of finding an audience. Today, the situation is different. Thousands of cartoonists find an enthusiastic, appreciative audience online.

The Webcomics Phenomenon

For the beginning cartoonist, the Web is a fantastic place to practice and improve your art. Finding an audience is much easier than in the world of print publication. Furthermore, through e-mail and online message boards, you can get immediate feedback on your work. Finally, since you can post an archive of previous strips, you are much more likely to accumulate new readers who might otherwise be confused by today's strip and leave.

Considering that the oldest cartoon posted on the Internet dates back to only 1991, Webcomics is a medium still in its infancy. But given the ability to discuss your work with both fans and other cartoonists, this is a medium with some considerable power.

The stories told by Webcomics tend to be far more complex than those handled by their print counterparts. The aforementioned archives help to make this possible. So do links to special Web pages that contain background information about your characters and the story you're telling. Where the predominant philosophy in newspaper comics leads cartoonists to consider each day a stand-alone entity, Webcartoonists are free to let the many features of their Web site answer any questions a confused reader might have. That's not to say that the Internet is strictly a practice area for cartoonists who are trying to break into print. Some Webcartoonists are making a significant amount of money from their Web site. A few have even been able to quit their day job, since the money their Webcomic generates is their primary source of income. The short list of full-time Webcartoonists includes the following artists:

- Pete Abrams, *Sluggy Freelance* (*www.sluggy.com*)
- Fred Gallagher, *Megatokyo* (*www.megatokyo.com*)
- Jerry "Tycho" Holkins and Mike "Gabe" Krahulik, *Penny Arcade* (*www.penny-arcade.com*)
- Scot Kurtz, *Player Vs. Player* (*www.pvponline.com*)
- J. D. "Iliad" Frazier, *User Friendly* (*www.userfriendly.org*)

In fact, Iliad's *User Friendly* has evolved into a publicly traded company listed on Canada's TSX Venture Exchange.

Importance of File Size

In the preceding chapter, you learned several methods of producing professional-looking images in print. These techniques, geared toward producing high-resolution images, often result in large files. You cannot use the same files on your Web site that you processed for print. The Internet is a low-resolution medium geared toward an audience with little tolerance for long download times.

Low Resolution

The standard resolution for Internet images is 72 ppi. Since each pixel your monitor displays is able to produce 256 shades of gray and over 16 million different colors, a low-resolution image still looks very good on a monitor. You can post images at a higher resolution (which increases the file size), but there will be very little perceivable improvement in quality.

Loading Times

Naturally, the larger the file size, the longer it takes for your readers' computers to download the file. And many valued members of your audience may still be using older, less advanced technology that will make the process slower yet. Decreasing the resolution of your images will enable your Web site to load faster for your readers.

Bandwidth

The smaller your file sizes, the less bandwidth your site uses. This is significant if the company that hosts your Web site charges you for the bandwidth your site uses. Bandwidth costs can quickly devour a Webcomic's profits.

To understand bandwidth, think back to the information superhighway metaphor. Bandwidth is the amount of space your files take up on the road. If your site uses small compact car–sized files, you're using relatively little

bandwidth. If your site is constructed with huge tractor trailer–sized files, though, you will require more room on the road.

Moreover, your bandwidth is not calculated solely by the size of the files being stored on your Web host's computers. Your bandwidth accumulates each time those files are delivered to another computer. In other words, every time a reader accesses your site, all of the files that get sent to her computer to create your Web site get counted as part of your bandwidth. If your file sizes are large, your site's bandwidth accumulates more quickly.

FACT

Scott Kurtz, creator of the daily comic strip *Player Vs. Player,* has written a very good account of how bandwidth costs can impact a Webcartoonist. His essay titled "Can Success Kill Your Webcomic?" is found online at *www.pvponline.com.*

File Formats

There are several different file formats used to present images on the Internet. Each has advantages and disadvantages. The best file format is the one that gives you the best image quality at the smallest file size.

Graphics Interchange Format (GIF)

GIF is by far the most popular type of image file found on the Internet. GIF files can be compressed to a very small file size and can be used for either color or black-and-white images. They can even be used to create crude animations. However, they are best used for black-and-white images. They can be used for graphics with flat areas of color, but they don't handle color gradients very well. Creating a GIF file for a black-and-white image is very easy. Follow these steps in Adobe Photoshop:

• Assuming you're starting with a black-and-white image that has been processed for print, you'll need to change it to grayscale mode by clicking

on Image in the menu bar and pulling down to Mode and then over to Grayscale.

- Go to Image in the menu bar, click and drag down to Image Size.
- Change the Resolution to 72 pixels and be sure Resample Image has been selected.
- Go to File in the menu bar and drag down to Save for Web.
- Along the right-hand side of your screen you will see a control panel with several options. You'll be focusing on the top area, labeled Settings.
- In the upper left-hand corner toggle box, click and select GIF.
- In the next toggle box down, click and select Selective.
- In the next toggle box down, click and select No Dither.
- In the upper right-hand corner of the Settings area, type 8 into the Colors field.
- Do not select Transparency.
- When you click OK, you will be asked to name the file and save it somewhere on your hard drive. Be sure to include ".gif" at the end.

ALERT!

Many Webcartoonists process their cartoons for the Web and never consider print. If your comic becomes popular, books and other print venues will become a valuable source of income. You don't want to be faced with rescanning hundreds of old cartoons. Process every cartoon for print, save a copy, then convert the file to low resolution.

If you're using a GIF format for a simple color graphic, you'll find it necessary to increase the number of colors and some of the other settings. The change from each adjustment will be displayed on the screen. Choose the combination that looks best at the smallest file size.

If you select Interlaced in the Settings control panel, it will save a GIF that loads on your Web site in multiple passes. The result is the illusion of a faster-loading GIF. The GIF will load immediately as a blurry image and become more and more sharply focused as the GIF loads—usually in three or four steps. Choosing an interlaced GIF will result in a slightly larger file size.

Joint Photographic Experts Group (JPEG) Format

With its ability to support the full 16.7-million-color spectrum, the JPEG format is best suited for photographic images. This format should be used for a cartoon only if the color illustration has a lot of gradation between colors. However, before committing to this format, compare file size and image quality with the same illustration processed as a Portable Network Graphics (PNG) file. Again, the image should be reduced to 72 ppi before you start any formatting whatsoever. As with the GIF, you can fine-tune your JPEG settings using Photoshop's Save for Web command. Use the upper left-hand toggle switch to select JPEG in the Settings control panel. Selecting Progressive has the same effect as selecting Interlaced for a GIF file. A lower number in the Quality field will decrease the file size but may visibly degrade the image quality.

The display will show two versions of the same image. On the left is the original image. On the right is how the image will look with the settings you've chosen. Experiment with the Quality field as well as the toggle bar under JPEG. As you will see, Low yields poor results. For most images, you'll set your JPEG at Medium or High.

Portable Network Graphics (PNG) Format

The PNG format is a relative newcomer to the Internet. However, its excellent image compression and unique features are making it a very popular choice. A PNG format handles both black-and-white and color images well.

As with the GIF and the JPEG, you can adjust your PNG settings in the Save for Web menu command. The settings are similar to the GIF. Select 8 colors for black-and-white images and 256 for color.

The PNG format has a minor problem. It is not recognized by some older Internet browsers. As the years go on, this will have a smaller impact. If you find a large savings in image size without decreased sacrifice in image quality, you may want to risk alienating a few potential readers with older browsers.

Finding a Web Host

Finding a good Web host can be a bit like choosing a long-distance telephone provider. It's difficult to compare different offers. One Web host offers

unlimited bandwidth at a flat rate but doesn't support certain types of programming language (such as Common Gateway Interface, also known as CGI), and another offers a fee that rises along with your bandwidth usage but supports several programming languages. Before you know which Web host is right for you, you must have some idea about how your site is going to operate, which makes it incredibly difficult for the first-timer. Remember, though, as with a long-distance provider, if you find that your current host is insufficient for your needs, you can switch to another with relative ease.

FACT

Most Web hosts will insist that you get a registered domain name. Your domain name is your address on the Internet—*www.amazon.com*, for example. You can register a name for a reasonable annual fee at sites such as *www.register.com*.

Bandwidth

The first variable to consider is bandwidth. Does the Web host offer sufficient bandwidth for the traffic your Webcomic generates? If you're launching a new title and don't have a clue about the traffic it will produce, aim for around 5 gigabytes per month.

Advertising

Some Web hosts offer a low price in exchange for the right to advertise on your site. This usually takes the form of banner ads, but can often include annoying popup ads. There's nothing wrong with advertising on your site—it helps to pay the bills—but many Webcartoonists would rather have greater control over their ads. Besides, if you are personally in charge of the advertising that runs on your site, then you can use that income to help pay your hosting fees—keeping the surplus if any exists.

Contractual Commitment

Some Web hosts require owners of Web sites to sign a contract that obligates the owners to a one- or two-year commitment. You don't want to wait

several years to switch if your Web host is insufficient for your needs. At the very least, look for a host that offers a money-back guarantee for a limited time so you can get out if the host doesn't live up to your expectations.

Disk Space

This is another factor that is difficult to estimate if you're just starting out. Disk space is the amount of computer memory it takes to store everything necessary to present your Web site. About 100 MB of disk space should be more than enough for a fledgling Webcomic. Before you sign, though, make sure you have the ability to get more—even if you have to pay a small fee— for extra space if you need it.

Monthly Data Transfer

Some Web hosts limit the amount of data you can upload per month. This really should not have a significant impact on your Webcomic. Try to get at least 1 gigabyte (1GB) of monthly transfer allowance.

Terms of Service

Finally, be sure to read the Web host's terms of service (TOS) document very closely. It's written in legal language, so take your time and study it carefully. Sometimes Web hosts will try to sneak language into the TOS that could cause trouble later. For example, don't sign with a Web host that claims ownership of the hosted content. Also, pay particular attention to sections regarding your privacy.

QUESTION?

How do I know which host is best for me?
Web Hosting Choice (*www.webhostingchoice.com*) is a service that can help you. It offers several tools to help you research the topic thoroughly. Also, enter the name of a host you're considering to see if anyone has registered complaints against the host.

Online Syndicates

An alternative to buying hosting for your Web site is signing with an online syndicate. These act very much like a newspaper syndicate, handling the distribution and promotion of your cartooning. Few are offering significant income to their members, unless those cartoonists are generating a high volume of traffic. However, online syndicates are still young.

There are many advantages to signing with an online syndicate. For example, many syndicates have automatic updating and archiving software as part of the hosting plan. Also, few syndicates limit their members' hard drive space, bandwidth, or data transfer. In short, online syndicates oversee the business end of Webcomics, freeing you to concentrate on the creative aspect.

Furthermore, online syndicates offer something that a Web host cannot: community. First of all, you will become part of a group of established Webcartoonists who can guide you through the finer details of publishing on the Web. Second, online syndicates cross-promote their strips—that is, they will promote your strip on the site of a larger, established Webcomic. Exposing your title to people who are already predisposed to reading Webcomics will increase your traffic exponentially.

Different online syndicates offer different services to members. For example, some of them also publish some of their members' comics in book form. Pay as close attention to their TOS and membership agreements as you would those of any other prospective Web host. Here are a few established online syndicates:

- Keenspot (*www.keenspot.com*): Membership by invitation only, but you can e-mail a submission asking Keenspot to consider your Webcomic. Your site must run banner ads and a daily cross-promotional newsbox. Profits from the site are split 50/50 between cartoonist and Keenspot.
- Keenspace (*www.keenspace.com*): Free Web hosting for Webcartoonists, with Keenspot's automatic updating/archiving software. Webcartoonists exceeding certain traffic amount may be eligible for a cut of the profits. The waiting list for a site can be quite long.

- Keenprime (*www.keenprime.com*): Membership by paid subscription. Web hosting service from Keenspot. Several levels of hosting options for cartoonists with different needs.
- Modern Tales (*www.moderntales.com*): Membership by submission/acceptance. Modern Tales is a subscription site, so the current strip can be seen for free, but archives and site extras are available only to subscribers. Cartoonist and syndicate split the profits from subscriptions.
- WebcomicsNation (*www.webcomicsnation.com*): Membership by paid subscription. Web hosting service from Modern Tales. Several levels of hosting options for cartoonists with different needs.
- Purrsia (*www.purrsia.com*): Membership by submission/acceptance. Purrsia is a noncommercial and nonadvertisement syndicate—the owners pay the hosting fees out of pocket. Therefore, there are no profits to divide from the Web site itself.
- Comics Sherpa (*www.comicssherpa.com*): Membership by submission/acceptance. Comics Sherpa has connections to Universal Press Syndicate (UPS), a newspaper syndicate.
- Wirepop (*www.wirepop.com*): Membership by submission/acceptance. Wirepop is for manga-style comics only. Creator gets a percentage of the profits.

If your site features a new cartoon every day, you'll want automatic updating and archiving. That way, every day a new comic appears on your site and the old one gets filed in a searchable archive. Keenspot cofounder Darren Bleuel wrote a CGI script you can download at *www.keenspot.com*.

Many Webcartoonists turn to self-hosting once they become established. None of the creators who make a living doing Webcomics are hosted by an online syndicate. That's not to say that it's impossible—it just hasn't happened yet.

Paying the Bills

It is possible to make money doing a Webcomic, but it's difficult. Much depends on your abilities as a businessperson. It's not enough to generate large amounts of traffic through your Webcomic. You have to find ways to get those readers to open up their wallets. You can do this directly, through selling them merchandise, or you can do it indirectly, through presenting advertisements for goods and services they will buy from someone else.

Advertising on Your Site

Most Internet advertising is sold according to a CPM measurement. CPM stands for "cost per thousand" impressions (M is the Roman numeral that stands for 1,000). An impression is counted each time a page loads on your site with an ad on it—regardless of whether the reader clicks on the ad.

If you decide to sell advertising on your site on your own, you will need to buy software that rotates the banners that appear on your site. The banners must be rotated so a company doesn't use up a huge amount of its CPMs on one reader clicking through your archives. Central Ad (*www.centralad.com*) and Open AdStream (*www.247realmedia.com/products/adserve.html*) are two such engines.

Another option is to enter into a partnership with a company that distributes Internet advertising. This frees you from the responsibility of selling ads for your site. However, you'll receive a smaller amount of revenue since you're now splitting the profits with a third party. Furthermore, many Internet advertising companies refuse to do business with sites that don't generate a hefty amount of traffic. Doubleclick (*www.doubleclick.com*), Adtegrity (*www.adtegrity.com*), and Engage (*www.engage.com*) are only a few of the many companies that distribute Internet advertising.

If you don't generate the kind of traffic that makes you a good candidate and you don't want to be a salesperson yourself, you still have another option. The Internet search engine Google (*www.google.com*) offers AdSense. AdSense distributes ads that correspond with a Web site's content. However, you get paid only for the ads that readers click.

Selling Merchandise

Another way to produce revenue from your Web site is to sell your readers merchandise based on your comic. You can freely merchandise just about anything with your characters printed on it. T-shirts, coffee mugs, mouse pads, posters, and books are often popular with fans.

Perhaps the best way to handle merchandising is to do it yourself. A local printer or T-shirt shop will probably offer you the best price for your budget. On the downside, you'll need to buy the merchandise in bulk—few companies can print just a dozen mugs or T-shirts. If the merchandise doesn't sell on your site, not only will you lose your initial investment, but you'll be stuck with a garage full of merchandise. One additional note of caution: You are providing entertainment to an international audience, so be prepared to handle overseas shipping.

ALERT!

Although laws regarding sales over the Internet and state sales tax are currently in flux, you may still be responsible for collecting sales tax. Contact a reputable certified public accountant (CPA) in your area before jumping into online sales.

CafePress (*www.cafepress.com*) offers a service through which you can upload an original image and arrange for it to be printed on demand. They offer several types of merchandise, from apparel to gift items. They also provide an online store through which purchasing and delivery is handled automatically. They print using a heat-offset system (similar to iron-ons), so they're able to print merchandise in the necessary quantities after it is ordered.

Another way to merchandise your Webcomic is to arrange for the individual cartoons to be collected and printed in book form. Plan Nine Publishing (*www.plan9.org*) specializes in such books for Webcomics. You must submit at least 270 cartoons in print to be considered. If accepted, Plan Nine also acts as seller and distributor of the books. The profits are split between Plan Nine and the creator at a predetermined percentage.

Web Design Basics

The design of your home page should be attractive and it should load quickly. The faster your page materializes on a reader's screen, the better. That means editing out any unnecessary elements. The essentials—like the comic strips, the title, and your name—should appear near the top of the page. Internet readers dislike sites that require a lot of scrolling. In addition to the basic essentials, there are a few elements that you should consider including on your home page.

About This Comic

You should supply a link to a separate Web page that contains information about your comic. Supply the kind of background information a new reader might require to understand your comic. Include character biographies and a synopsis of the current story line, if applicable.

Archives

Your home page should have a link to your archives. Encourage new readers to read back through your previous material. The more they read, the more they are liable to get hooked on your comic and bookmark your Web site for daily reading.

Contact Information

Putting your e-mail address on your home page makes it easy for readers to contact you with feedback, questions, or comments. One of the truly unique aspects of Webcartooning is the relationship you'll build with your readers. The more they communicate with you, the more you'll be able to improve as a cartoonist. Make it easy for them to get in touch.

Copyright

At the bottom of your home page, include a copyright notice. It can be as simple as the following: "© 2005 [Your Name], All rights reserved." You can get the "©" by hitting Option-g on your Mac or Alt-g on your PC. (Copyright will be covered more thoroughly in Chapter 23.)

Understanding Web Statistics

Now that you've started publishing on the Internet, you'll want to gauge how you're doing. There are several traffic counters available. Site Meter (*www.sitemeter.com*) is free and provides very detailed statistics. Webalizer (*www.mrunix.net/webalizer*) is also a fine counter but requires some advanced knowledge of Internet programming. Once you've installed a counter, you should become familiar with the terminology.

- **Hits:** Every item that contributes to building a page counts for one hit. A page with four graphics will count for five hits because the HTML document that constitutes the pages is counted as well.
- **Page views:** The number of HTML pages served from your site. If one person looks at your home page and three pages of archives, she has been counted for four page views.
- **Visits:** Visits are counted by tracking the individual Internet service provider (ISP) addresses of the people who visit your site. It should indicate how many individuals were at your site, except that sometimes a proxy server that serves several people may count as only one ISP address.

When you hear someone bragging about how many *hits* his Web site gets, be wary. It's not a legitimate indicator of Web traffic. Most Webcartoonists measure their traffic by the number of page views their counter tracks.

Building Traffic

Once you've started self-publishing on the Internet, you'll need to find a way to attract potential readers to your site. Don't get discouraged—the first couple of months can be devastatingly slow. The best use of your time during this period is in activities that help you drive traffic to your site.

Networking

The most direct way to get some traffic to your site is to convince an established Webcomic to link to your site. Exercise proper etiquette when approaching a fellow Webcartoonist for a link. In a brief e-mail, explain that

you're launching a new strip. Provide your site's Web address and politely ask the Webcartoonist if he or she would consider linking to your site.

Often Webcartoonists will link to another comic only if they think that the comic would be appreciated by their readers. If they decide against linking to you, it is not necessarily an indication that they don't approve of your strip. They may have simply decided that it's not the right material for their audience.

Your mother may have told you that you should always bring a gift when visiting someone's house. This advice works well on the Web, too. Attaching "fan art"—your drawing of the other Webcartoonist's characters—will give that Webcartoonist some extra content for her site and a good excuse to link to your site.

Web Rings

A Web ring is a system of linking to and from other sites of a similar theme. In becoming a member, you display the Web ring's banner somewhere on your home page. The banner consists of links to other Webcartoonists' sites. In addition, a link to your site gets added to the banners displayed on the other members' sites.

Web Organizations

There are several online groups and organizations available to help Webcartoonists get more traffic. For example, at OnlineComics.net (*www.onlinecomics.net*), you can submit an ad for your Webcomic free of charge. You can also buy ads that get better promotion on the site. Webcomics are grouped into categories to make finding your strip easier for a reader who might be interested in your subject matter.

There are also several sites that report Webcomics news. Many welcome a short introductory message from beginning Webcartoonists. Among them:

- Comixpedia (*www.comixpedia.com*)
- Digital Webbing (*www.digitalwebbing.com*)

- The Comics Journal message board (✍*www.tcj.com/journalista/*)
- The Comicon.com forums (✍*www.comicon.com/forums*)
- The Keenspot public forum (✍*http://forums.keenspot.com/viewforum.php?f=1*)
- The Modern Tales forum (✍*www.talkaboutcomics.com*)

When posting a promotion for your Webcomic in a forum or message board, it is considered good etiquette to begin the label of the post with "HYPE:" in all caps.

Search Engines

A great way to promote your site is to ensure that Internet search engines can find it. Luckily, it's not necessary to submit your site to each search engine. Rather, when you submit a site to the Open Directory Project (✍*http://dmoz.org/add.html*), it gets added to all of the major search engines. Be sure to follow the instructions carefully. Not every search engine uses the data collected by this site—Yahoo.com does not—but many do.

Chapter 22

Getting Published

As a cartoonist, you have thousands of opportunities to make your skills pay off. Publishers use cartoons for all sorts of products, from book design to greeting cards to advertising. There are a few full-time jobs available; the vast majority of the work is freelance. To survive in this climate, you must know where the opportunities lie—and how to behave professionally once you find them.

Approaching a Client or Publisher

Whether you're trying to sell your cartooning to a greeting card company or a comic strip syndicate, take some time to research how they prefer to be contacted. Most companies will be much more receptive to your query when it's clear that you respect their system. Most publishers and printers make their expectations clear on their Web sites. In general, the majority of companies follow some standard procedures. Here are a few tips to stay in the clear:

- Never send original art. Your submissions should be clean photocopies.
- Make sure each sample has your contact information printed on it.
- Include a self-addressed stamped envelope (SASE) so they can contact you easily.
- Include a query letter. This is a brief introduction that explains the purpose of the mailing and includes your contact information.
- Don't fold your samples. Slide a piece of cardboard into the envelope to keep it from getting bent in the delivery process.

Above all, think twice before picking up the telephone. Following up a mailing with a telephone call is risky. You might be remembered as a nuisance. For better results, wait a few months, double-check your contact information, and mail another submission.

Artist's and Graphic Designer's Market is an annual publication that contains contact information for publishers of greeting cards, magazines, and books. It also has information on contacting newspaper syndicates and other opportunities for cartoonists. There is also an excellent section on negotiating pay rates and royalties.

You will be mailing a lot of samples to several different companies. Keep a log of the companies you've contacted, the date the samples were mailed, which samples were mailed, and whether you've received a response. This will help you to organize your mailings—timing follow-up mailings correctly and avoiding sending the same samples out to the same prospective client.

Greeting Cards

A greeting card is an excellent vehicle for cartoonists. In most cases, the setup appears on the cover, and the punch line is delivered within. The act of opening the card is a natural tension builder. It's fertile ground for you to flaunt your talents.

However, chances are you will not be flaunting those talents for Hallmark or American Greetings. They have a stable of artists and steady freelancers they use. Don't hesitate to approach them for full-time employment if that's your desire, but don't expect freelance jobs. Luckily, that leaves about 2,000 other greeting card companies to choose from.

As you're brainstorming greeting card ideas, consider the fact that about half of the greeting cards sold are seasonal—the other half are considered everyday cards.

Seasonal		Everyday (rounded)	
Christmas:	61%	Birthday:	61%
Valentine's Day:	25%	Other:	13%
Other:	4.5%	Anniversary:	8%
Mother's Day:	4%	Get Well/Feel Better:	7%
Easter:	3%	Friendship/Encouragement:	7%
Father's Day:	2.5%	Sympathy:	6%

Greeting card companies work on seasonal materials about six months before the season. Don't bother sending Christmas samples after June.

FACT

According to GreetingCard.org (*www.greetingcard.org*), over 90 percent of U.S. households buy greeting cards, and the average greeting-card-buying household buys thirty-five cards every year. Women buy over 80 percent of the cards.

Magazine Submissions

Magazines are particularly well suited for cartoonists. Of course, magazines often use single-panel cartoons to enhance their pages. But they also use cartoonists to provide illustrations for stories. These illustrations are called spot illustrations. Spot illustration assignments present a unique challenge for a cartoonist: Design an illustration that works with a written piece to present a topic.

Like the greeting card industry, it is unlikely that a beginning cartoonist is going to catch the attention of the best-paying magazines such as *Playboy* and *The New Yorker*. However, there's an entire universe of magazine publishing that you're probably not even aware of. These smaller magazines don't pay as well, but getting published in them will have a tremendous pay-off in terms of experience and portfolio pieces for your next promotional mailing.

It's best to pick up a few copies of a publication and page through them before mailing a query. If you see cartoons and spot illustrations, chances are that the magazine is a good candidate. Flip to the first couple of pages of the magazine and look for the masthead—a box with the publication's address and the names of the people in charge of each department. Send your query to the individual who is listed as the Art Director or the Cartoon Editor.

Theme Magazines

The first stop for a cartoonist assembling a list of potential clients is theme magazines. Write a list of your favorite activities and include your current life situation. Then, go to the newsstand or bookstore and peruse the magazines there. Look for publications that match your list.

For example, maybe you are a parent of two children who enjoys golf and playing video games. If so, your list would include *Parenting, Child, American Baby, Nick Jr., Parent & Child, Parents, Golf, Golf Digest, Golf Illustrated, Golf Tips, Golf Week, Golf World, PC Gamers, GamePro, Electronic Gaming Monthly*, and dozens more. Matching your personal interests with the client's theme increases the chances that you will be able to provide the kind of cartoons that it will appreciate.

Trade Magazines

Don't forget trade publications when assembling your list of potential clients. Trade publications are magazines that cater to a particular occupation. For example, *Waste News* is a bimonthly publication that covers the solid- and hazardous-waste management industry.

You can approach trade magazines in much the same way you did theme magazines. If you're a beginning cartoonist, you probably have a day job. As such, you're privy to a wealth of humor that is particularly entertaining to other members of that profession. You can use trade magazines to market specific cartoons as well. For example, if you have a killer cartoon about what two eyeglasses would say to each other, you might consider *Eyecare Business.*

Trade magazines are marketed directly to people in the publication's targeted industry, so they can be hard to find. Try Web sites such as TradePub (✐*www.tradepub.com*) and Large Print Reviews (✐*www.large printreviews.com*) for a listing of several trade publications.

Local Magazines

Finally, you should consider local magazines in your search for potential clients. They have a limited distribution area, but they often use freelance artists. Every region has elements that make it unique—whether it's squid on the ice of a Detroit Red Wings hockey game or the best place to get a cheesesteak in Philadelphia. You can use your knowledge of the region to provide cartoons that are especially attractive to members of that community.

Newspaper Submissions

Newspapers no longer present an appealing prospect for the freelance cartoonist. There are a few art directors who hold on to a miniscule budget for freelance artists, but not many. For the most part, newspapers get most of their illustrations from a small group of full-time artists. For the rest of their

needs—daily comics and a few spot illustrations—newspapers subscribe to syndicates.

Editorial Pages

You may be able to use the current state of the newspaper industry to your advantage. Larger newspapers may have an editorial cartoonist on staff, but the majority of them get editorial cartoons from a syndicate. That leaves a demand for cartoons on local and regional subjects. You may be able to negotiate a regular freelance engagement with the editorial page editor of midsize and smaller newspapers. They will love the opportunity to print high-quality editorial cartoons on local issues.

Features Section

Similarly, you may be able to arrange a similar deal with the features editor if you can produce a cartoon feature that addresses local topics. It's unlikely that you'd be able to convince him to publish a daily feature, but you might be able to negotiate a less frequent schedule. Study your newspaper's Features section. It probably addresses different topics in rotation every day: Monday is food, Tuesday is fashion, Wednesday is entertainment, and so on. Perhaps you can develop a weekly cartoon that would work well within the parameters of one of these themes.

Alternative Newspapers

Large metropolitan cities have an additional source of potential income for the freelance cartoonist. Alternative newspapers are usually published weekly and feature a strong leaning to offbeat topics and local entertainment. They often run comics from self-syndicated cartoonists.

Alternative newspapers—sometimes referred to as alternative newsweeklies—are very receptive to cartoonists who are considered too raw for syndication. There are more relaxed limits on language and mature content. Furthermore, topics such as politics and social criticism are much less likely to cause a furor at an alternative newspaper.

Don't feel obligated to limit your queries to local newsweeklies. There are several across the country that hire freelance cartoonists. Yahoo. com has a very thorough listing on alternative newsweeklies. You can find it at ✑*www.yahoo.com*. You will be able to find contact information at each paper's site.

Campus Newspapers

Newspapers published by colleges and universities can also be a great place to try to get your cartoons published. Many campuses run a daily newspaper as part of their journalism curriculum.

Campus papers seldom have a budget to spend on cartoons, so you might have to offer your feature for free. On the bright side, your cartoon will be read by a very favorable demographic. College students usually have a great deal of disposable income. If you're marketing merchandise related to your comic, it may be well worth offering it to college publications for free. The Open Directory Project has a good listing of campus newspapers by state: ✑*www.dmoz.org/News/Colleges_and_Universities/Newspapers/ United_States.*

The Newspaper Syndicate

The decline of the newspaper industry is leading to the decline of the newspaper syndicate. For decades, syndication was the only option for a cartoonist to publish her comic strip or single-panel comic on a large scale. Now, with the growth of the Internet, the newspaper syndicate faces becoming obsolete.

The Bad News

A syndicated cartoonist's success depends on the willingness of a newspaper editor to rearrange the comics page to make room for a new addition. This usually means discontinuing an existing cartoon, which will certainly

alienate some readers. With newspaper circulation as poor as it is, editors are reticent to do anything that upsets even a few readers.

As a syndicated cartoonist, you will share the profits with the syndicate. Newspapers pay between $10 and $15 per week for a syndicated comic. Most comics don't provide an adequate livable wage until more than sixty newspapers are running the feature. Many newly syndicated cartoonists have found themselves taking second jobs—working on their cartoons in their off-hours.

FACT

For a bracing look at newspaper syndicates, read Stu Rees's Harvard Law School thesis written in 1997. You can find it online at ✐*http://stus.com/ thesis.htm.* In addition to the eye-opening discussion of a topic most cartoonists view with rose-colored glasses, there is a copy of a standard syndication contract.

Submitting a Cartoon Feature to a Syndicate

Doom and gloom aside, it's still the goal of many cartoonists to see their feature in newspapers. Each syndicate has its own guidelines for submissions. You can find specific information on their Web sites:

- Creator's Syndicate: ✐*www.Creators.com/index2_submissions.html*
- King Features: ✐*www.kingfeatures.com/subg.htm*
- Tribune Media Services: ✐*www.comicspage.com/submissions.html*
- United Media: ✐*www.unitedmedia.com/uminfo/um_faq.html#26*
- Universal Press Syndicate: ✐*www.amuniversal.com/ups/submissions.htm*

In general, syndicates ask to see between four and six weeks' worth of dailies. Dailies are considered to be the strips that run Monday through Saturday. In other words, that's between 24 and 36 samples of your work. Some syndicates ask to see a sample for the Sunday comic, but not all of them list it as a requirement. Photocopy your originals so they fit onto standard, letter-sized paper (8.5" × 11"). Be sure to include your contact information on each sheet. Many syndicates also request a brief cover letter and a character sheet. The character sheet should consist of drawings of the

central characters in the comic with a short biography for each. Remember to include your contact information on these pages as well.

Under no circumstances should you telephone a syndicate. They get far too many submissions every year to field phone calls from even a small percentage of them. If your comic fits their needs, they'll contact you.

Self-Syndication

If you've been turned down by the syndicates but still believe your cartooning has what it takes to be printed in newspapers, you may wish to consider self-syndication. Self-syndication is a daunting task and requires a great deal of persistence. As a self-syndicated cartoonist, you will not only produce the feature, but act as the salesperson as well.

Promo Folder

Your first order of business is to design a promotional folder. This should feature a cover illustration on the front, along with the title of your feature. On the back, you can include a little information about yourself as well as your contact information. If you can afford printing on the inside, you may choose to present a few of your best comics there, along with an introduction to the characters.

▲ An example of a promo folder from the front (left), inside (center), and back (right)

Printing will be expensive. The folder should be printed on heavy, glossy stock. Also, printers cannot run a job like this for just a dozen copies. You'll be required to order by the hundreds.

Color printing is preferable, but it is expensive. Since your promo folder will likely be printed in black and white, take special care in its design. Big, bold line art works very well. This is going to be the first impression an editor receives. Make it one of confidence and professionalism.

Finally, try to design the promo folder with longevity in mind. You'll be ordering several hundreds of these, so you'll be using them for at least a couple of years. Don't include information that's likely to change.

List of Newspapers

Your next obstacle is to assemble a list of potential newspapers. Be sure to include alternative newsweeklies and campus newspapers if you think your feature is appropriate for those publications. Since there are so many daily newspapers, going to the Web site of each and locating the contact information would be incredibly time-consuming.

U.S. Newspaper List (*www.usnpl.com/address/npmail.html*) offers a list of newspapers' contact information. For $45, you can download a list of over 3,000 current newspaper addresses. The list is presented in several formats, including a Microsoft Excel file and a Microsoft Word document designed to print on Avery 5160 mailing labels.

What to Send

Your promo folder should contain four to six weeks of sample cartoons. You should also include a cover letter and a character sheet. Feel free to send any additional promotional material as well. If you've been featured in any reviews or newspaper articles, include a photocopy.

Finally, include a rate sheet—a page that advertises your pricing. The rate sheet should always be separate from the promo folder because you may change rates depending on the newspaper in question and your level of success in general. You may want to start out by offering the comic for free—or on a limited free trial.

Mailing out Promos

After you stuff your promo folder with the appropriate materials, mail it flat in a manila envelope. Don't address the envelope by hand. Use your computer's printer to print both the newspaper's address and your return address on labels.

Address the package to an individual whenever possible. Newspapers seldom have "comics editors." Most likely, the responsibility of the daily comics falls to someone in the newspaper's Features department who already has full-time responsibilities elsewhere.

Place a call to the main operator of the newspaper and ask for the name of the person in charge of the comics. Resist the temptation to have the operator connect you. Remember to get the correct spelling. Address your package to this person and include his proper title at the newspaper.

A Word on Contracts

When a newspaper has expressed interest in running your comic, offer to send them a contract. It doesn't need to be an elaborate piece of legal prose, but you do need to establish some expectations—for both sides. For your part, the contract should state that you agree to provide this specific cartoon feature in an agreed-upon format a certain number of days before it is to be published. For their part, they should agree to print your comic and pay you a certain amount per week on an agreed-upon schedule. Contracts are covered in greater detail in the next chapter.

Delivery Agreement

In entering into a syndication relationship with a newspaper, you must determine how it prefers to have its cartoons delivered. You will probably be asked to send a digital file—such as a TIFF file—to someone at the newspaper. In some cases, the newspaper contracts an outside company to compile its comics pages, and you will be delivering your files to that company, not to the newspaper.

Build on Success

Finally, once you begin to add newspapers to your list of clients, don't be afraid to list them in your next round of mailings. If you've gotten any response from editors or newspaper readers, ask them for permission to use a quote in your promotional material. "Nothing succeeds like success," goes the old adage. The more successful you're perceived as being, the more likely a fence-sitting editor will be to land on your side.

Take some time for shameless self-promotion. Notify the local newspapers and TV stations about your success. Your self-promotion can pay off in more fodder for your folder.

Be sure to put your copyright information on every digital file you send to a client or publisher. It doesn't need to be large—6- or 7-point type works well. If there's room for your Web address and your e-mail address, be sure to include them as well.

Chapter 23

Taking Care of Business

Being a successful cartoonist goes far beyond brainstorming funny punch lines and incorporating them into well-constructed illustrations. In reality, you are starting your own small business. Your success or failure will be directly linked to your competence as a businessperson—how well you understand the nature of your business and the rules that govern it. It's the least glamorous aspect of cartooning, but it's one of the most important.

Copyright Laws

The most significant legal matter for you to consider is that of copyright. Copyright is the right to copy your original art. A magazine may copy it a few thousand times in producing a single edition. A local band may copy it a few dozen times in producing a flyer for its next gig. Either way, copyright laws protect you from someone's printing your work without either paying you or getting your permission first.

Your work is copyrighted from the second the ink is dry. Once your work is finished, copyright law goes into effect. Although the copyright notation is not necessary, it is recommended for several reasons. Primarily, it serves as a warning to someone who might mistakenly think the work can be freely reproduced. It also supports legal proceedings against anyone who does reproduce it without your consent.

FACT

A fictional character from Fred Allen's 1940s-era radio show was so successful that an animation studio based a cartoon character on him. The studio copyrighted both the character and the character's identifiable mannerisms. Later, the voice actor had to get permission from the studio (Warner Brothers) to do the radio character he created (Senator Claghorn), so as not to infringe on the copyrighted character (Foghorn Leghorn).

Copyright Notation

A copyright attribution usually takes the form of a small line of type—perhaps 6 or 7 points in size. The standard notation is: © [Artist's Name], Date of Publication. For example, a work by John Timothy published in 2005 would have the following notation: "© John Timothy, 2005." You can type the © symbol by hitting Option-g on your Mac or Alt-g on a PC.

Spelling out "Copyright"—as opposed to using the © symbol—is an acceptable variation. Also, you may choose to include a short sentence such as "All rights reserved." In any case, copyright law automatically transfers legal rights to a published work to the creator, unless otherwise stated in a contract.

Copyrighting Digital Files

You should always include your copyright notation as part of any illustration you produce—even if the final art is a digital file. If you are producing and distributing digital documents, you can institute a second line of copyright defense. You can include your copyright information as part of the programming of the digital file itself.

In Adobe Photoshop, click on File and drag down to File Info. In the dialogue box that appears, you will be able to enter the title of the piece and your name. There is a caption field in which you can enter other related information. If it's a comic strip, consider transposing the dialogue from the strip into the caption field. Under the caption field is the Copyright Status toggle box. Click on this and drag to Copyrighted Work. Type your copyright notation into the Copyright Notice field. If you have a Web site at which an individual can find additional information about purchasing reproduction rights, enter it in the Owner URL field.

Registering a Copyright

For the greatest amount of protection, you can register your copyright with the U.S. Copyright Office. There is a filing fee of $30. Their Web site (*www.copyright.gov*) has detailed information available for download. Of particular interest are circulars numbered 40, 40a, 41, and 44. You can also call (202) 707-3000 Monday through Friday, 8:30 A.M. to 5:00 P.M., EST, for answers to specific questions. If you are copyrighting a continuing series of cartoons—such as a daily comic strip—you may submit your series as a unit. You will need to send photocopies of two or more unpublished strips to qualify for registration. However, realize that your registered copyright will apply only to copyrightable sections included in your submissions. Therefore, be sure the strips you submit as part of your registration include any elements you'd like protected—particularly the characters.

C-Net (*www.c-net.com*) offers a service through which you can register for a copyright over the Internet. You'll pay a small service fee in addition to the regular filing fee.

Trademarking Your Work

A trademark is a word, phrase, symbol, or design—or a combination of those things—that identifies and distinguishes a provider of goods or services. In your case, the service you provide can be considered to be a continuous series of cartoons, such as a daily comic strip. Therefore, any images that identify your work—a logo, for example—need to protected with a registered trademark.

The U.S. Patent and Trademark Office Web site (*www.uspto.gov*) has detailed information on the topic. They also have a search engine you can use to find out if another individual already owns the trademark on the combination of words, phrases, symbols, or designs that you're trying to register. Filing a trademark is expensive—you'll pay over $300. Many cartoonists find adequate protection in a copyright, but if you have a recognizable logo or slogan, you may wish to consider registering a trademark.

The Importance of Contracts

Every business relationship is built around a written contract. For the beginner, this can be a difficult concept to grasp. After all, most people view contracts with distrust—we remind ourselves to "read the fine print," for example, when signing up for a credit card. Often, we tell ourselves, companies hide things in contracts that they use to their advantage later. So it's difficult to be on the other side of the table—the one asking someone else to sign on the dotted line.

Difficult as it may be, it is completely necessary—and expected. Once you start doing business with a client or publisher, they will not be offended when you offer to deliver a contract. It's not a sign of mistrust. A contract is simply a way that two entities in a business relationship explain their expectations.

Drafting the Contract

Your contract does not necessarily have to be a multipage document written in incomprehensible legal jargon. In many cases, you can draft your own contract or use one from the *Graphic Artists Guild Handbook*. However,

if you have any doubt as to the quality of the contract, don't hesitate to hire a lawyer. The expense is worth it—not only in terms of the protection, but for peace of mind as well.

The *Graphic Artists Guild Handbook of Pricing and Ethical Guidelines* is an indispensable resource for the freelance cartoonist. Not only does it explain legal issues in detail, it offers sample contracts and pricing guidelines for different situations as well.

First-Time Rights and One-Time Rights

It is vital for you to identify the rights a publisher or client has in reproducing your work. If the contract leaves this area undefined, the publisher may have the freedom to reproduce your cartoons many more times and in many more ways. For example, if your contract doesn't limit a publisher's reproduction rights, the publisher may print your cartoon in subsequent editions of the publication as well as on coffee mugs, Web sites, and any other medium—making money licensing your work.

Therefore, your contract should always stipulate that the publisher has either *one-time rights* or *first-time rights* in reproducing your work. A publisher with one-time rights is limited to reproducing your work one time. For a magazine publisher, that "one time" could actually represent a million copies, but the cartoon would be protected from appearing in future issues of the magazine.

A publisher signing a contract specifying first-time rights is paying for a cartoon that has not been published anywhere before. You can negotiate a higher price for first-time rights. However, if you're sending the same samples to different prospective publishers, be sure to keep accurate records so you don't mistakenly offer the same first-time rights to two different publishers.

In some cases, the publisher will have a standard contract that will guide the business relationship. Read the contract very carefully before signing it and pay attention to phrases such as "all electronic rights" or "all rights in the media now in existence or invented in the future in perpetuity." It is poor

practice to sign away all your rights to an original cartoon. If the publisher insists on buying rights that extend beyond a one-time use, you are entitled to negotiate a higher price.

QUESTION?

How can I decode a contract?
Go to the Graphic Artists Guild's Contract Monitor (✍*www.gag.org/ contracts/contracts.html*). It has a thorough glossary of commonly used contract terms as well as an archive of actual contracts, including one from King Features Syndicate.

Royalty Agreement

A royalty is a percentage of the price of the item that is paid to the artist, based on how many units were sold. If your cartoons are used as a central selling point of an item, you're entitled to request royalties. A book that collects several months of your daily single-panel comic, for example, would be merchandise on which you could negotiate royalties.

Reprint Rights and Original Art

Keep in mind that in offering reproduction rights to a publisher, you retain the original art to do with as you wish. Future reproductions will be dictated by the contract you signed. If it was a *one-time* or *first-time* contract, you can offer *reprint rights* to another publisher (at a lower price, of course). Regardless of the contract, you can reproduce the image in any self-promotional material. Finally, you retain the right to sell the original art.

Work for Hire

If you work as a full-time artist for a company, that company has full rights over the reproduction of the art you create on the job. This is a concept known as work for hire. As the argument goes, your benefits such as health insurance and compensation for job-related injuries constitute payment for

the rights you're giving up. Sometimes a freelance artist will be faced with a work-for-hire contract. In this situation, the artist gives up all claims to the copyright of her work, granting it to the publisher. Legally, the publisher is considered the author of the work. The publisher may then reproduce the work freely in any medium into perpetuity.

A work-for-hire contract must be approached cautiously. If you do accept a work-for-hire project, do not use any characters or concepts that you'd like to keep ownership of. At the very least, you should negotiate a price that is much higher than your standard price, since you will not have a chance to recoup any future earnings from this work.

Paying Taxes

Paying taxes is a normal part of doing business. As a businessperson, you'll be required to familiarize yourself with applicable tax laws and to keep accurate records of any transactions you're involved in. The better prepared you are for tax season, the less likely you'll be to pay too much.

Sales Tax

Merchandising is a great way to generate additional income from your cartooning. Readers often buy coffee mugs and T-shirts emblazoned with their favorite cartoon characters. If you operate a Web site, you can reach a large number of potential customers and facilitate the ordering process quickly and easily.

ALERT!

Be sure to operate within the limits of the laws in your area. If you sell more than a certain dollar value, you will be required to report that income. You may be also required to charge sales tax for the goods you sell and remit that money to the state.

There is a bright side, however. If you're collecting sales tax, you need to register as a vendor. You will be issued a resale number that allows you to make tax-free purchases on those materials used in producing your goods.

Record Keeping

Be sure to keep accurate records of all of your purchases and sales. Keep the receipt from every purchase of cartoon-related merchandise. Write a brief description of the item and its usefulness to your cartooning at the top of each receipt. Issue a numbered sales slip or invoice with every sale, and retain a copy for your records.

File these documents in a fireproof lockbox. Try to keep your files in a neat, organized manner. If you end up getting audited, the last thing you'll need is to try to organize a box full of loose receipts under pressure.

Hiring a CPA

Becoming a professional cartoonist is much like launching a small business. As such, it's a good idea to have someone on your side to help you navigate the foreign terrain. Try to find a CPA who has experience dealing with freelance artists. Ask colleagues for referrals.

A CPA can help you in several ways. If you're selling merchandise, your CPA can get you registered as a vendor in the state and explain all of the local requirements. Furthermore, your CPA can help you find the deductions necessary to keep your small business running. If it is used for cartooning, some of the cost of a new computer may be deductible. Here are some other possible deductions:

- Your art supplies—pens, ink, illustration board, and so forth—may be deductible.
- If you've completely set aside a room in your house as a studio, a portion of your mortgage or rent payment may be tax deductible.
- If it is used to help produce your final work, the cost of a new computer or computer equipment may be at least partially deductible.
- Any travel you incur in promoting your cartooning may be at least partially deductible.

Certainly, a good CPA isn't cheap. But the money you'll save and the guidance you'll receive are well worth the expense. Besides, you can deduct your CPA's fees on next year's taxes.

Comic Conventions

The best way to promote your cartooning is to target areas in which cartoon fans congregate. Your local comic shop is one such place. But to expose your work to a large amount of cartoon fans in a short time, go to a comic convention.

To find a comic convention near you, pick up a copy of *Wizard* magazine. Published monthly, *Wizard* covers the comic book industry. Near the back of every issue is a state-by-state listing of comic conventions.

Attending a Convention

If you've never been to a convention—colloquially referred to as a con—your first trip should be as an attendee rather than as an exhibitor. If it's possible to preregister, do so. Often the lines for registration get very long and, depending on the size of the con, you can waste hours waiting to get registered.

Once you're registered, roam around the convention floor. You'll probably notice that the majority of the exhibitors are involved in the comic book industry. However, you can usually find the entire spectrum of cartooning represented at an average con.

Most of the exhibition areas are set up as booths. Artists and writers sit at the booths and try to expose their comics to as many people as possible. Comic-related merchandise is available—often signed on the spot by the cartoonist. Pay attention to which booths draw the largest crowds and why.

Finally, look at the schedule you received when you registered. Many cons have programs that run throughout the convention. These programs discuss comics-related topics and issues. Often, comic creators whose work fits the theme of a certain program will be in front, discussing the topic and answering questions. If your experience would qualify you to be involved in one of these programs, contact the convention officials next year.

Exhibiting at a Convention

Having familiarized yourself with comic conventions, you're ready to exhibit your work. Most conventions will offer several levels of booths. The most expensive booths, obviously, have the best exposure to con traffic.

Usually, conventions set aside space for an "Artists Alley." This is a place for individual artists to promote their comics and sell their merchandise. The space is small—sometimes as little as half a table—but the price is right. Artists Alley tables get very good traffic. More importantly, they offer great opportunities to meet other cartoonists.

If you buy booth space, you will often get a table and a significant amount of space behind the table to sit and store your merchandise. This is preferable if you have a large amount of products to sell. If you're planning on bringing a computer or any other electrical appliance, make prior arrangements. Access to an electrical hook-up often costs extra.

If you do decide to sell merchandise, you may be required to charge sales tax. Be prepared to fill out the necessary forms with information such as your vendor number. Bring enough money to make change. You'll need plenty of one-dollar bills and several rolls of coins. Also bring a lockbox to store your money.

The long registration lines at a comic convention present an excellent marketing opportunity. You have access to a group of people with plenty of time on their hands. Print up some promo booklets that feature your best work and distribute them to the bored masses. If you're exhibiting, don't forget to add your booth number.

Freebies

Your primary goal as an exhibitor is to make people remember you when they go home. Unfortunately, a comic convention can often cause sensory overload in just a few minutes. It's a good idea to have a giveaway. Here are some ideas:

- Print a small booklet of your best work at the photocopy center.
- Use special ink-jet paper to produce magnets with your characters printed on them.
- Use special ink-jet paper to produce temporary tattoos featuring your character.
- Offer to draw sketches incorporating the conventioneer into a cartoon.

Remember, when they register, conventioneers are given a plastic sack to hold all of their freebies. Yours needs to stand out from the other freebies in the sack. No matter how you choose to promote, be sure the promotion works for you. If you're a Webcartoonist, your Web address must appear legibly on the freebie. If you self-publish a comic book, make sure the title and purchasing information are readable.

ALERT!

Spend a little extra on making your booth look good. Many small printers and photocopy centers can print vinyl banners. Ask them about printing a banner that will fit in your booth space. Never attempt to hang these yourself without asking a convention director—the convention center may have union labor with that responsibility.

Appendix A

Additional Resources

PRINT RESOURCES

The Art of Caricature by Dick Gautier, Perigee Books, 1985.

Artist's and Graphic Designer's Market. Edited by Mary Cox, Writer's Digest Books, 2003.

The Business of Comics by Lurene Haines, Watson-Guptill, 1998.

Comedy Writing Secrets by Melvin Helitzer, Writer's Digest Books, 1987.

The Comic Book: The One Essential Guide for Comic Book Fans Everywhere by Paul Sassienie, Chartwell Books, 1994.

Comics and Sequential Art by Will Eisner, Kitchen Sink Press, 1992.

The Complete Book of Cartooning by John Adkins Richardson, Prentice Hall, 1977.

Digital PrePress for Comic Books: The Definitive Desktop Guide by Kevin Tinsley, Stickman Graphics, 1999.

Dynamic Anatomy by Burne Hogarth, Watson-Guptill, 1990.

Graphic Artists Guild Handbook: Pricing and Ethical Guidelines. Edited by Rachel Burd, Graphic Artists Guild, 2003.

How to Draw Comics the Marvel Way by Stan Lee and John Buscema, Simon and Schuster, 1978.

How to Self-Publish Your Own Comic Book by Tony C. Caputo, Watson-Guptill, 1999.

Manga! Manga! The World of Japanese Comics by Frederik L. Schodt, Kodansha International, Tokyo 1983.

Reinventing Comics by Scott McCloud, Paradox Press, 2000.

Understanding Comics: The Invisible Art by Scott McCloud, Harper Collins Books, 1994.

Will Eisner's Shop Talk by Will Eisner, Dark Horse, 2001.

Women and the Comics by Trina Robbins and Catherine Yronwood, Eclipse Books, 1985.

Writers on Comic Scriptwriting by Mark Salisbury, Titan Books, 1999.

Your Career in Comics by Lee Nordling, Andrews McMeel, 1995.

WEB SITES

Blambot

www.blambot.com
Computer fonts for cartoonists.

Comicon.com message boards

www.comicon.com/forums
News on comics and Webcomics.

Comicraft

www.comicraft.com
Computer fonts for cartoonists.

The Comics Journal

www.tcj.com/journalista/
News on Webcomics.

Comixpedia

www.comixpedia.com
Webcomics news and views.

Creator's Syndicate

www.Creators.com
Web presence for newspaper syndicate.

Digital Webbing.com

www.digitalwebbing.com
News on comics and Webcomics.

The Everything® Cartooning Book Web Site

www.everythingcartooning.com
A companion site to this book maintained by the author. Here, you can get answers to your questions and additional information about the more technical

aspects of cartooning. Postings of freelance cartooning opportunities are also available.

Figure Drawing for All It's Worth, by Andrew Loomis
✐*www.saveloomis.org*
Phenomenal figure-drawing guide available for download in PDF and HTML formats.

Keenspot
✐*www.keenspot.com*
Invitation-only Web host featuring over fifty regularly updating comics.

Keenspot public message board
✐*http://forums.keenspot.com/viewforum.php?f=1*
News and discussion about Webcomics.

King Features Syndicate
✐*www.kingfeatures.com*
Web presence for newspaper syndicate.

Greystone Inn by Brad J. Guigar
✐*www.greystoneinn.net*
Author's comic strip, updated daily since February 2000.

Modern Tales
✐*www.moderntales.com*
Web hosting for approved cartoonists.

Modern Tales message boards
✐*www.talkaboutcomics.com*
News and discussion about Webcomics.

OnlineComics.net
✐*www.onlinecomics.net*
Webcomics directory.

Plan Nine Publishing
✐*www.plan9.org*
Webcomics book publisher. Accepted cartoonists can have collections of cartoons published and sold through Plan Nine Publishing.

Planet Cartoonist
✐*www.planetcartoonist.com*

Web resource for every type of cartoonist from comic book artist to animators.

Tag-Board
✐*www.tag-board.com*
Free real-time message board for Web sites.

TalkAboutComics.com
✐*www.talkaboutcomics.com*
Free message-board hosting for Webcartoonists.

Tribune Media Services
✐*www.comicspage.com*
Web presence for newspaper syndicate.

U.S. Copyright Office
✐*www.copyright.gov*
Web site of the U.S. Copyright Office, featuring information on how to register a copyright.

U.S. Newspaper List.com
✐*www.usnpl.com/address/npmail.html*
Site offers a mailing list of U.S. newspapers.

U.S. Patent and Trademark Office
✐*www.uspto.gov*
Web site of the U.S. Patent and Trademark Office, featuring information on registering a trademark as well as a search engine of trademarks already filed with the agency.

United Media
✐*www.unitedmedia.com*
Web presence for newspaper syndicate.

Universal Press Syndicate
✐*www.amuniversal.com*
Web presence for newspaper syndicate.

WebcomicsNation
✐*www.webcomicsnation.com*
Web hosting with expanded services for Webcartoonists for a price.

Wirepop
✐*www.wirepop.com*
Online syndicate for manga-style Webcomics.

Appendix B

Glossary

all caps: Printing words and sentences that are formed using uppercase, or capital, letters only. Most cartoons feature writing that is displayed in ALL CAPS.

anthro: Slang for cartooning style that incorporates anthropomorphic characters.

anthropomorphic: Given human qualities. Animals are often drawn by cartoonists in an anthropomorphic style, resulting in characters such as Mickey Mouse, who acts more like a human than a mouse.

antonym: A word with an opposite meaning.

application: Computer software.

bandwidth: The amount of memory needed to serve the files that create a Web site to a viewer.

banner ad: A horizontal advertisement, usually appearing at the top of a Web site. Clicking on the ad takes the reader to the advertiser's Web site. Standard banner ads are 486 × 60 pixels.

baseline: Typographic term describing the imaginary line on which a row of type is arranged.

benday sheets: Sheets of clear plastic paper with adhesive on one side and dots printed on the other. Various sizes and quantities of dots on Benday sheets produce grays at different darknesses.

bird's-eye view: A drawing in which the perspective is such that the viewer seems to look down on a scene.

bitmap: An image in which every pixel is either black or white.

bristol board: Heavy paper specially created for drawing.

byte: Unit used to measure the size of a computer file or document. Abbreviated "K," a byte is 8 bits. A

bit (binary digit) is the smallest unit of information used by a computer.

caricature: An illustration that exaggerates a person's features to produce a grotesque or comical effect.

centered alignment: Typographic term describing how lines of text in a paragraph are positioned. Lines of text that are centered are placed at an equal distance from both the left and right borders.

chibi: Style of illustration used in manga in which the characters are drawn in a silly, cartoony style to reflect a light moment in the story.

CMYK (cyan, magenta, yellow, and black): Color mode used in the printing process. The acronym stands for the colors of the four inks used: cyan, magenta, yellow, and black (K).

comic: Slang for either comic strip or comic book.

comic book: A book that uses several pages of comic-strip-style panels or sequential illustrations to tell a story.

comics: Slang for the comic book industry. For example, "getting a job in comics."

comic strip: Any cartoon that uses a sequence of more than one panel.

composition: The placement of elements in an illustration such that the reader's eyes are directed in a meaningful way.

copyright: The legal authority to reproduce an image.

CPM (cost per thousand): Rate of payment for Web advertising. Payment is arranged for every thousand advertisements served to viewers of a Web site.

crosshatching: Creating the illusion of gray tones by filling areas with black lines. Sometimes darker gray

values are indicated as crosshatch lines drawn at different angles overlap.

dialogue box: Box that pops up in a computer application that allows the user to alter the document in some way.

dingbat: Small character in the corner of a political cartoon, used to express further commentary or a secondary punch line.

download: To obtain a file from a source on the Internet.

dpi (dots per inch): Unit for measuring the resolution of a printed image. The higher the number, the sharper the image. "Dpi" and "ppi" are used interchangeably.

Easter egg: A visual gag hidden in a cartoon for the reader to find.

editorial cartoon: A single-panel cartoon that satirizes politics, society, or current events.

EPS (Encapsulated PostScript): A computer file format best used when vectors are part of the file.

file server: A special computer on a network that is set aside to store, retrieve, and share files with other computers on the network.

file size: The amount of computer memory used to store a digital file on the computer. File size can usually be measured in bytes or megabytes.

first-time print rights: The legal authority to print a work that has never been previously published.

flush-left alignment: Typographic term describing how lines of text in a paragraph are positioned. Lines of text that are aligned flush left are lined up against the left border.

flush-right alignment: Typographic term describing how lines of text in a paragraph are positioned. Lines of text that are aligned flush right are lined up against the right-hand border.

foreshortening: Perspective drawing technique in which closer images are drawn larger and farther images are drawn smaller.

FTP (file transfer protocol): A method of uploading and downloading files over the Internet.

furry: Slang term for a cartoon that features anthropomorphic characters.

GIF (graphics interchange format): File format used on the Internet. Very good for black-and-white images and small graphics and logos.

graphic novel: Unlike a monthly comic book, a graphic novel is published once and printed on a better-quality paper. Some graphic novels are reprints of several months of comic books, and others are original stories.

grayscale: An image composed of black, white, and up to 254 shades of gray.

gutter: Space between panels in a comic strip or comic book.

halftone: An image that uses solid black dots to create the illusion of gray areas.

heroic proportion: Proportions to which a superhero is drawn—usually eight and a half heads tall.

hit: Unit for measuring traffic on a Web site. A hit is registered for each image file and HTML page that is used to create a Web page on the viewer's computer.

homonym: Words with different meanings that sound the same.

horizon line: When drawing in perspective, the horizon line is the viewer's eye level.

HTML (hypertext markup language): Computer programming language that facilitates the reading and writing of pages to be accessed through the World Wide Web.

hue: A specific gradation, shade, or tint of color.

hyperbole: Exaggeration.

idiom: A commonly used phrase.

image size: The actual physical size of the image, often measured in either inches or picas.

impact explosion: Visual effect—usually drawn as a starburst—used in cartooning to show impact.

imposition: See *page pairing*.

India ink: Black ink used by cartoonists. India ink can be mixed with water to produce gray tones that can be applied to paper with a brush.

inker: An individual who specializes in inking. An inker is usually part of the team that produces a comic book.

inking: The process of executing a final illustration in ink using pen, brush, or marker.

ink wash: Illustration technique that uses India ink diluted with water to form gray tones that are applied with a brush.

isometric perspective: A method of drawing in which the lines are drawn parallel to one another rather than receding to a vanishing point.

ISP (Internet service provider): The company through which a user buys access to the Internet.

JPEG (Joint Photographic Experts Group): Computer file format used in displaying images on the Web. This format is best used for photographs and complex color illustrations.

juxtaposition: Positioning two objects or ideas side by side for comparison.

kerning: Typographic term describing the distance between letters in words.

leading: Typographic term describing the distance between the baselines of two lines of text. Leading is often measured in points.

lettering: The act of adding text to a cartoon, either by hand or by using a computer.

line art: An image that is made up entirely of black marks on a white background.

LPI (lines per inch): Unit for measuring the number of rows of dots used in a halftone.

LZW: A method of compressing a TIFF file, named for the three people who invented the algorithm used in the process: Abraham Lempel, Jacob Ziv, and Terry Welch.

manga: Japanese-style comic book.

megabyte (MB): Unit for measuring file size. Equal to roughly 1 million bytes.

moiré pattern: Optical illusion caused by resizing a halftone bitmap. The realignment of the dots creates patterns that the human eye reads as lines, circles, and other shapes.

motion lines: Lines that indicate how an object in a cartoon is moving. Motion lines show where the object was and the path the object followed to get where it is.

narration box: A shape—usually a rectangle—that encircles narration in a cartoon. The narration usually contains background information to help the reader understand the cartoon.

nib: Special metal device attached to pen holder and used to apply ink in consistent lines.

nonphoto blue: Type of pencil or pencil lead that, because of its light-blue color, does not photocopy.

one-time print rights: The legal authority to reproduce a work for only one cycle. For example, a magazine that purchases one-time rights to a cartoon may reproduce the cartoon 2 million times in its next edition, but it cannot reproduce it again in subsequent editions or in different media such as the Internet.

onomatopoeia: Words that are pronounced like the sound they represent; for example, "pow" and "bang."

page pair formula: Formula used to determine page pairs: $T + 1 - P$. T is the total number of pages. P is one of the page numbers. For example, if it's a forty-page book and you're trying to find the page pair for

page 36, the equation is $40 + 1 - 36 = 5$. Page 5 pairs with page 36.

page pairing: Comic books are printed on long pieces of paper with four pages printed on each sheet—two on either side—and stapled in the middle. Page pairing is the process of establishing which pages get paired with which. The pages, once paired, are referred to as page pairs.

page views: Unit for measuring traffic on a Web site. A page view measures each time an HTML page is retrieved from the Web site's file server and presented to a viewer.

panel: Unit of division in a comic strip or comic book. For example, if a comic strip has four sequential illustrations, it can be said to have four panels.

penciller: An individual who specializes in pencilling. A penciller is usually part of the team that produces a comic book.

pencilling: The process of creating a preliminary illustration in pencil that will be refined in ink to form the final illustration.

pica: Unit used by printers to measure physical size. A pica is 12 points.

pinup: Full-page illustration in a comic book that is unrelated to the story.

pixel: Short for "picture element," a pixel is the smallest unit an image can be composed of. Each pixel contains 3 bytes of data—one for the value of each color (red, green, and blue) used to create that pixel's hue.

PNG (Portable Network Graphics): Relatively new computer file format that combines many of the strengths of a GIF and a JPEG. However, older Web browsers may not recognize PNG files.

point: Unit used in measuring type. There are 72 points in an inch.

pointillism: Process of creating the illusion of gray tones by placing black dots in an area. Light grays can be indicated by small dots spaced far apart, and darker grays can be created by larger dots spaced closely together.

political cartoon: A single-panel cartoon that satirizes politics, society, or current events.

popup ad: A type of Web advertisement that appears as a separate window in front of the host's Web site.

ppi (pixels per inch): Unit for measuring the resolution of a digital image. The higher the number, the sharper the image. "Ppi" is used interchangeably with "dpi."

process color: Printing term used to describe any printing process that uses the CMYK color model.

pun: A joke that uses a play on words, usually based on words with different meanings that sound alike.

punch line: In a joke, the part in which the humor is exposed.

punch word: In a punch line, the word that contains the maximum surprise.

quiver lines: Small motion lines that hover around an object to indicate the object's back-and-forth motion.

reprint rights: The legal authority to reproduce a work that has already been published.

resolution: The sharpness of an image.

RGB: Color mode used in light-based image projection such as with TV and computer monitors. The acronym stands for the three colors of light used to make a spectrum of hues: red, green, and blue.

royalties: Payment made based on a percentage of the price of related merchandise.

sans serif font: Any font or typography that does not use serifs.

search engine: Internet device that accesses Web sites that contain content that matches the keywords a user types in.

serif: A small stroke or embellishment added to the main letterform.

serif font: Any font or typography that uses serifs as part of the letters.

silhouette: A drawing that is filled with solid black. A silhouette drawing has very little detail except for the outline of the object.

single-panel cartoon: A cartoon that is composed of one illustration, usually with a caption underneath. Also called a gag cartoon.

splash page: Full-page panel in a comic book used to lure the reader into the story.

syndicate: A company that markets and distributes comics to newspapers and other publishers.

synonym: Word with the same or similar meaning as another word.

syntax: The rules a language follows in using words and sentences to communicate ideas.

thought balloon: Modified word balloon depicting a character's thought. A thought balloon is typically drawn in a cloud shape, with bubbles leading to the head of the character thinking the thoughts.

thumbnails: Small, quick sketches used to plan an illustration.

TIFF (Tag Image File Format): TIFF is the format used for files that use pixels to form images.

trademark: A word, phrase, symbol, or design—or a combination of these—that identifies the provider of goods or services.

typography: The art of designing letters and the craft of using those letters to form words, sentences, and paragraphs legibly and beautifully.

upload: To send a file to a storage area on the Internet.

vanishing point: When drawing in perspective, the vanishing point is the point to which all lines lead. There may be several vanishing points in one drawing, depending on the scene.

vector: A path or shape generated by a computer application. Vectors are created mathematically and are not pixel based. Therefore, they can be resized indefinitely without harming the quality of the image.

visit: Unit for measuring a Web site's traffic. A visit is counted each time a user's ISP address is registered loading one of the pages of the Web site.

Web: Short for World Wide Web.

Webcartoonist: A cartoonist who predominantly publishes on the World Wide Web.

Webcomic: A cartoon that is published on the World Wide Web.

Web host: An individual or organization that offers its file server(s) to house the necessary files and HTML pages required to present a Web site.

Web ring: System of linking one's Web site to—and being linked by—several other Web sites with a similar theme.

word balloon: A shape that encircles text in a cartoon and points to the speaker with a tail.

work for hire: A kind of contract that stipulates that the publisher gains all rights to the finished work.

World Wide Web: A service—based on HTML programming—through which information on the Internet is stored and retrieved.

worm's-eye view: A drawing in which the perspective makes it seem as if the viewer is looking up at the scene.

ZIP: A method of compressing TIFF files. Not to be confused with the external digital storage brand Zip, as in "Zip drives" and "Zip disks."

Index

THE EVERYTHING SERIES!

BUSINESS

Everything® Business Planning Book
Everything® Coaching and Mentoring Book
Everything® Fundraising Book
Everything® Home-Based Business Book
Everything® Landlording Book
Everything® Leadership Book
Everything® Managing People Book
Everything® Negotiating Book
Everything® Online Business Book
Everything® Project Management Book
Everything® Robert's Rules Book, $7.95
Everything® Selling Book
Everything® Start Your Own Business Book
Everything® Time Management Book

COMPUTERS

Everything® Computer Book

COOKBOOKS

Everything® Barbecue Cookbook
Everything® Bartender's Book, $9.95
Everything® Chinese Cookbook
Everything® Chocolate Cookbook
Everything® Cookbook
Everything® Dessert Cookbook
Everything® Diabetes Cookbook
Everything® Fondue Cookbook
Everything® Grilling Cookbook
Everything® Holiday Cookbook
Everything® Indian Cookbook
Everything® Low-Carb Cookbook
Everything® Low-Fat High-Flavor Cookbook
Everything® Low-Salt Cookbook
Everything® Mediterranean Cookbook
Everything® Mexican Cookbook
Everything® One-Pot Cookbook
Everything® Pasta Cookbook
Everything® Quick Meals Cookbook
Everything® Slow Cooker Cookbook
Everything® Soup Cookbook

Everything® Thai Cookbook
Everything® Vegetarian Cookbook
Everything® Wine Book

HEALTH

Everything® Alzheimer's Book
Everything® Anti-Aging Book
Everything® Diabetes Book
Everything® Dieting Book
Everything® Hypnosis Book
Everything® Low Cholesterol Book
Everything® Massage Book
Everything® Menopause Book
Everything® Nutrition Book
Everything® Reflexology Book
Everything® Reiki Book
Everything® Stress Management Book
Everything® Vitamins, Minerals, and
 Nutritional Supplements Book

HISTORY

Everything® American Government Book
Everything® American History Book
Everything® Civil War Book
Everything® Irish History & Heritage Book
Everything® Mafia Book
Everything® Middle East Book

HOBBIES & GAMES

Everything® Bridge Book
Everything® Candlemaking Book
Everything® Card Games Book
Everything® Cartooning Book
Everything® Casino Gambling Book, 2nd Ed.
Everything® Chess Basics Book
Everything® Crossword and Puzzle Book
Everything® Crossword Challenge Book
Everything® Drawing Book
Everything® Digital Photography Book
Everything® Easy Crosswords Book
Everything® Family Tree Book

Everything® Games Book
Everything® Knitting Book
Everything® Magic Book
Everything® Motorcycle Book
Everything® Online Genealogy Book
Everything® Photography Book
Everything® Poker Strategy Book
Everything® Pool & Billiards Book
Everything® Quilting Book
Everything® Scrapbooking Book
Everything® Sewing Book
Everything® Soapmaking Book

HOME IMPROVEMENT

Everything® Feng Shui Book
Everything® Feng Shui Decluttering Book, $9.95
Everything® Fix-It Book
Everything® Homebuilding Book
Everything® Home Decorating Book
Everything® Landscaping Book
Everything® Lawn Care Book
Everything® Organize Your Home Book

EVERYTHING® KIDS' BOOKS

All titles are $6.95

Everything® Kids' Baseball Book, 3rd Ed.
Everything® Kids' Bible Trivia Book
Everything® Kids' Bugs Book
Everything® Kids' Christmas Puzzle
 & Activity Book
Everything® Kids' Cookbook
Everything® Kids' Halloween Puzzle
 & Activity Book
Everything® Kids' Hidden Pictures Book
 Everything® Kids' Joke Book
Everything® Kids' Knock Knock Book
Everything® Kids' Math Puzzles Book
Everything® Kids' Mazes Book
Everything® Kids' Money Book

All Everything® books are priced at $12.95 or $14.95, unless otherwise stated. Prices subject to change without notice.

Everything® Kids' Monsters Book
Everything® Kids' Nature Book
Everything® Kids' Puzzle Book
Everything® Kids' Riddles & Brain Teasers Book
Everything® Kids' Science Experiments Book
Everything® Kids' Soccer Book
Everything® Kids' Travel Activity Book

KIDS' STORY BOOKS

Everything® Bedtime Story Book
Everything® Bible Stories Book
Everything® Fairy Tales Book

LANGUAGE

Everything® Conversational Japanese Book
(with CD), $19.95
Everything® Inglés Book
Everything® French Phrase Book, $9.95
Everything® Learning French Book
Everything® Learning German Book
Everything® Learning Italian Book
Everything® Learning Latin Book
Everything® Learning Spanish Book
Everything® Sign Language Book
Everything® Spanish Phrase Book, $9.95
Everything® Spanish Verb Book, $9.95

MUSIC

Everything® Drums Book (with CD), $19.95
Everything® Guitar Book
Everything® Home Recording Book
Everything® Playing Piano and Keyboards Book
Everything® Rock & Blues Guitar Book
(with CD), $19.95
Everything® Songwriting Book

NEW AGE

Everything® Astrology Book
Everything® Dreams Book
Everything® Ghost Book
Everything® Love Signs Book, $9.95
Everything® Meditation Book
Everything® Numerology Book
Everything® Paganism Book
Everything® Palmistry Book
Everything® Psychic Book
Everything® Spells & Charms Book
Everything® Tarot Book
Everything® Wicca and Witchcraft Book

PARENTING

Everything® Baby Names Book
Everything® Baby Shower Book
Everything® Baby's First Food Book
Everything® Baby's First Year Book
Everything® Birthing Book
Everything® Breastfeeding Book
Everything® Father-to-Be Book
Everything® Get Ready for Baby Book
Everything® Getting Pregnant Book
Everything® Homeschooling Book
Everything® Parent's Guide to Children
with Asperger's Syndrome
Everything® Parent's Guide to Children
with Autism
Everything® Parent's Guide to Children
with Dyslexia
Everything® Parent's Guide to Positive Discipline
Everything® Parent's Guide to Raising a
Successful Child
Everything® Parenting a Teenager Book
Everything® Potty Training Book, $9.95
Everything® Pregnancy Book, 2nd Ed.
Everything® Pregnancy Fitness Book
Everything® Pregnancy Nutrition Book
Everything® Pregnancy Organizer, $15.00
Everything® Toddler Book
Everything® Tween Book

PERSONAL FINANCE

Everything® Budgeting Book
Everything® Get Out of Debt Book
Everything® Homebuying Book, 2nd Ed.
Everything® Homeselling Book
Everything® Investing Book
Everything® Online Business Book
Everything® Personal Finance Book
Everything® Personal Finance in Your
20s & 30s Book
Everything® Real Estate Investing Book
Everything® Wills & Estate Planning Book

PETS

Everything® Cat Book
Everything® Dog Book
Everything® Dog Training and Tricks Book
Everything® Golden Retriever Book
Everything® Horse Book
Everything® Labrador Retriever Book
Everything® Poodle Book

Everything® Puppy Book
Everything® Rottweiler Book
Everything® Tropical Fish Book

REFERENCE

Everything® Car Care Book
Everything® Classical Mythology Book
Everything® Einstein Book
Everything® Etiquette Book
Everything® Great Thinkers Book
Everything® Philosophy Book
Everything® Psychology Book
Everything® Shakespeare Book
Everything® Toasts Book

RELIGION

Everything® Angels Book
Everything® Bible Book
Everything® Buddhism Book
Everything® Catholicism Book
Everything® Christianity Book
Everything® Jewish History & Heritage Book
Everything® Judaism Book
Everything® Koran Book
Everything® Prayer Book
Everything® Saints Book
Everything® Understanding Islam Book
Everything® World's Religions Book
Everything® Zen Book

SCHOOL & CAREERS

Everything® After College Book
Everything® Alternative Careers Book
Everything® College Survival Book
Everything® Cover Letter Book
Everything® Get-a-Job Book
Everything® Job Interview Book
Everything® New Teacher Book
Everything® Online Job Search Book
Everything® Personal Finance Book
Everything® Practice Interview Book
Everything® Resume Book, 2nd Ed.
Everything® Study Book

SELF-HELP/
RELATIONSHIPS

Everything® Dating Book
Everything® Divorce Book
Everything® Great Sex Book

All Everything® books are priced at $12.95 or $14.95, unless otherwise stated. Prices subject to change without notice.

Everything® Kama Sutra Book
Everything® Self-Esteem Book

SPORTS & FITNESS

Everything® Body Shaping Book
Everything® Fishing Book
Everything® Fly-Fishing Book
Everything® Golf Book
Everything® Golf Instruction Book
Everything® Knots Book
Everything® Pilates Book
Everything® Running Book
Everything® T'ai Chi and QiGong Book
Everything® Total Fitness Book
Everything® Weight Training Book
Everything® Yoga Book

TRAVEL

Everything® Family Guide to Hawaii
Everything® Family Guide to New York City,
 2nd Ed.

Everything® Family Guide to Washington D.C.,
 2nd Ed.
Everything® Family Guide to the Walt Disney
 World Resort®, Universal Studios®,
 and Greater Orlando, 4th Ed.
Everything® Guide to Las Vegas
Everything® Guide to New England
Everything® Travel Guide to the Disneyland
 Resort®, California Adventure®,
 Universal Studios®, and the
 Anaheim Area

WEDDINGS

Everything® Bachelorette Party Book, $9.95
Everything® Bridesmaid Book, $9.95
Everything® Creative Wedding Ideas Book
Everything® Elopement Book, $9.95
Everything® Father of the Bride Book, $9.95
Everything® Groom Book, $9.95
Everything® Jewish Wedding Book
Everything® Mother of the Bride Book, $9.95
Everything® Wedding Book, 3rd Ed.

Everything® Wedding Checklist, $7.95
Everything® Wedding Etiquette Book, $7.95
Everything® Wedding Organizer, $15.00
Everything® Wedding Shower Book, $7.95
Everything® Wedding Vows Book, $7.95
Everything® Weddings on a Budget Book, $9.95

WRITING

Everything® Creative Writing Book
Everything® Get Published Book
Everything® Grammar and Style Book
Everything® Grant Writing Book
Everything® Guide to Writing a Novel
Everything® Guide to Writing Children's Books
Everything® Screenwriting Book
Everything® Writing Well Book

Introducing an exceptional new line of beginner craft books from the Everything® series!

EVERYTHING C·R·A·F·T·S®

All titles are $14.95.

Everything® Crafts—Create Your Own Greeting Cards
1-59337-226-4
Everything® Crafts—Polymer Clay for Beginners
1-59337-230-2

Everything® Crafts—Rubberstamping Made Easy
1-59337-229-9
Everything® Crafts—Wedding Decorations
and Keepsakes
1-59337-227-2

Available wherever books are sold!
To order, call 800-872-5627, or visit us at *www.everything.com*
Everything® and everything.com® are registered trademarks of F+W Publications, Inc.